HAVE
BOARD,
WILL
TRAVEL

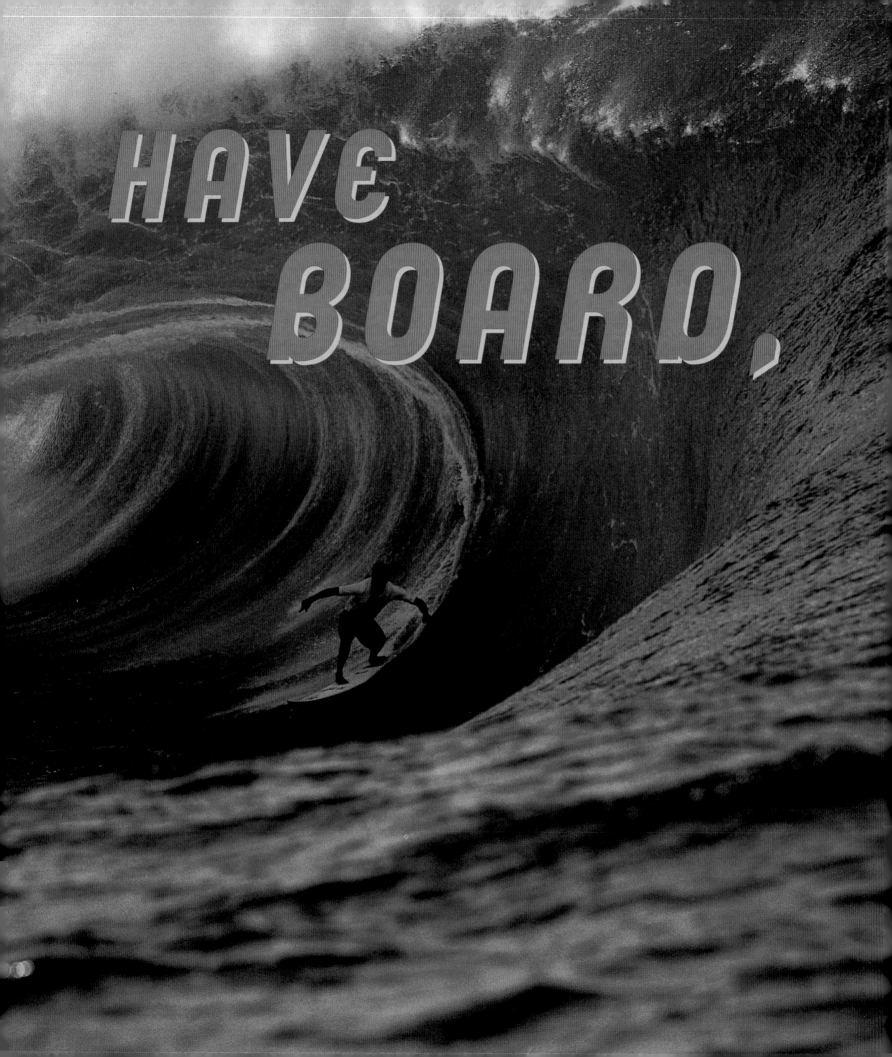

WILL
TRAVEL

THE DEFINITIVE HISTORY
OF SURF, SKATE, AND SNOW

Jamie Brisick

HarperEntertainment
An Imprint of HarperCollinsPublishers

Credits appear on page 189.

HAVE BOARD, WILL TRAVEL. Copyright © 2004 by Jamie Brisick. All rights reserved. Printed in China.
No part of this book may be used or reproduced in any manner whatsoever without written permission
except in the case of brief quotations embodied in critical articles and reviews. For information address
HarperCollins Publishers Inc., 10 East 53rd Street, New York, NY 10022.

HarperCollins books may be purchased for educational, business, or sales promotional use.
For information please write: Special Markets Department, HarperCollins Publishers Inc.,
10 East 53rd Street, New York, NY 10022.

FIRST EDITION

Designed by Jeffrey Pennington

Printed on acid-free paper

Library of Congress Cataloging-in-Publication Data

Brisick, Jamie.
Have board, will travel / by Jamie Brisick.—1st ed.
p. cm.
ISBN 0-06-056359-1
1. Surfing. 2. Skateboarding. 3. Snowboarding. I. Title

GV840.S8B77 2004
797.32—dc22 2003067511

04 05 06 07 08 ❖/TP 10 9 8 7 6 5 4 3 2 1

To my dear cousin Jeffrey, who turned me on to skateboarding and surfing in the mid-seventies. And to my cousin Pete and brothers Kevin and Steven, with whom I was fortunate enough to share those first glorious rides. And to my girlfriend, Gisela, a regular foot with loads of style. And to all riders out there who know the side-stanced buzz, be it on water, cement, snow, or all three—long may you rip.

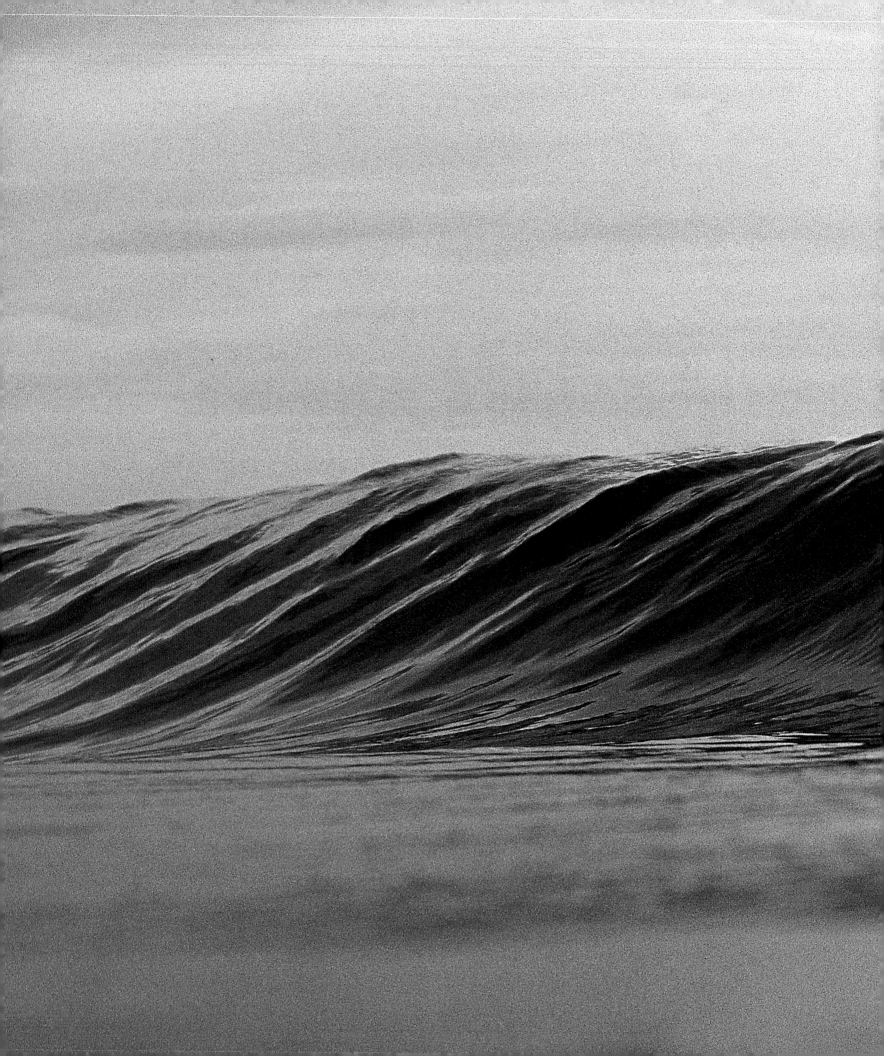

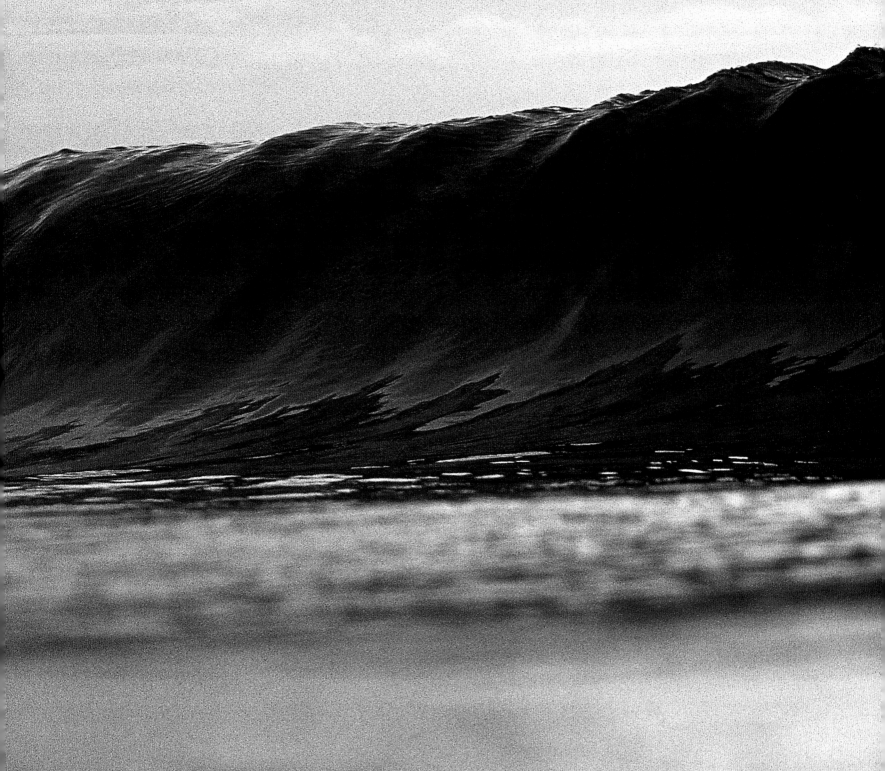

I DIDN'T START surfing because I expected it to be my career. It was something I just had a good time doing. But once I started, I couldn't stop. Nothing compared to the thrill of riding waves.

—Kelly Slater, *Pipe Dreams: The Life of Kelly Slater*

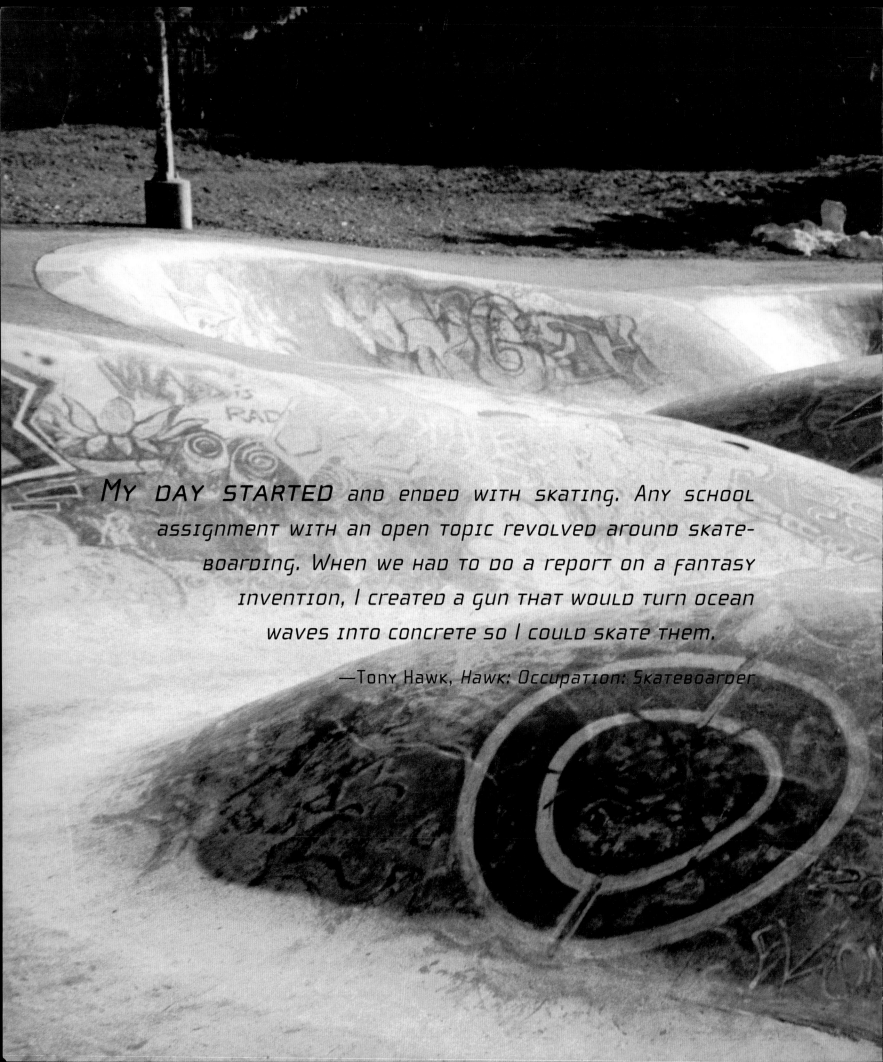

My day started and ended with skating. Any school assignment with an open topic revolved around skateboarding. When we had to do a report on a fantasy invention, I created a gun that would turn ocean waves into concrete so I could skate them.

—Tony Hawk, *Hawk: Occupation: Skateboarder*

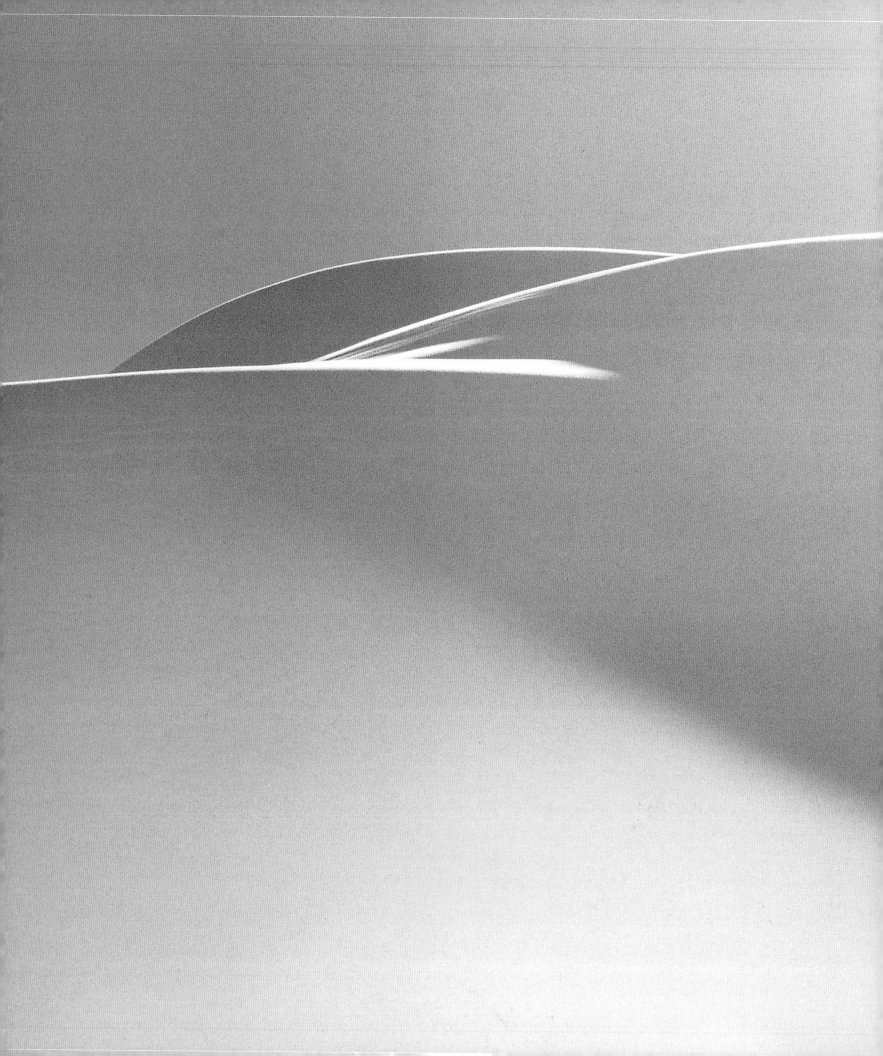

LIKE SURFING AND SKATEBOARDING, snowboarding is something you have to figure out. You have to earn it. You have to make it over different hurdles before it reveals its soul. And when that happens, its soul becomes part of you.

—Todd Richards, *P3: My Adventures in the Pipes, Parks, and Powder*

FADE IN:

A winter's day in North America, sometime between November and April . . .

TRESTLES, CALIFORNIA
2:45 P.M.

The sky is gray, the ocean silver. Two surfers straddle their boards, facing a horizon of possibility. The waves are one foot and few and far between, and during a lull, the surfer on the left says, "I hear it's been dumping at Vail for a week straight." "No shit?" says the surfer on the right. "What are we doing here?" Both surfers imagine a white mountain of steep powder fields and cliff drops to carve and free-fall.

CUT TO:

VAIL, COLORADO
3:45 P.M.

While waiting in line to catch a chair lift over to the half pipe, a couple of unruly-looking snow-boarders discuss the north shore of Oahu. "When the winds are right and the swell's got just the right amount of north in it, Sunset is as good a big wave as any . . ."

CUT TO:

SUNSET BEACH, HAWAII
12:45 P.M.

In the foreground, a towheaded kid in board shorts fakies back and forth on a wooden half pipe. In the background, the Pacific Ocean delivers a beautiful set of head-high waves. Out of the corner of his eye the kid sees the waves. He stops, flicks his skate-board away, grabs a 5'10" thruster off the lawn, and runs toward the surf.

In a Cross-fire Hurricane

Surfing started as a tree. That tree sprouted and produced the seeds that eventually grew into skateboarding. The two trees grew side by side, their branches mingling with each other, their trunks distinctly separate. Somewhere along the way, the pair dropped the seeds that would form snowboarding, so there were three trees growing in a cluster—their branches bouncing off one another, entwining here, intermingling there. From a distance you see more oneness than separation. Just a big vibrant life force that sprouts from the same soil. *Have Board, Will Travel* starts with the original seed of the first tree (surfing), follows it from the roots to the trunk, the branches, and the leaves, splinters off into the roots of the second tree (skateboarding), follows that tree's growth in relation to the first, then splinters again into the third tree (snowboarding). The three are tracked in parallel, covering their connections, divergences, and ultimate parallels until we arrive in the here and now. And this is where things get interesting: When you get to the tips of the branches, it's sometimes hard to tell where things start and where they end.

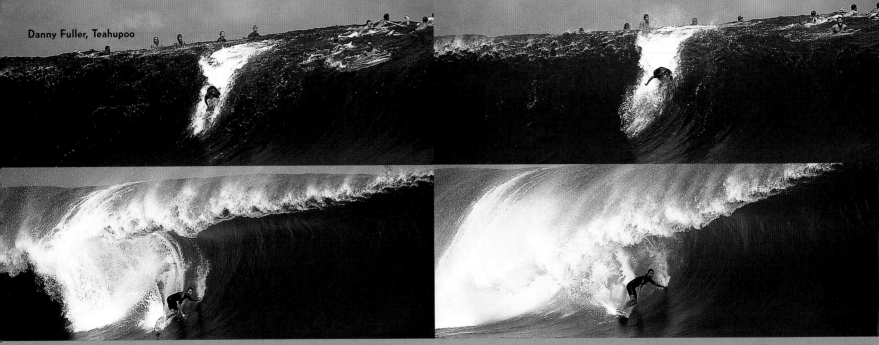

Danny Fuller, Teahupoo

Energy waves run our universe and surfers have figured out a way to plug into one of the only waves in the universe that becomes visible. I don't care if you

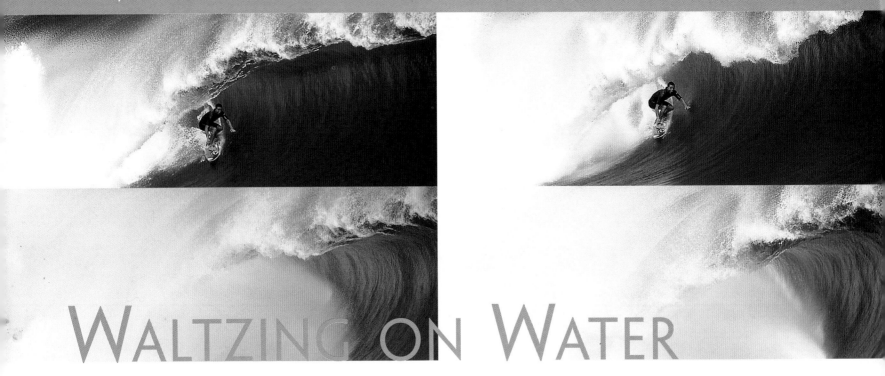

WALTZING ON WATER

THE POETIC RAPTURE THAT IS SURFING

Sometime in the mid-1900s, an adventurous surfer by the name of Greg Noll was on a pioneering mission down in Mazatlán. Surfing had yet to hit the Mexican shores at this time, and the sight of man riding wave was a new phenomenon. One afternoon Noll came in from a session at a long, rolling point break. He was greeted at the shoreline by an old man who'd been watching him surf. The old man's eyes were bulging.

He bowed his head and made the sign of the cross, whimpering something in Spanish. Noll didn't know what the hell was going on. It wasn't until later that he found out the old guy suffered from bad eyesight and mistook Noll standing on a board as Jesus walking on water.

At its best, surfing is a spiritual pursuit that enriches and enlarges the individual, creating a kinship with nature that's

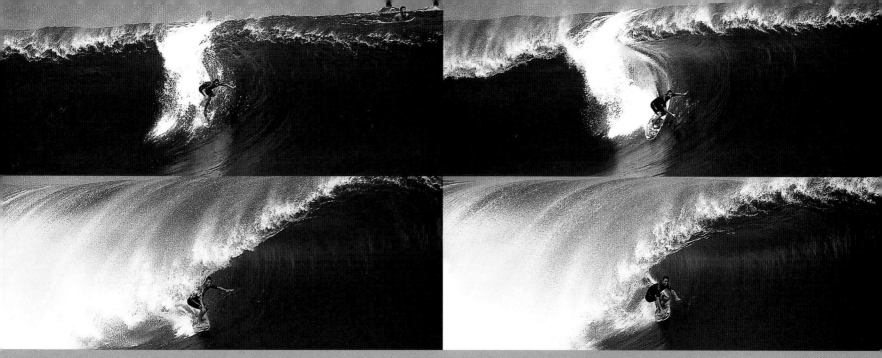

> CATCH a TWO-FOOT Wave at Doheny or a GIANT Wave at Jaws, THAT ENERGY FLOWS INTO YOU—AND SO SURFING'S A DIFFERENT FORM OF GRAVITY SPORT.　—Sam George

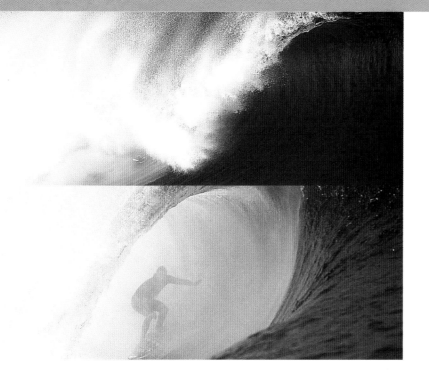

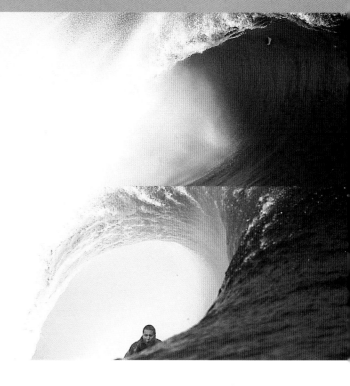

unlike any other sport. Wind, weather, and tide all have a hand in creating its playing field. That playing field is ever changing; hence no two waves are exactly the same. Waves are pulses of energy—aquatic metaphors for the bigger picture that is the cosmos. Surfers catch these waves and ride them for no particular reason other than fun. There is an extreme case of adaptability going on here. Imagine trying to toss a ball into a hoop, but the hoop is ducking and weaving and in flux. This is the kind of dance partner with which surfers have to deal. And there is no permanence in the act of wave riding, nothing to show for one's efforts. As quickly as the wave breaks it dissipates back into the giant vastness of the sea, the cycles of the universe mirrored perfectly, the dance of surfing a dress rehearsal for all of life's lessons.

ALL THOUGHT OF WORK is at an
end, only that of sport is left. The wife may go hungry,
the children, the whole family, but the head of the house does
not care. He is all for sport, that is his food. All day there is
nothing but surfing.

—Kepelino Keauokalani, *Traditions of Hawaii*, mid-1800s

BIRTH TO 1950

IN THE BEGINNING

Exactly when and where surfing began is all a bit gray. Some say it started in Peru in the fifteenth century when fishermen stood up in their canoes while waves pushed them shoreward. Others tell the same story, placing it in West Africa. There's the whacky theory that back in biblical times, when Moses was put in the reed basket and sent down the river, he became the world's first surfer. We're pretty sure Polynesians brought surfing from the Society Islands to Hawaii around A.D. 500 and

we're almost positive that by A.D. 1000 *he'e nalu*—also known as surfboard riding—was in full effect. The best recorded history we have starts with Captain Cook's diaries when he sailed to Hawaii in 1778. As the story goes, the early Polynesians migrated to Hawaii and brought their oceanic lifestyle with them. Everything revolved around the sea—from work to food to recreation. When the surf was up they did what surfers do today—drop everything and paddle out. Hawaii sits right

smack in the middle of the Pacific Ocean. There was no shortage of waves. You may have heard of surfing referred to as "the Sport of Kings." Well, back then it truly was. Surfers came from royal families. They'd paddle their oversized *wili wili* wood boards out to Waikiki, catch the sloping swells that seemed to go forever, and ride them shoreward with stiff, hood ornament–like styles. Back then boards were sacred. Surfers would find just the right tree, chop it down, carve it into shape with sharp stones or coral, stain it with *ti* root, and then lug it down to the beach. Upwards of twenty feet and weighing in over 100 pounds, they were a nightmare to drag around. Early surfers wore loincloths or nothing at all, frolicking in the fun and celebration of it all, enjoying surfing for its playfulness and sense of freedom. But when Christian missionaries arrived on the scene in the early 1800s, they decided these demonstrations of liberation threatened their stiff and upright ideals. They declared it impure and unethical, and consequently, surfing's popularity diminished throughout the century.

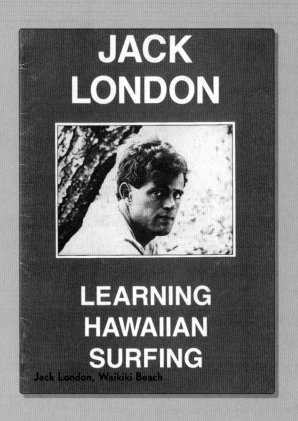

JACK LONDON

LEARNING HAWAIIAN SURFING

Jack London, Waikiki Beach

WHERE BUT THE moment before was only the wide desolation and invincible roar, is now a man, erect, full-statured, not struggling frantically in that wild movement, not buried and crushed and buffeted by those mighty monsters, but standing above them all, calm and superb, poised on the giddy summit, his feet buried in the churning foam, the salt smoke rising to his knees, and all the rest of him the free air and flashing sunlight, and he is flying through the air, flying forward, flying fast as the surge on which he stands.

—Jack London, *Learning Hawaiian Surfing*, 1907

GREAT LITERATURE AS GREAT PR

In 1907, thirty-one-year-old Jack London showed up in Hawaii with his wife and wave-lust in tow. Not only was London curious about surfing, but he also happened to be America's most famous writer. His plan was to perch himself in the heart of Waikiki, immerse himself in the "beach boy" lifestyle, and scribe his findings for all America to read. Under the tutelage of two local surfers—Alexander Hume Ford and George Freeth—London ended up falling in love with surfing, which he wrote about both eloquently and enthusiastically in a beautiful book called *Learning Hawaiian Surfing*, as well as a few well-circulated magazine articles. Hume Ford went on to start the Waikiki Outrigger Canoe and Surfboard Club, Freeth became famous for introducing wave riding to California, and London's surf stoke was broadcast throughout the country, letting the entire nation in on the magic of waltzing on water.

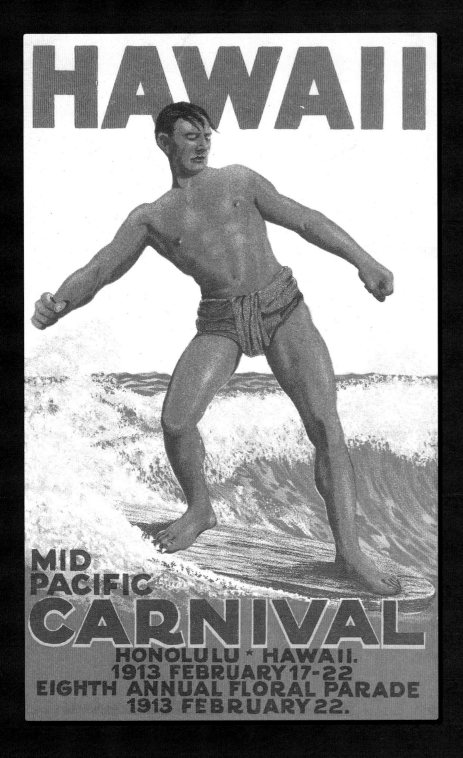

THE MAN WHO WALKED ON CALIFORNIA WATER

George Freeth was dubbed "the Man Who Can Walk on Water" when he showcased surfing for the first time at Redondo Beach in the summer of 1907. Freeth was regarded as the best surfer at Waikiki, and he'd been invited to California to help promote the new railway line that brought inlanders to the beach. Thousands of spectators huddled about the shore, amazed and astonished, as Freeth cut left, cut right, and essentially cut the ribbon on surfing in the mainland United States.

BEACH BOYS APLENTY

By 1915, Waikiki's Outrigger Club had over a thousand surf-stoked members. And they weren't the only game in town—the Hui Nalu Club was also up and running, with a more local, Hawaiian roots membership. Waikiki was booming with new hotels and restaurants, boatloads of tourists, and surfers aplenty. The local beach boys shared their lifestyle with the traveling *haoles* (mainlanders) and taught them how to surf. Hawaiians had a holistic view of the water—surfing was not just something you did, it was something you lived. They fished, they paddled, they dove, they rode waves, and they loved women like water monkeys. Legend has it, one beach boy took a young lass out for a night surf instructional and ended up teaching her the joys of making love while standing on a surfboard—a glorious image. Beach boys also swam like Olympian athletes, and sure enough, an Olympic gold medalist emerged from the bunch.

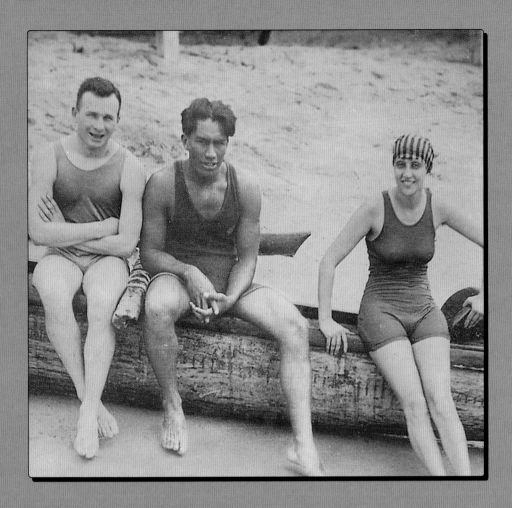

THE DUKE

Duke Kahanamoku is regarded as the father of modern surfing, and for good reason. He was baptized in the waters of Waikiki, was rumored to be the fastest swimmer in the world, and went on to win a couple of Olympic gold medals in the 100-meter freestyle. His achievements elevated him to celebrity status, and he toured throughout the United States, Europe, and Australia giving swim demos and showcasing surfing wherever possible. His 1914 demo at Freshwater Beach in Sydney is the stuff of legend. He walked the length of the board like a bronzed Jesus, did handstands and headstands with grace and glory, took a young girl out for a wave, and scattered the seeds for what would later become Australia's second most popular sport. Duke's godliness attracted the showbiz set. He went to Hollywood, wooed women, and appeared in a few films. In his later years he acted as Hawaiian ambassador, shaking hands, spreading aloha, and sharing surfing.

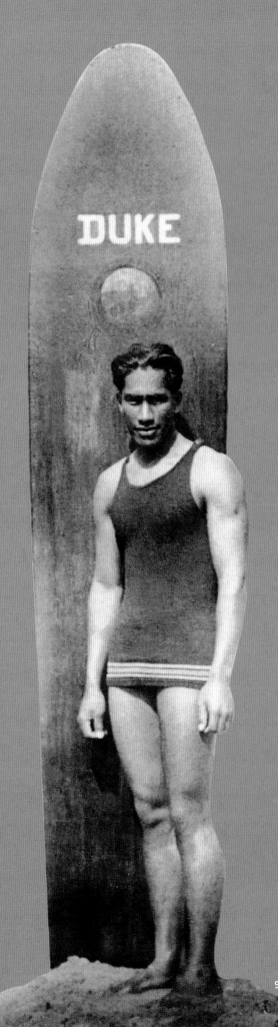

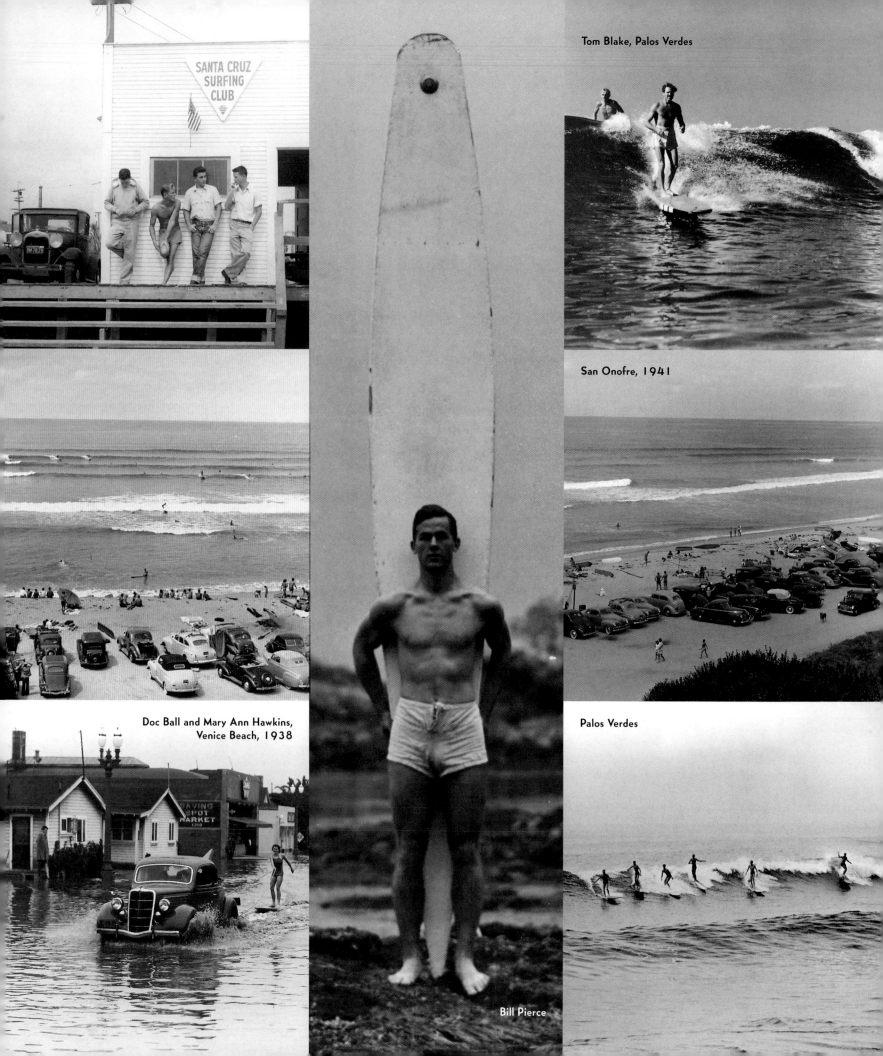

Santa Cruz Surfing Club

Tom Blake, Palos Verdes

San Onofre, 1941

Doc Ball and Mary Ann Hawkins,
Venice Beach, 1938

Bill Pierce

Palos Verdes

ENTER TOM BLAKE

In 1920, on his way home from winning his second 100-meter freestyle Olympic gold medal, this time in Antwerp, Belgium, Duke Kahanamoku stopped off in Detroit, Michigan, where he met Tom Blake, a Wisconsoner who was so taken by the Duke that he decided right then and there he'd devote the rest of his life to Hawaiian watersports. Blake relocated to Hawaii, where he proceeded to paddle, swim, and surf with mad fervor. He became obsessed with board design and took on the role of craftsman. Borrowing the plan shape of the ancient *olo* boards, Blake dug hundreds of small holes in the wooden plank, covered the whole thing with plywood, and created a board much lighter than what people were riding at the time. At first he was laughed at, but after winning a major paddle race on his sixteen-foot "cigar board" a short time later, the one laughing hardest was Blake. Duke eventually tried it and liked it, giving full credibility to the new design. The "Hawaiian Hollow Surfboard," patented by Blake in 1930, did two major things: one, it kick-started a huge design renaissance, and two, it made surfboards a hundred times more user friendly (they were a lot easier to lug around). Blake's remembered as a huge visionary—he wrote books, shot photos, and invented the first surfboard fins and camera water housings.

GOOFYS AND REGULARS

There's a good chance that the first man to ever stand on a surfboard did so with a parallel stance, but through trial and error, it was quickly discovered that surfing was a little like boxing—you're going to be at your most solid with one foot forward, the other back. And so the side stance evolved, one of the first big links of the board sports. Important to note: He or she who rides with their left foot forward is a regular foot. He or she who rides with their right foot forward is a goofy foot. Kelly Slater, for example, is a regular foot while Gerry Lopez is a goofy.

CALIFORNIA SWELLS

Back on the mainland, clusters of surfers began to appear at places like San Onofre, Corona del Mar, Palos Verdes, the South Bay, Malibu, and on up to Santa Cruz. The same holistic/beach boy approach to the water was adapted by Californians, but the colder weather was a hurdle. Leroy Grannis, a well-known surf photographer who was part of the scene back then, remembers dealing with the pre-wetsuit cold water: "It was so cold sometimes you'd paddle out, and twenty minutes later you were all froze up, with no coordination." Regardless, surfing continued to grow.

HOT CURL

As legend has it, the waves were fifteen to eighteen feet at Brown's, a spot just outside Waikiki, the day Wally Froiseth, Fran Heath, and John Kelly realized the boards they were riding were way too wide for the big surf. They'd take off on a wave, attempt to angle down the face sideways, and end up sliding out. There was no traction. So what did they do? They went in, axed off the sides of their tails, and paddled back out. And ripped! Because of the gunnier plan shapes, "hot curl" boards allowed more holding power, and hence more speed, control, and maneuverability. This opened new doors as far as what was rideable and what wasn't, and top Hawaiian surfers like Froseith, Heath, Kelly, and George Downing began migrating to other parts of the island, giving the first hints of hotdog surfing in the process.

WARTIME SURFING

Although the surf boom slowed during the war years, the hardcore kept marching forward. California, Hawaii, and the east coast of Australia were all very much aware of each other's presence, and board design and riding styles cross-pollinated via word of mouth. There were no magazines, no videos, and still no contests, but surfers were a naturally competitive bunch, and boundary pushing occurred off in its own little cocoon, sometimes too much so . . .

NORTH SHORE STORY

The year was 1943. The time: late afternoon. The sun was nearing the horizon. Dickie Cross and Woody Brown, a couple of big wave mavericks from Hawaii, had paddled out into a twenty-foot rising swell at Sunset Beach that was now up around thirty feet. They'd been fighting the rip current for half an hour. Well aware that they were in way over their heads, they made a joint decision. They'd let the rip take them out beyond the massive breakers, stroke parallel to shore on down to Waimea Bay, and then utilize the bay's deeper water to safely reach the shore. But when they finally reached Waimea it had gotten even bigger, and there was no passage to shore other than to take off on a wave or swim for it. Woody thought it best to swim. Dickie thought otherwise. When a jacking three-story-sized wave came, Dickie swung around. Woody shouted, *"Nooo!"* Dickie disappeared over the ledge, the wave erupting in a thunderous roar. The ocean continued on like a washing machine. Woody was alone in a black sea under a black sky. He bailed his board and his trunks and stroked shoreward. He was later found on the beach, naked and unconscious, but still breathing. Dickie Cross was never seen again.

1950s

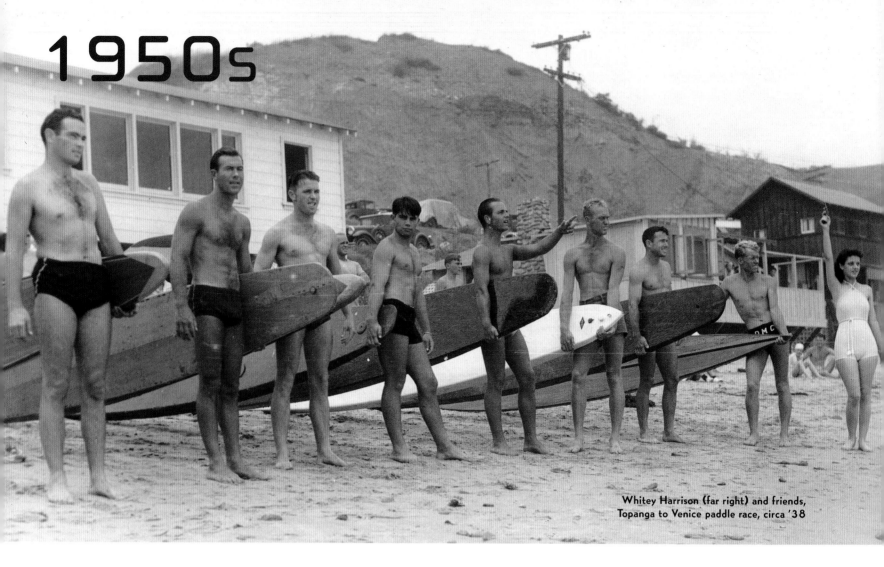

Whitey Harrison (far right) and friends,
Topanga to Venice paddle race, circa '38

MALIBU TITANS

Back in California, Malibu had emerged as an ideal spot to launch new styles, maneuvers, and designs. The long point waves offered long rides, in turn giving surfers time enough to walk up and down their boards—a fancy footwork approach known as "cross-stepping." Bob Simmons built surfboards out of his garage in Pasadena. He was enrolled at the California Institute of Technology and soaked up all the hydrodynamic theory he could. In an effort to reduce the weight of the all-wood boards of the time, Simmons sandwiched polystyrene foam between sheets of plywood, sealed the whole thing in fiberglass, and created the biggest design breakthrough since Blake's hollow boards twenty years previous. He and his design-obsessed pals Joe Quigg and Matt Kivlin progressed big-time on the lighter equipment. Quigg and Kivlin refined Simmons's designs even further, and before you knew it, surfers everywhere were using fins on their boards, giving them more hold, maneuverability, and speed.

BIG BUSINESS

With surfing's popularity on the rise and demand for the new, more user-friendly boards increasing by the day, Hermosa Beach surfer/shaper Dale Velzy set up shop, literally. He and partner Hap Jacobs sold boards, sponsored riders, and promoted surfing's growth. Others followed, with Greg Noll, Hobie, and Dewey Weber leading the pack. Further up the coast near San Francisco, Jack O'Neill, a surfer who'd had enough of freezing his nuts off in cold water, began making wetsuits out of a new, rubberlike substance called neoprene. In true P.T. Barnum fashion, he'd wrap his kids in it and have them bathe in a tub of ice water for hours for all his surfer friends to see. Soon wetsuits became shuffled into the mix, and surfing as a year-round affair in the mainland United States became a much warmer reality.

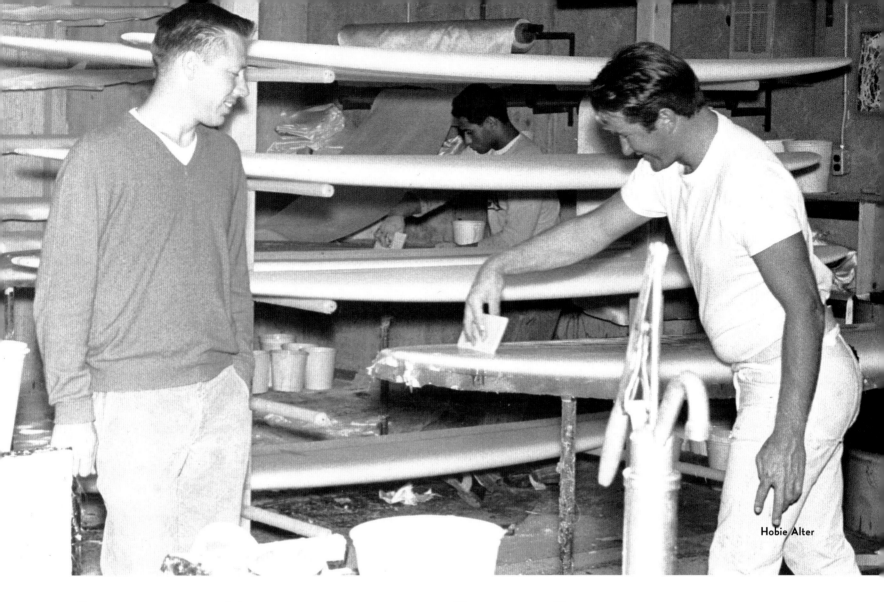

Hobie Alter

COMPETITION IN MAKAHA

There was still no surf media to spread news of the sport in the early fifties, but there were stories, and one of them was about a place called Makaha. Situated on the west coast of Oahu, Makaha was rural, idyllic, isolated, and, best of all, had great waves. Hawaiians and Californians would stay there for weeks—surviving on fish and fruit, sleeping in their cars, and surfing three or four sessions a day. It developed into such a scene that they decided to hold a major contest there. Hawaiian George Downing won the first annual Makaha International Surfing Championships in 1954, and rightly so. He'd been hipped to Makaha many years back and knew the spot inside and out. Makaha continued to be the destination of choice throughout the decade, and the contest turned into a legendary annual event.

FOAM AND FIBERGLASS

Hobie Alter was a surf-stoked Laguna Beach kid who'd started out making balsa chip boards for his friends and eventually opened a shop in Dana Point in 1954. At the time, the economy was up and people were enjoying the beach for all its leisurely aspects, surfing included. So one day this salesman from Reichold Plastics rolls in with this new style of foam he thinks Hobie may have a use for. With the increased demand for surfboards and the limited supply of balsa, Hobie saw a golden opportunity. He began experimenting with the foam—testing its strength, weight, and ability to be carved with a planer. It was magic. And super-light. But it also absorbed water like a sponge. Hobie quickly appointed one of his glassers, Gordon "Grubby" Clark, on the project. Clark sealed the foam in fiberglass cloth and resin, making it 100 percent waterproof, and the rest is history. Surfboards were both revolutionized and democratized in one fell swoop.

THUNDER DOWN UNDER

Surfing was a hot ticket in the States, and when it came time to send their athletes to Australia for the 1956 Olympic Games, the U.S. government was kind enough to include surfing in the package (not to compete, but simply to showcase a few top riders). Tom Zahn and Greg Noll were among the lucky invites, and when they arrived on Australian shores they were absolutely stoked to find a surf movement in full swing. The Aussies were on fire. But their boards were a bit behind the eight ball. Zahn and Noll brought them up to speed, elements of the Malibu chip found their way into Australian surfboard design, and a few years later, Midget Farrelly, a renowned hotdogger from Sydney, voyaged to Hawaii and earned himself a world title—the first of many for the Lucky Country.

BIG-WAVE SURFING

The North Shore of Oahu is big-wave riding heaven. With very little continental shelf to disrupt the open ocean Aleutian swells, huge waves explode across a wide variety of shapely reefs, creating the kind of waves surfers live for. But when the swells get up in the twenty-foot-plus range, the majority of the spots close out, meaning they dump all at once, giving the rider nowhere to go. It's around twenty feet that Waimea Bay is only *just* finding its form. To this day, Waimea Bay is one of the most famous big-wave spots in the world. Prior to the 1950s, it was rarely surfed, and with the Woody Brown/Dickie Cross story still floating around, it was more or less bad *juju*. But all this would soon change. Greg Noll was a mainlander who'd dropped everything and moved to Hawaii in 1952. He'd had a fair taste of big waves at Makaha, was in rock-solid physical shape, and was notorious for being a ballsy dude. He was also notorious for his Waimea fascination. For years he'd been trying to muster the guts to paddle out. On November 7, 1957, a day he describes as eighteen to twenty feet, Noll and a few brave buddies paddled out to the Bay. They broke the ice cautiously, starting off with the smaller waves and working their way into the big ones. And by the time their session was over they were certain of three things:

1) No one had died,
2) the Bay was in fact very rideable, and
3) judging by the crowd that had amassed on the beach, spectators love to watch surfing in big waves.

AT WAIMEA, THE SURF WOULD COME UP fast and make real serious sounds. I remember one night when it made the windows in our house rattle. That same night, the surf covered up the telephone poles with 30 feet of sand. This tells you Waimea is closing out.

—Bruce Brown, *Da Bull*

THE 'BU BLOWS UP

Throughout the decade, Malibu had been swelling steadily, and by the late fifties, the scene had reached full capacity. Guys like Lance Carson, Johnny Fain, Mickey Munoz, Kemp and Denny Aeberg, Gard Chapin, Dewey Weber, Miki Dora, and many others walked the nose, hung ten, shot the curl, did left-go-right takeoffs, and contributed much to the evolution of hotdog surfing, all the while attempting to protect Malibu from inland "ho-dads" and ravenous outside interests, all of which would come to a grand, celluloid crescendo in 1960.

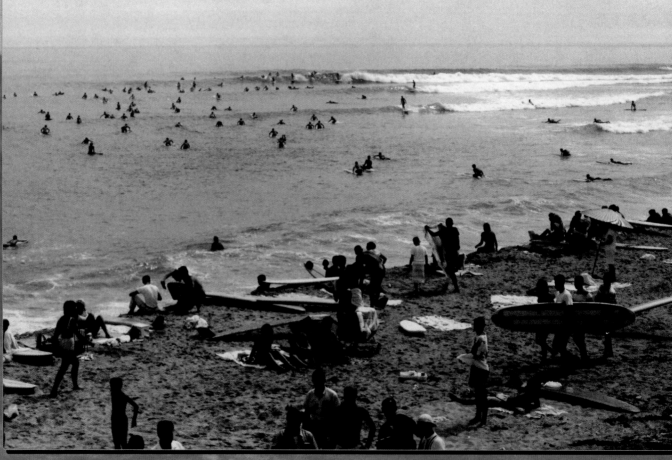

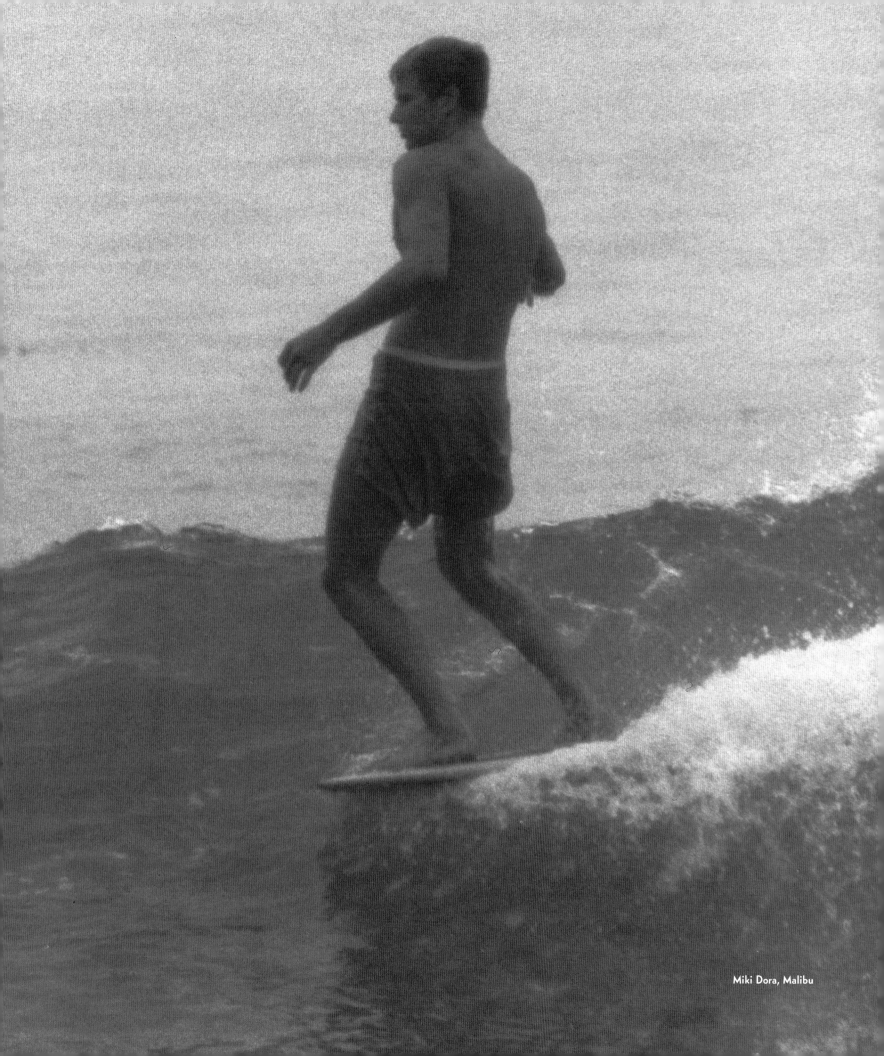
Miki Dora, Malibu

Rolling on Pavement

THE FOUR-WHEELED WONDER THAT IS SKATEBOARDING

There's a vibration and a rumble that comes from riding a skateboard that perpetuates youth. It enters through the feet, climbs up the legs, rushes through the organs, and shoots into the brain, transforming even the most refined man into an imaginative, improvisational child of the concrete. Skateboarders see possibility where most pedestrians see only a curb, a park bench, or a set of stairs with a smooth handrail. They transform the banal urban landscape into a fun park; turn chicken shit into chicken salad.

Skateboarding spawned from surfing, a variation of the same act on different terrain. With surfing you've got waves and water—always moving and ever changing. With skateboarding you've got a static playing field—hence the opportunity to practice the same trick over and over again. For this reason, the performance aspects of skateboarding evolve at a faster rate than surfing. With surfing you've got about twenty-five tricks in total, with skateboarding you've got hundreds.

Unlike surfing, skateboarding does have a utilitarian purpose. You can use it to get from point A to point B. But the essence of skateboarding—much like surfing—is all about fun. There are no finish lines, no goals to get the ball through, no right or wrong. It's not "what" you do, it's "how" you do it that counts. In other words, style and individuality are a big part of the package.

A SKATEBOARD IS the ultimate street surviving utensil. You can open a beer with it. You can beat somebody back with it. You can get on a bus with it. You can take it to a movie.

—Jake Phelps

1960s

SKATEBOARDING'S FIRST RUMBLINGS

Much like surfing, pinpointing the first ever skateboarder is like finding the needle in the proverbial haystack. There were handlebar-holding/skate-minded kids pushing along on scooters in the thirties and forties, steering left and right with a trace of surfy flow. There's talk of a guy called Peter in La Jolla in 1947 who officially kicked the whole thing off. But for fact we know that sometime in the mid to late 1950s Southern California kids began tearing the handles off scooters as well as ripping the wheels and trucks off rollerskates and nailing them onto two by fours, marking the first rumblings of skateboarding as we know it today.

Mark Richards

SIDEWALK SURFING

The early days of skateboarding were a far cry from what they are now. Firstly, the sport had yet to stand on its own two feet. Skateboarding, or "sidewalk surfing" as they called it, was more something surfers did when they weren't surfing, more a second-best than a first. Boards were made of blocks of heavy wood and wheels and trucks were what they designed for roller skaters. They were hard to turn and the metal wheels rolled like rocks, making the slightest blemish in the pavement a potential disaster. Bearings didn't come sealed the way they do now. They were miniature marbles and a nightmare to manage. Tricks were all about surfing. When they'd pass under a hedge growing over the sidewalk, early skaters imagined it as a tube and ducked and pretended. Over a long stretch of flat they'd walk to the nose, curling their toes over the tip like they were hanging ten. But the equipment was horrible and in desperate need of some kind of evolution.

GIDGET

Kathy Kohner was fifteen when she began battling with the big boys at the 'Bu. A tomboy with an open mind, Kohner was embraced by the elite Pit crew and spent an entire summer leading the Malibu version of the Waikiki beach boy lifestyle. Kohner's father became fascinated with his daughter's interactions with the hedonistic, live-to-surf sorts she hung out with, and went on to write a book about it. In 1960, *Gidget* was turned into a movie, which instantly became a huge hit. More beach movies followed, and though they parodied surfing rather than authentically represented it, the buzz caught on and surf fever spread throughout the nation, eventually making its way to vinyl.

LITERALLY THERE WAS a governor on those wheels that said you can only go so far, and that's it. It was as if the surfing god said, "Hey, we don't want you to eclipse us, so we're going to keep these certain wheels under your feet." Knowing that if we put the right wheels under your feet, you're going to go off and do better things than you can on surfboards.

—Stacy Peralta

THE SURFER

SURF MUSIC

Surfing may be the only sport in the world that actually has it's own musical genre linked to it. Dick Dale is known for being the papa of the surf guitar, but it was the Beach Boys who scattered the seed the furthest, with *Pet Sounds* going down in twentieth-century history as one of the great rock albums of all time. "Wipeout" by the Surfaris is still as groovy a tune as any to come from the era, and "Surfin' Bird" by the Trashmen has been covered by garage bands worldwide.

TIC TACS

Skateboarding slowly progressed, both equipment- and performance-wise. Roller Derby skateboards sold in toy stores for under ten bucks. They were twenty-four inches long and four inches wide. They had steel wheels. Soon surf shops like Hobie, Makaha, Jack's, and Val Surf were selling boards, and skaters were adding a little dance to their act. Tic tac–ing happened when a skater stomped the tail, lifted the front wheels, and banged them right and left, little baby kick-turns that moved the board forward. Before you knew it they were doing 360s.

Sports Illustrated

JULY 18, 1966 40 CENTS

I GREW UP on a surfboard!

—Elvis Presley, *Blue Hawaii*

SURFING'S EAST COAST BOOM

TOP STYLIST PHIL EDWARDS
RIDES AT VIRGINIA BEACH

MEDIA BLITZ, MEDIA BLITZ

Prior to 1960 there were no
surf magazines to circulate the
latest, greatest advances in the
sport. There had been a few books and
films, but no periodicals and nothing that
documented the movement on a regular basis.
All this changed when John Severson published *The
Surfer,* which swiftly became *The Surfer Quarterly,* and later
simply *Surfer.* Throughout the decade, circulation of *Surfer,*
aka "the Bible of the Sport," boomed from 5,000 to 100,000
copies per issue, giving tangible evidence that the surfing tribe was on
the rise.

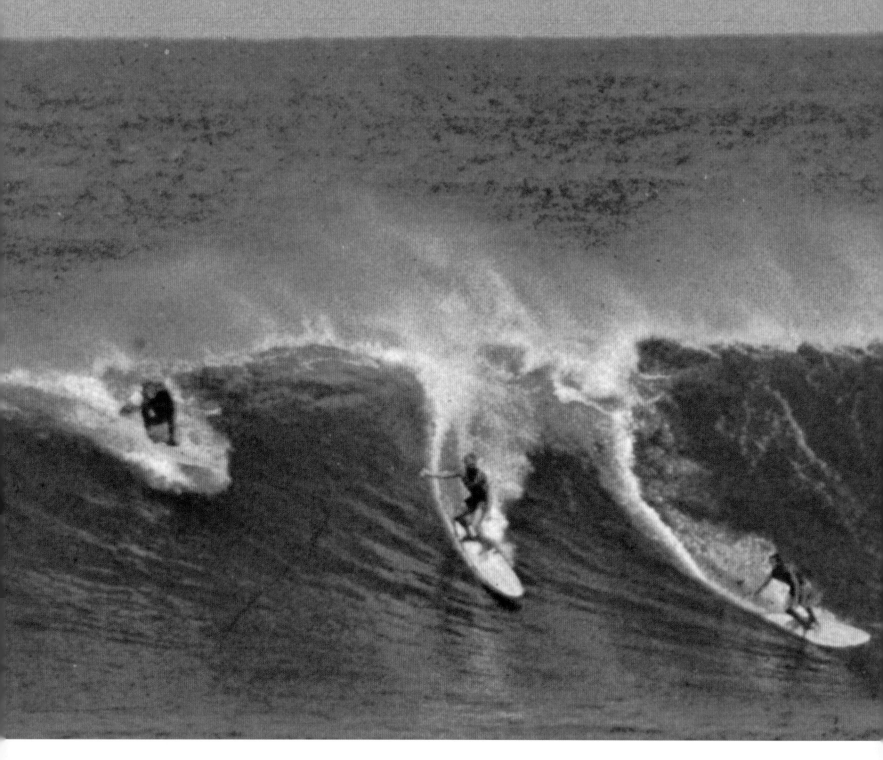

GOING GLOBAL

Surfing spread like a watery virus, converting a huge wave of East Coast U.S. surfers as well as those in far-off destinations like South and Central America, Europe, Africa, and eventually Asia.

SKATEBOARDS EVOLVE

Mark Richards was at the helm of Val Surf, a surf and skate shop in Southern California, when the first wave of skate craze kicked in in the early sixties. Skateboards were selling like mad, but the technology was still primitive. That's when he took matters into his own hands. "We approached Chicago Skate Co. in sixty-two," Richards remembers. "We had our wood decks but we had to get the skates. Up until that time the Chicago Truck Assembly was riveted on to a boot, with two trucks and wheels to go with roller skates, and a plate that connected them." Mark suggested to the Chicago Truck people that they cut the plate

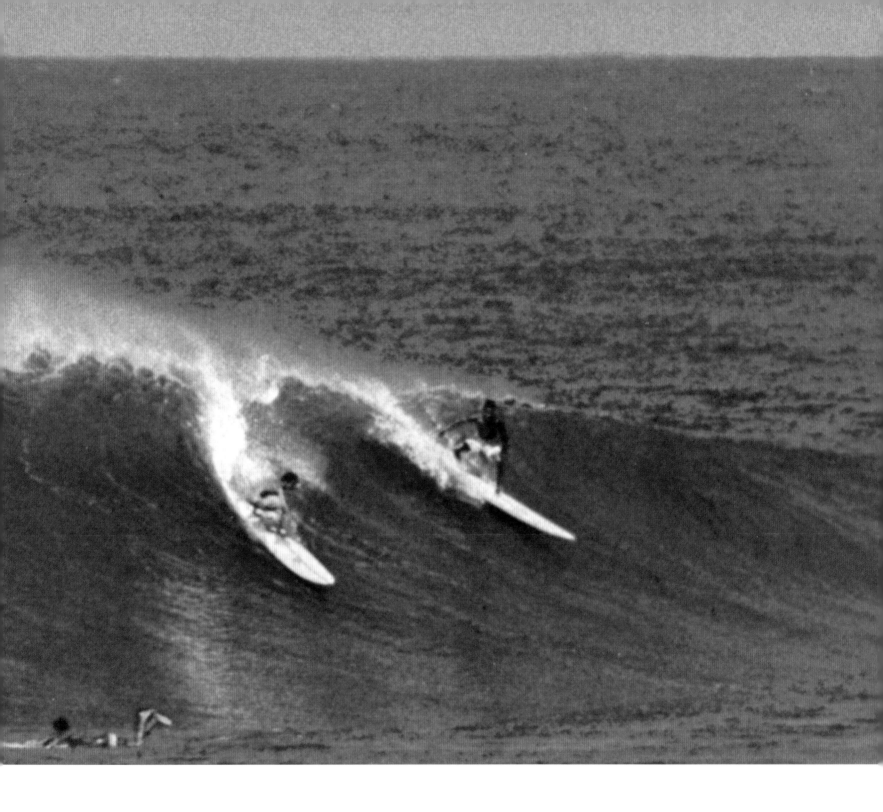

in half and add screw holes, so the trucks could be screwed onto the deck. Chicago complied, and the first official skateboard trucks were in motion.

SKATEBOARDING BOOMS

By 1964, skateboarding had swelled considerably and companies like Black Knight, Sterling, Nash, Native Custom, Makaha, Hobie, and G&S were selling skate decks made of plastic, wood

(oak, ash, and mahogany), and later fiberglass. The boards were shaped like surfboards, and savvy skaters would glue blocks of wood to the backs of them, creating kicktails. The first official skateboard team came into being via Hobie. They demo'd throughout the country, scattering the seeds of skate lust to the yet-to-be-converted masses. Meanwhile, performance levels were lifting, boards were selling like hot cakes, and the mainstream media had their eyes pointed skateward.

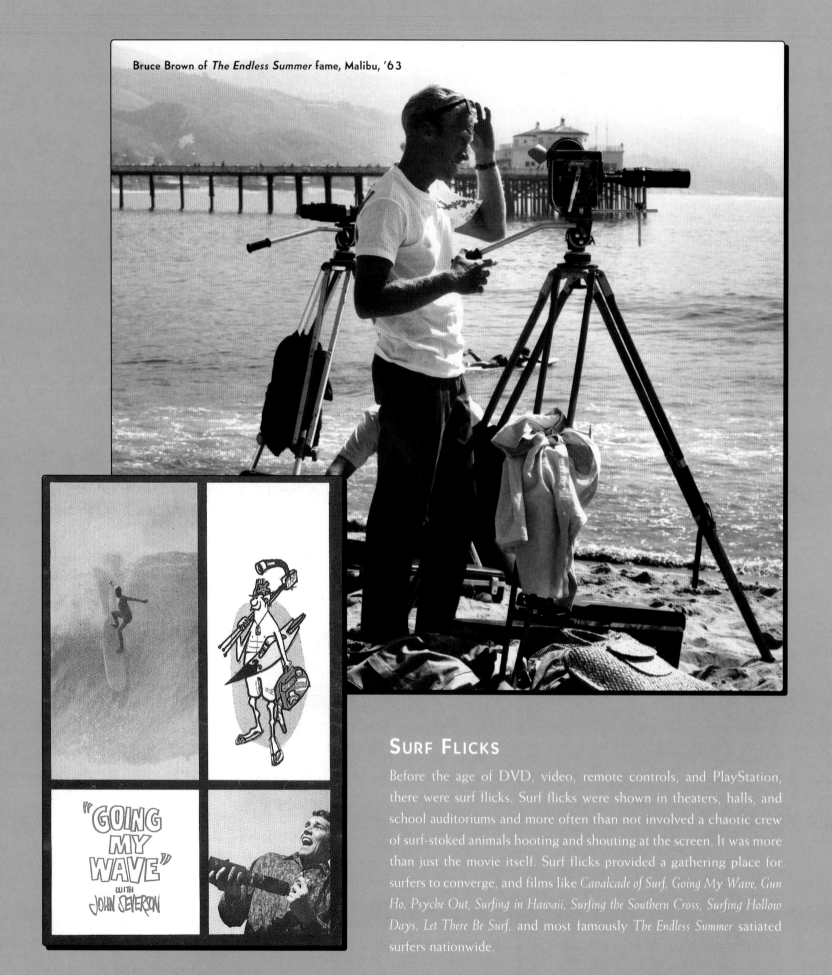

Bruce Brown of *The Endless Summer* fame, Malibu, '63

"GOING MY WAVE" WITH JOHN SEVERSON

SURF FLICKS

Before the age of DVD, video, remote controls, and PlayStation, there were surf flicks. Surf flicks were shown in theaters, halls, and school auditoriums and more often than not involved a chaotic crew of surf-stoked animals hooting and shouting at the screen. It was more than just the movie itself. Surf flicks provided a gathering place for surfers to converge, and films like *Cavalcade of Surf, Going My Wave, Gun Ho, Psyche Out, Surfing in Hawaii, Surfing the Southern Cross, Surfing Hollow Days, Let There Be Surf,* and most famously *The Endless Summer* satiated surfers nationwide.

Bud Browne
presents

GUN HO!

1963 Color Surf Film

FEATURING

**Phil Edwards, Mickey Dora, John Peck, Butch Van Artsdalen, Mike Doyle, Rusty Miller, Dewey Weber, Paul Strauch
Mike Hynson, Midget Farrelly, Johnny Fain, Greg Noll, Candy Calhoon, Linda Benson, Linda Merrill, L.J. Richards
Ricky Grigg, Buzzy Trent, George Downing, Fred Van Dyke, Corky Carrol and other top surfers of the era.**

Video Now Available

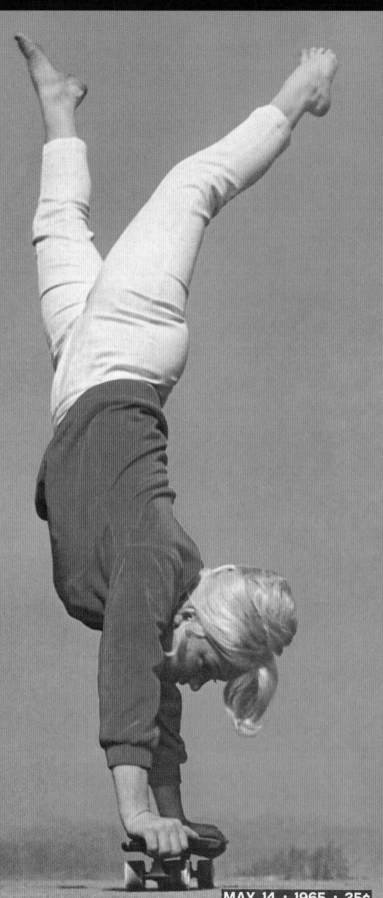

LIFE

The craze and
the menace of

SKATEBOARDS

San Diego's Pat McGee,
national girls' champion,
does a handstand on wheels

MAY 14 · 1965 · 35¢

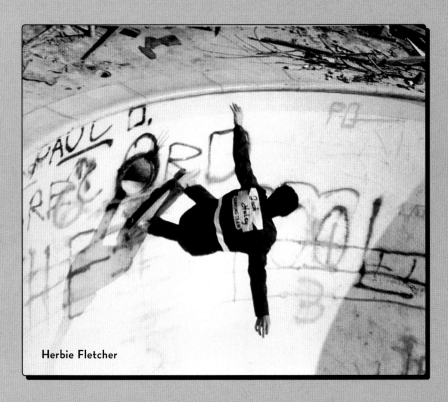

Herbie Fletcher

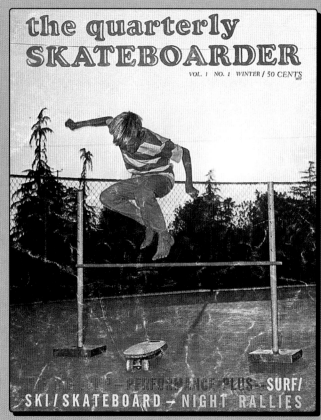

THE BALL ROLLS . . . INTO A WALL

In the summer of 1964, *Life* magazine hyped the skate craze with an article entitled "Here Come the Sidewalk Surfers." That same year, *The Quarterly Skateboarder* was launched, spreading word of red-hot riders like Torger Johnson, Bruce Logan, Steve and Dave Hilton, Bob Mohr, and Woody Woodward. Then *Skater Dater* came out, a movie presenting skateboarding in a charming, innocuous light. Things continued to snowball. In 1965 the National Skateboard Championships enchanted an entire stadium of spectators in Anaheim, California. The event got airtime on ABC's *Wide World of Sports*, demanding that the entire American public take notice. Kids were doing handstands, nose and tail wheelies, and multiple 360s. There was even talk of skaters riding empty pools. But somewhere along the line, the roar of wheels on pavement managed to scare the trousers off protective parents, inspiring *Life* to run a second skate story, this time titled "Skateboard Mania—A Teeter Totter on Wheels Is a New Fad and Menace."

THE SNURFER

Invented by Sherman Poppen of Muskegon, Michigan, in 1965, "The Snurfer" was a bindingless board that came with a rope handle for added stability. Snurfers were not designed for water or concrete, they were designed for snow-covered mountains, and for the next fifteen years a group of surfer/skaters began to explore ways of surf/skating on snow (turn to page 68).

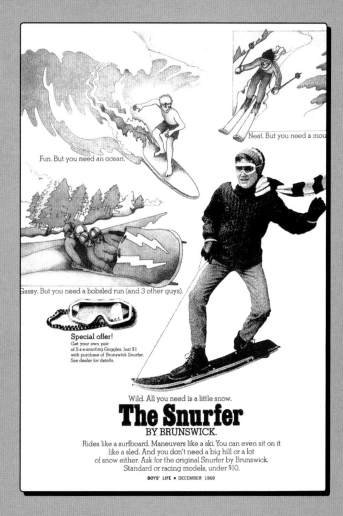

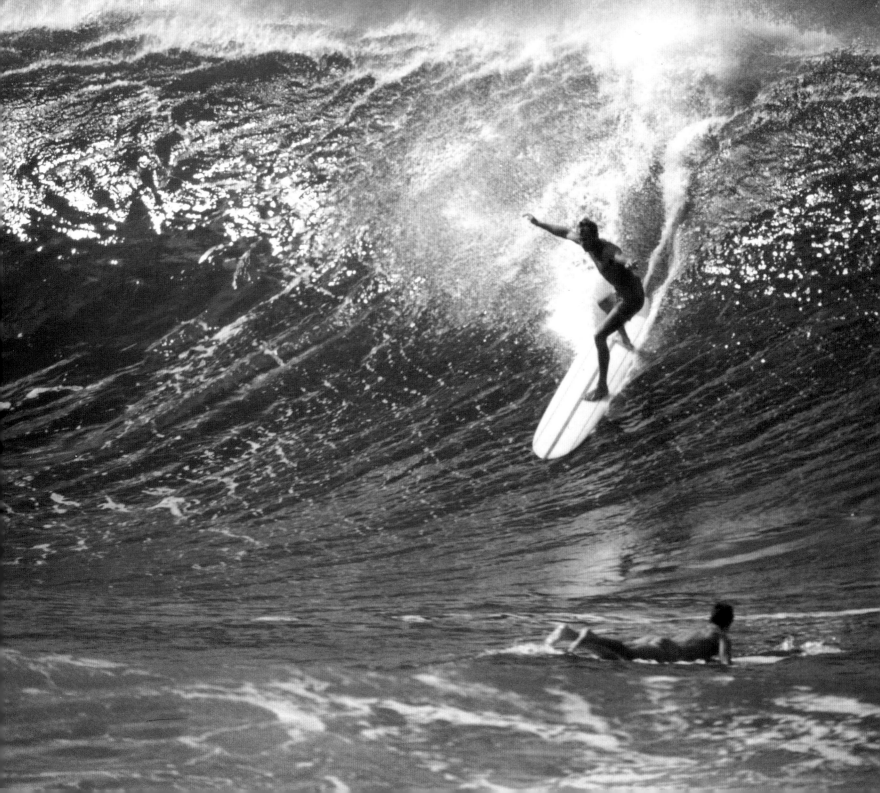

THERE IS THIS POUNDING, slamming sense of brief glory while sailing along in that white crash of water. The water is alive with sparkle, and the surfboard makes a hissing sound like a thousand yards of tearing silk. You are, for a moment, completely unplugged from life and complete unto yourself. —PHIL EDWARDS

"In surf up to six feet you are full of whip and snap. Life is easy riding and you are pumped. In surf up to twelve feet you're facing a bigger test. The rides suddenly become bumpy, tricky. At twelve to eighteen feet you are slightly cuckoo. But you are on the edge of the ultimate danger." So says Phil Edwards, Pipeline pioneer. The Banzai Pipeline is one of the most frightening waves on Oahu's North Shore. Between its heaving barrels and the sharp coral reef just a few feet beneath the surface, Pipeline is an accident waiting to happen. In the sixties it was no secret. Surfers had had their eyes on it for years. They'd sit on the beach and watch it pitch and peel and produce perfect barrels. But as perfect as they were, they were considered by all to be perfectly unrideable. All except Phil Edwards. On a day when Sunset was fifteen feet, he and filmmaker Bruce Brown ventured down to Pipe to sit on the beach and mind-surf the heaving "Holland Tunnels," as they called them. These wave images stuck with Edwards, and a few days later he decided to break the ice. "You could have driven a truck through it" was how he described his first wave at Pipeline in 1963. And from that point onward, Pipeline became one of the most famous surf spots in the world.

THERE IS NOTHING MYSTICAL about this. There is a need in all of us for controlled danger; that is, a need for an activity that puts us—however briefly—on the edge of life. Civilization is breeding it out of us, or breeding it down in us, this go-to-hell trait. Gradually, the day-to-day people, the hackers, are taking over. There are, as you read this, uncounted millions of people who now go through life without any sort of real, vibrant kick. The legions of the unjazzed. —PHIL EDWARDS

DA CAT

There's not a surfer in history whose name carries the kind of mystique and curiosity that Miki Dora's does. Dora was an iconoclast and a genius, a rebel and a prankster, an artist and an outlaw. Dora also rode Malibu with the smoothest, loosest, and springiest styles of the day, hence his nickname, *da Cat*. Throughout the latter half of the fifties and right through the sixties, Dora became famous for both his surfing prowess and his original mind. He despised commercialism and declared contests a hoax. During an event at Malibu, whilst trimming gracefully across a beautiful blue wall of water, Dora dropped his shorts and flashed a big bare ass at the judges. It was his final statement. And from that point onward, he sidestepped the media and shunned being a surf star.

THE ADVENT OF "professionalism" TO THE sport WILL BE THE FINAL BLOW. Professionalism WILL BE completely DESTRUCTIVE OF ANY CONTROL AN INDIVIDUAL HAS OVER THE sport AT present.

—MIKI DORA, 1969

THE SKATE CRASH

This idea that skating was dangerous and subversive became embedded in people's minds, and by early 1966 skateboarding took a big nosedive, in turn shutting down the sport's one and only magazine, *The Quarterly Skateboarder.* There was even a published report from a pediatric medical group blaming skateboarding for a rash of broken wrists. With mainstream scorn and no media to circulate news, skateboarders were reduced to only the hardest-of-core types, kids who really wanted to ride. And these kids were looked upon as second-class citizens, outcasts and misfits.

CONTEST CONTROVERSY

As the sixties wore on, attitudes became more and more of the flower-power sort and lifestyles became what the squares like to call "alternative," which conflicted with the idea of surf contests. How can you "judge" something as poetic as wave riding, thought the hippies. Regardless, contests continued to appear on the scene and the best riders couldn't help themselves. In the United States there was much debate over who was the nation's best: Phil Edwards or Miki Dora? In Australia it was much the same thing, with Midget Farrelly and Nat Young as the main contenders.

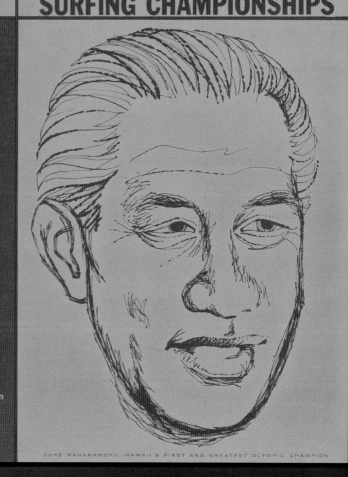

FIRST ANNUAL

INVITATIONAL
SURFING CHAMPIONSHIPS

December 13 to 17, 1965
Oahu, Hawaii

COMPETITORS

Robert August
Joey Cabell
Corky Carroll
Richard Chew
Bob Cloutier
Peter Cole
Mickey Dora
George Downing
Mike Doyle
Jackie Eberle
Skip Frye
Jeff Hackman
Fred Hemmings
Kimo Hollinger
Mike Hynson
Kealoha Kaio
Rusty Miller
Mickey Munoz
Greg Noll
John Peck
Felipe Pomar
Paul Strauch
Butch Van Artsdalen
Dewey Weber

50 CENTS

DUKE KAHANAMOKU, HAWAII'S FIRST AND GREATEST OLYMPIC CHAMPION

THE MAD SCIENTIST

George Greenough was an inventive Californian with a huge respect for wave-riding. He made bellyboards, kneeboards, boats, fins, water housings, Go-Karts, and, most importantly, the surfboards that inspired the shortboard revolution. His sparring-partner relationship with Australian board builder Bob McTavish led to the realization that boards didn't need to be plank-like.

They could be loose little zappy toys that rode tight to the pocket and up and down. But boards alone were not enough for the always-thinking Greenough, and in 1971, he made *The Innermost Limits of Pure Fun,* a surf film that showed, for the first time ever, surfing as experienced by the surfer—specifically, from the inside of the tube looking out.

Birth of Shortboards

The year was 1966. The place: San Diego. Red-hot Californian David Nuuhiwa had been favored to win the World Surfing Championships. He'd mastered nose-riding like no one before him, and he knew the waves around La Jolla like he knew the board under his feet. But that board was soon to change. Australian Nat Young showed up in California with a surfboard called "Sam." It was two feet smaller than what everyone else was riding, and narrower and gunnier. Nat surfed "Sam" off his back foot. He didn't bother to pose hood ornament–like; he turned the board up and down, off the bottom/off the top. And the judges loved him. Eighteen-year-old Nat Young won the 1966 World Championships and in the process gave birth to a new style of surfing. Throughout the rest of the decade, surfers shaved inches, even feet, off their boards in the quest to make them smaller, lighter, and more maneuverable.

MUSIC WAS GOING from straight-ahead rock to psychedelic, hair was going from straight to long, the highs were going from alcohol to drugs. . . . There was this giant swirl of change that coincided with what was to become known as the shortboard revolution, surfing's great period of change. And had it happened five years earlier or later, it wouldn't have been nearly as colorful.

—Matt Warshaw, *The Encyclopedia of Surfing*

Nat Young, '66 Worlds, San Diego

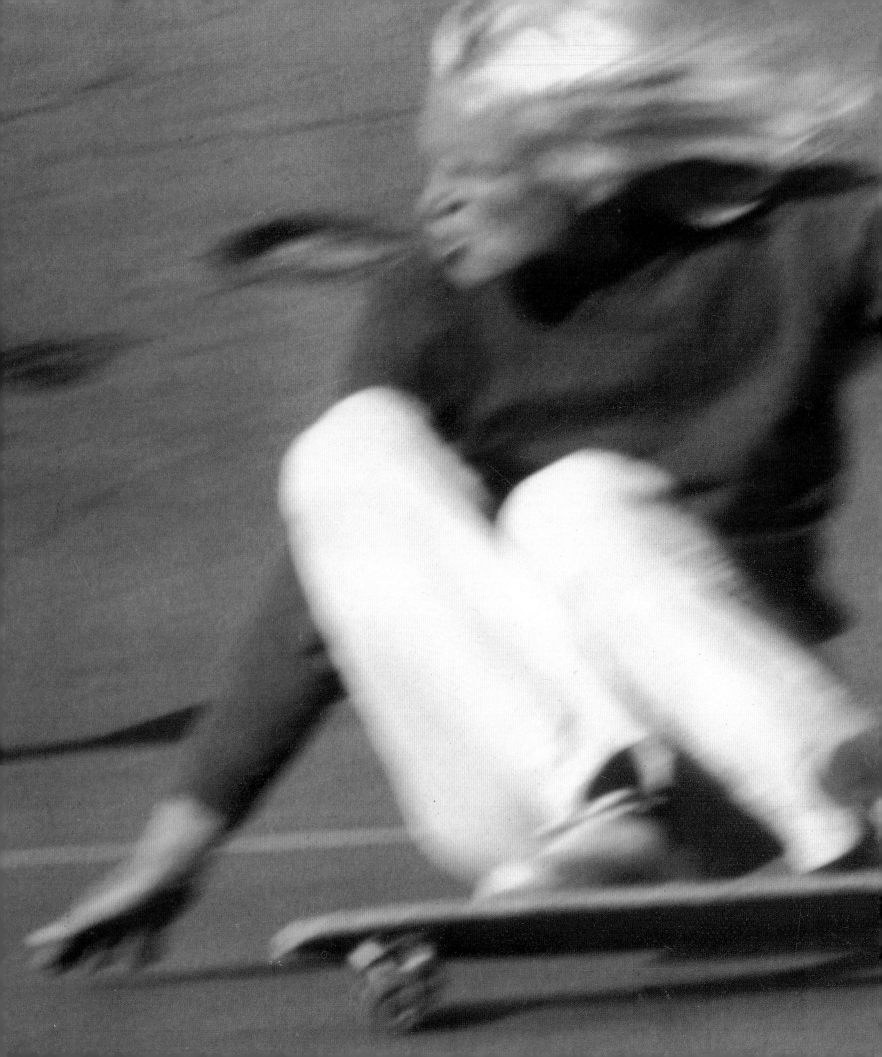

1970s

SKATE INTO THE SEVENTIES

Pick a tune, any tune, from early-seventies Led Zeppelin or Jimi Hendrix, run it through your head for half an hour, then skateboard down the sidewalk barefoot on a board with clay wheels, and you might get a hint of what skateboarding was like for the early part of the decade. Maneuvers consisted of flat land–oriented tricks (headstands, handstands, 360s, walking the dog, nose wheelies, double-boarded tail wheelies, high jumps, barrel jumps, and "gorilla gripping"), surf-inspired flow (tight-arced kick-turns, power slides, slalom, walkovers), and downhill speed rush (bombing hills). Boards were made of wood, plastic, aluminum, or thin, flexible fiberglass. Skatewear consisted of surfer attire—Levi's, raggedy T-shirts, and Van's deck shoes (if any).

SKATEBOARDING IN THE EARLY DAYS

DIDN'T EXIST AS ITS OWN ENTITY. IF YOU WERE SKATEBOARDING, YOU WERE SKATEBOARDING TO SURF ON THE PAVEMENT. YOU WERE SKATEBOARDING TO COMPLEMENT YOUR SURFING. AND YOU WERE SKATEBOARDING TO BECOME A BETTER SURFER, AND IF YOU WERE SKATEBOARDING YOU WERE SKATEBOARDING BECAUSE YOU COULDN'T SURF AT THAT TIME BECAUSE THE WIND HAD BLOWN OUT THE WAVES OR THE TIDES WERE WRONG.

—STACY PERALTA

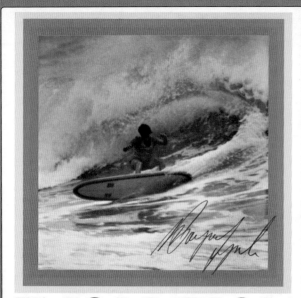

EVOLUTION

EVOLUTION IS A NATURAL CHANGE, AN UNFOLDING.

WAYNE LYNCH, NAT YOUNG, TED SPENCER AND MANY OTHER GREAT SURFERS ARE PART OF THIS EVOLUTION.

JOIN THE EVOLUTION AS IT TRAVELS AROUND THE WORLD EXPLORING SURFING'S UNKNOWN TERRITORY.

PAUL WITZIG FILMS, Box 64 AVALON, N.S.W. AUSTRALIA.

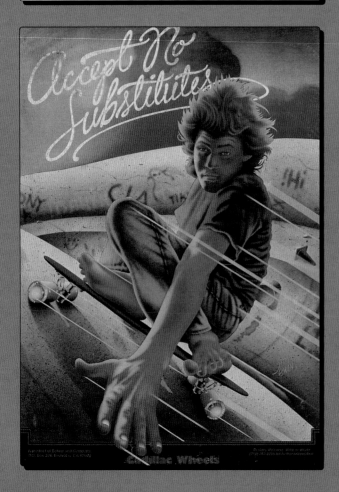

HOT-DOGGING REACHES NEW HEIGHTS

With the shortboard revolution kicked into high gear, surfers of the early seventies began going up and down on waves, careening their boards above and below the trim line and changing direction more abruptly and with tighter arcs than ever before. The thinner, narrower, pin-shaped single fins fit with the wave better, in essence liberating surfing from the straight-line track it had been confined to for so many years. What the board was doing became infinitely more important than what the feet were doing, and a lot of the cross-step/hang-ten/ballet-like stuff that was happening throughout the sixties gave way to full-rail carving, where the surfer leans into his turns rather than riding upright.

THE ESTABLISHED INDUSTRY was kind of on the ropes; too many years of the same thing had weakened their mobility to change. While their contributions to basic surfboard construction, polyurethane foam, and polyester resin were our foundation, we didn't have much use for their design theories. The shortboard was here to stay. —Gerry Lopez

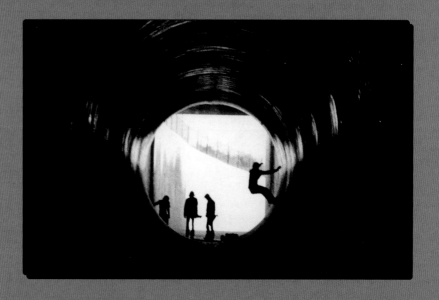

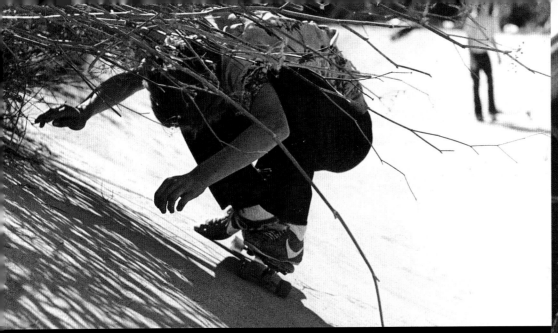

REINVENTING THE SKATEBOARD WHEEL

In 1970 an East Coast surfer by the name of Frank Nasworthy entered into a plastics factory in Virginia and discovered something that would eventually come to revolutionize skateboarding. The factory was making urethane wheels for roller-skates, and Frank, a resourceful sort, realized then and there they'd be perfect for skateboards. Frank bought a few sets and found the ride to be 30,000 times smoother than the metal and clay wheels they were using at the time. He turned a few friends on—they loved 'em as well. A year later Frank moved to California and launched his new business, Cadillac Wheels—the name inspired by the smooth ride of Cadillac cars. Cadillac Wheels took a while to catch on (they came with a hefty price tag), but after a while skaters got hip to them and by 1973 they were selling like hot cakes. Urethane wheels allowed skaters to ride rougher pavement, effectively opening up all kinds of new terrain. Soon after Cadillac came Road Rider, with their all-new NHS encased bearings, which effectively ended the Cadillac craze. Precision bearings soon became the norm, and to this day skateboards use a standard size 608 bearing, originally developed for vacuum cleaners.

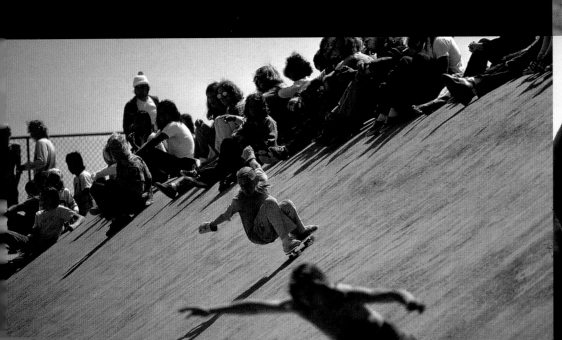

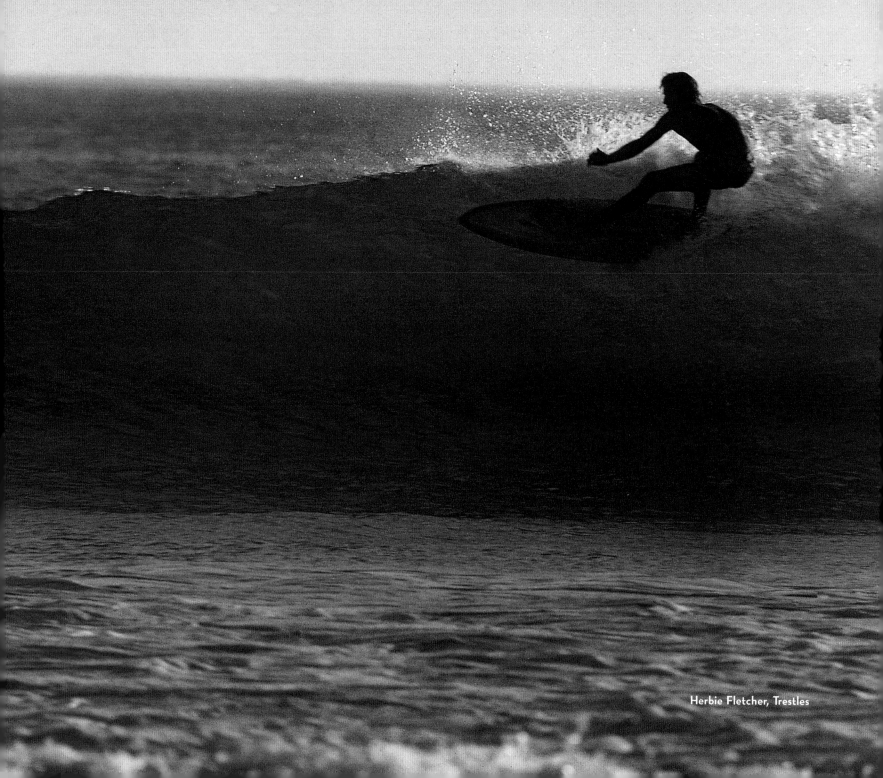

SURFING IS LIKE A MIRROR. *You can see yourself in the act of riding a wave. And your personality or style shows in the way you ride it, whether you're a defensive person, or offensive, or awkward, or graceful.* —Steve Pezman

Herbie Fletcher, Trestles

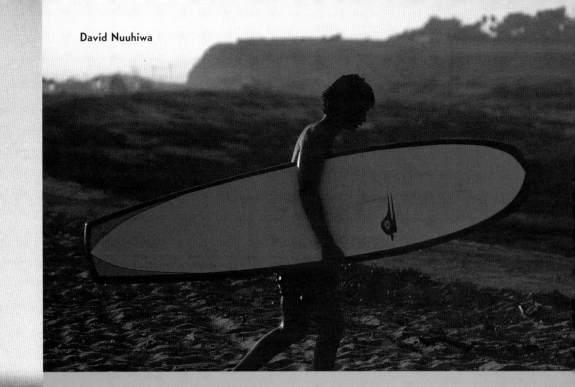

David Nuuhiwa

SOUL PRESERVATION

Unlike skate contests where the terrain remains the same, surf contests rely heavily on Mother Nature to deliver rideable or at least "contestable" waves. This was a problem that plagued the 1970 World Titles in Australia. Bells Beach was all set up to see history in the making. They had the TV cameras, sponsors' banners, spectators, bleachers, judges, judges' tower, and surfers, but unfortunately, no surf. It was looking very much like the 1970 World Titles would not live to see its champion. But in a last-ditch effort to salvage the event, organizers decided to relocate to Johanna, a rural, slow-paced farm town a few hours south, notorious for picking up even the slightest hint of swell. In Johanna they had waves, but no presence. What was to be a major international event resembled more a small-town club competition. Californian Rolf Aurness took the gold and literally ran with it. After being announced the winner in a makeshift parking lot ceremony, Aurness grabbed his trophy, smiled at his fellow competitors, then faded off into obscurity, never to compete again. Same goes with a bunch of others. Seeing no merit in the concept of contests, Aussies like Nat Young and Wayne Lynch and Ted Spencer moved to the country, lived off the land, and surfed solely for themselves. Back in the mainland United States and Hawaii, surfing was on a similar trip, shunning the ego-based idea that there should be "winners" out in the surf.

KOOK CORDS

In 1971, the first leashes arrived on the scene, dividing the surf population into those who partook and those who didn't. Leash users were more new school, more into catching a lot of waves, and less into swimming for lost boards. Leash despisers believed that surfing came from the all-encompassing waterman heritage, that long swims were part of that process and served as a natural crowd controller. The emergence of the leash meant that any clown could paddle out, flounder repeatedly, yet never lose his place in the lineup. A few years later the Morey Doyle came into being, a soft, squishy, user-friendly beginner board invented by world champion Mike Doyle. The combination of the leash and the Doyle made surfing a lot easier to learn, converting thousands and cluttering lineups. Die-hard surfers reacted appropriately enough—they set off for foreign shores in search of new spots with no one out.

THE PERFECT WAVE

Since day one, surfers have always been a nomadic tribe, and no time more so than the seventies has the wanderlust been stronger. Inspired by the mythology presented in *The Endless Summer* and increased crowding, surfers voyaged to places like Central America, West Africa, Morocco, France, Spain, Ireland, and Indonesia in search of the perfect, empty wave. What did they find? Point breaks, reef breaks, and beach breaks in a variety of shapes and sizes. Waves work like this: As a swell travels across the sea, it moves uninhibited until it runs into something shallow enough to cause it to break. If the bottom's made of sand we call this a "beach break." If the thing that causes the wave to break is an outcropping of land, we call it a "point break." If the bottom consists of rock or coral, we call it a "reef break." Each and every wave has its own personality and no two are exactly alike, but particular surf spots have their own particular brand of wave. For example, in the case of Kirra on the Gold Coast of Australia, waves break from the left to the right (in surf terminology, a "right-hander"). They wrap down the point, conforming to the curve of the land, giving the rider a long, fast tube that's considered world-class.

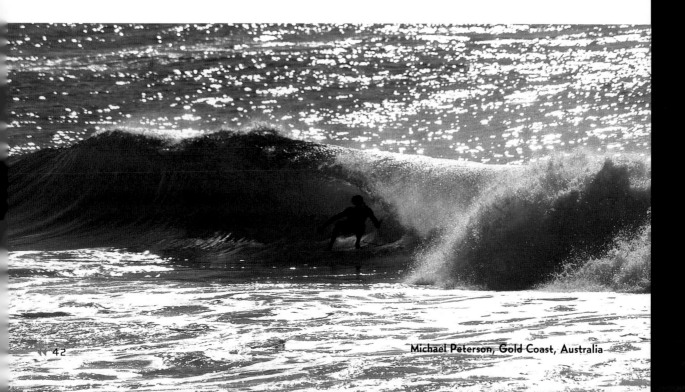

Michael Peterson, Gold Coast, Australia

Skate: Better, Faster, More

In the same way leashes helped to democratize surfing, urethane wheels did the same with skateboarding, making it more user friendly and converting a new batch of riders in the process. The industry expanded. Cadillac joined forces with a surf company called Bahne, who made thin, flexible decks out of fiberglass. Tracker released the beefy, four-inch-wide Fultrack in 1975, setting forth the modern truck as we know it today. Riser pads and grip tape soon entered the picture. And in direct relation to equipment evolution was terrain. Skaters started riding banks, spillways, drainage ditches, concrete pipes, and empty swimming pools with names like the Vermont Drop, Stoker Hill, Wallos, Toilet Bowl, Tea Bowl, Baldy Pipeline, Keyhole, and Box Pool. Angled concrete was the name of the game and flat-ground riding became a thing of the past.

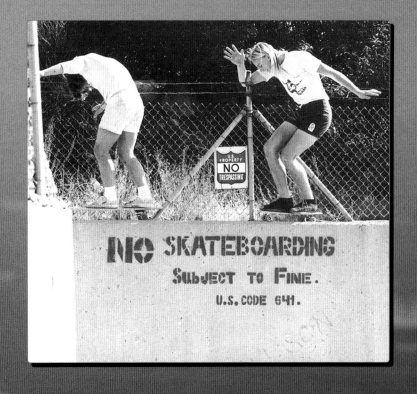

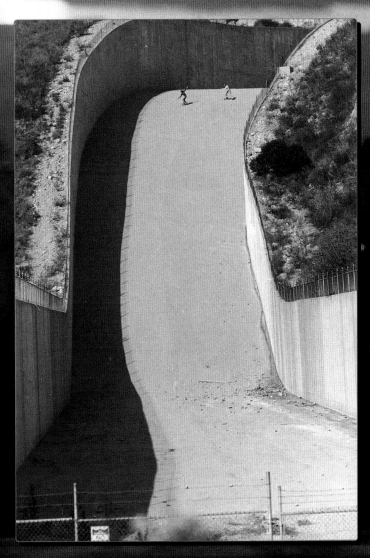

TWO HUNDRED YEARS of american technology has unwittingly created a massive cement playground of unlimited potential. But it was the minds of eleven-year-olds that could see the potential.

—Craig Stecyk, 1975

Bob Moore

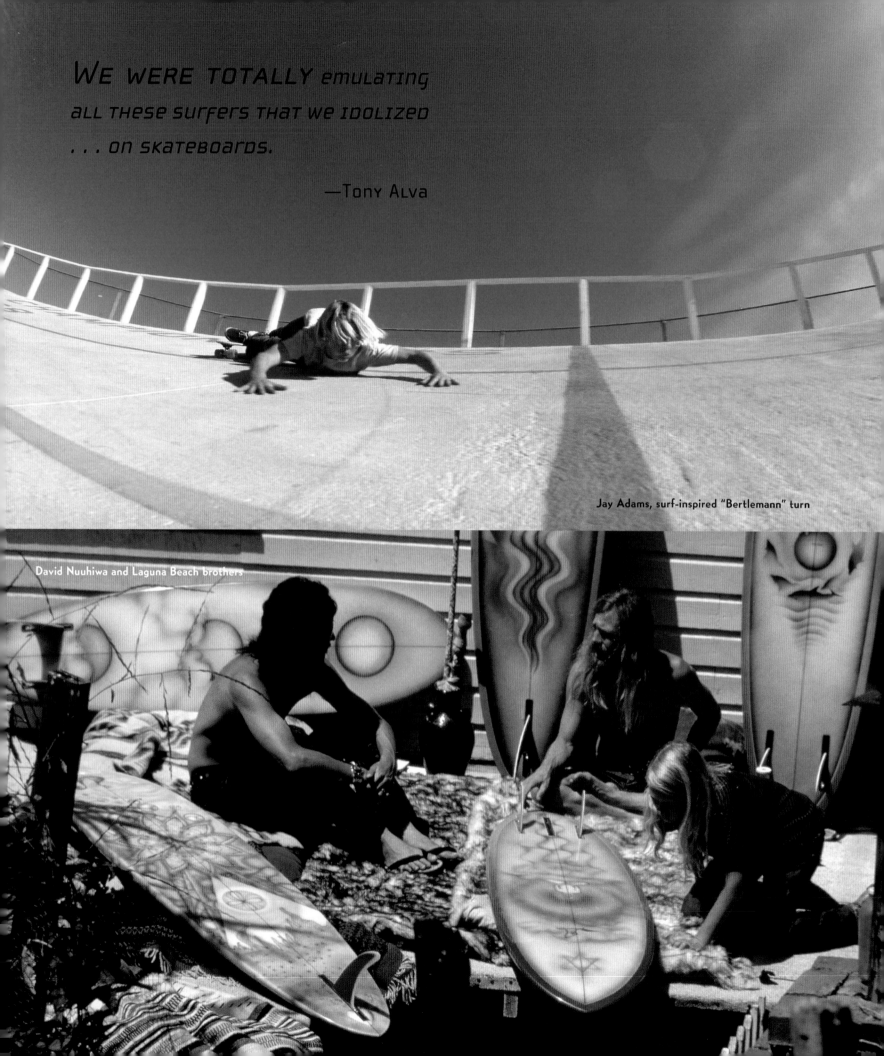

WE WERE TOTALLY emulating all these surfers that we idolized . . . on skateboards.

—TONY ALVA

Jay Adams, surf-inspired "Bertlemann" turn

David Nuuhiwa and Laguna Beach brothers

DOGTOWN

In 1975, a twenty-six-year-old hypercreative guy named Craig Stecyk wrote a story for *Skateboarder* magazine about a place called Dogtown, which existed on the border between Santa Monica and Venice; its epicenter being POP, an abandoned, carcass of a carnival pier that crumbled in the mid-sixties and remained in a state of disrepair. POP was a haven for all manner of outcast, as well as the local Zephyr team, a wayward clan of radical surf/skaters. The Z-Boys skated with a more surf-inspired, lower center of gravity approach than what was happening at the time. They rode banks and drainage ditches and considered style to be the most sacred quality a rider can possess. Because they hailed from Dogtown, Z-Boys were also known as "Dogtowners."

THE DEL MAR CONTEST

In 1975, the first major skateboarding event since the mid-sixties was held in Del Mar, California, not far from the place where Nat Young and his board "Sam" changed the face of surfing back in 1966 (see page 34). The terrain was set up the way they had done it in the sixties—a long plywood ramp with cones for slalom races, a patio-sized plywood platform for freestyle, and haystacks all around to catch flying boards. At the time, typical skate styles were still upright and technical, with tricks like 360s, nose- and tail-wheelies, and headstands and handstands being the stuff that scored big points. Leaders of the day were guys like Bruce Logan, Ty Page, Henry Hester, and the gymnast-like Russ Howell, whose routine was as fine-tuned as any Olympic athlete's. So the contest was running along smooth when all of a sudden a stringy, blond-haired kid with a chain wallet let loose with an approach like no one had ever seen before. He improvised his way about the wooden platform, hopping and sliding and changing the face of skateboarding as he went. Jay Adams was the first Z-Boy to ride that day, and after he and his teammates brought what they'd been doing in Dogtown to Del Mar, and to the judges, and to their fellow skaters, and to *Skateboarder* magazine, who'd recently appeared back on the scene, skateboarding was never the same again.

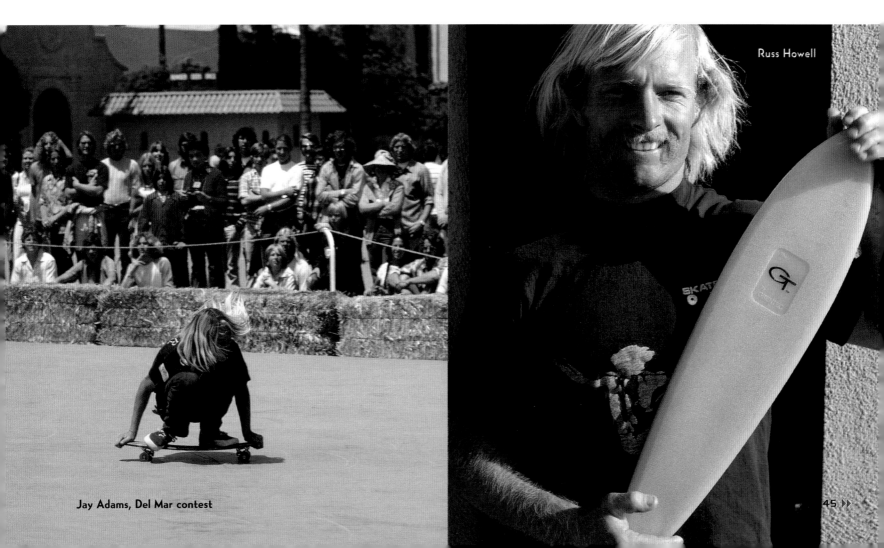

Jay Adams, Del Mar contest

Russ Howell

VERTICAL
ENTERS
THE PICTURE

In the seventies, Southern California was hit with a severe draught that caused a mass of homeowners to drain their pools in order to conserve water, which, in turn, created a Disneyland of tile and coping for skateboarders. From higher perches the Dogtown boys would scan the Los Angeles landscape, find the backyard pools, hop the fences, and skate with gusto until they were kicked out or arrested. Skating had been about banked surfaces. Now it was all about vertical. In the beginning they'd only go halfway up the wall and kick-turn back down, but in a short while they were getting two wheels out, then three, then three and a half, and then . . .

ALVA'S AIR

In the fall of 1977, Tony Alva did the first official air at the Dog Bowl, a kidney shaped pool in a ritzy part of Santa Monica. It was a big moment, a breakthrough move that ultimately set skateboarding off on it's own tangent, and from that point onward, skateboarders no longer looked to surfing for inspiration.

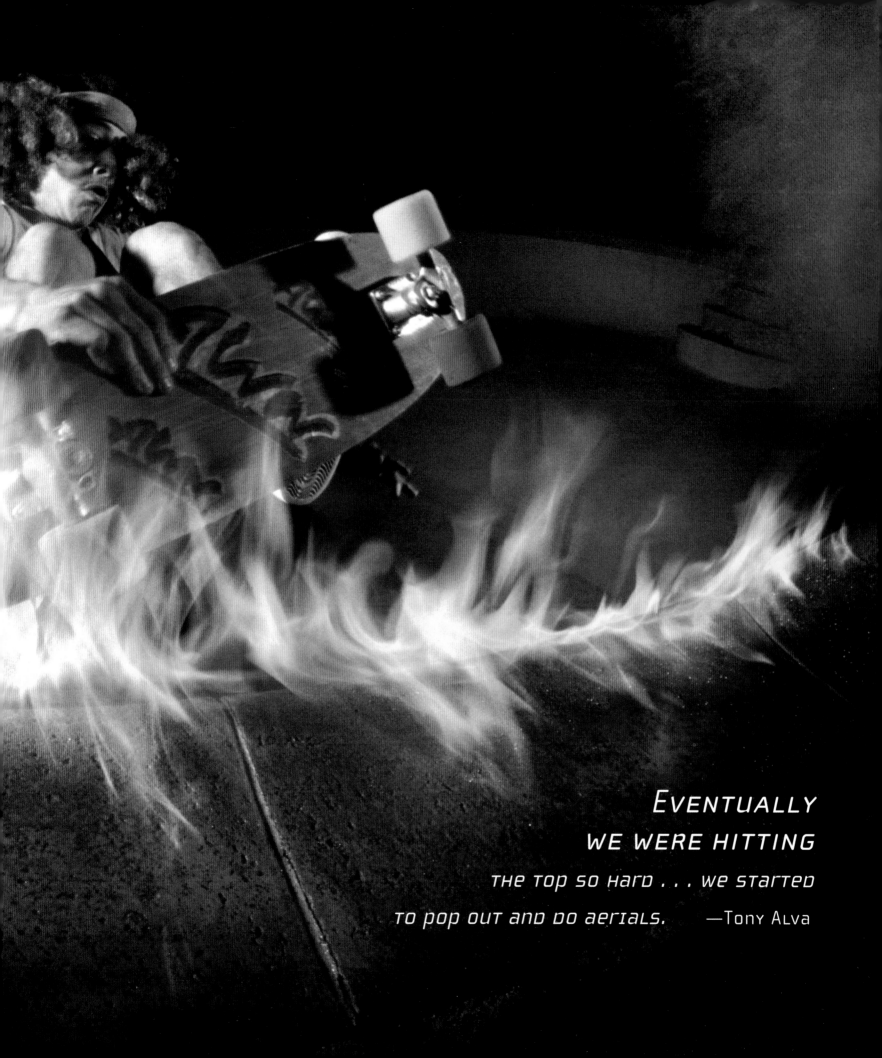

EVENTUALLY
WE WERE HITTING
THE TOP SO HARD . . . WE STARTED
TO POP OUT AND DO AERIALS.　—TONY ALVA

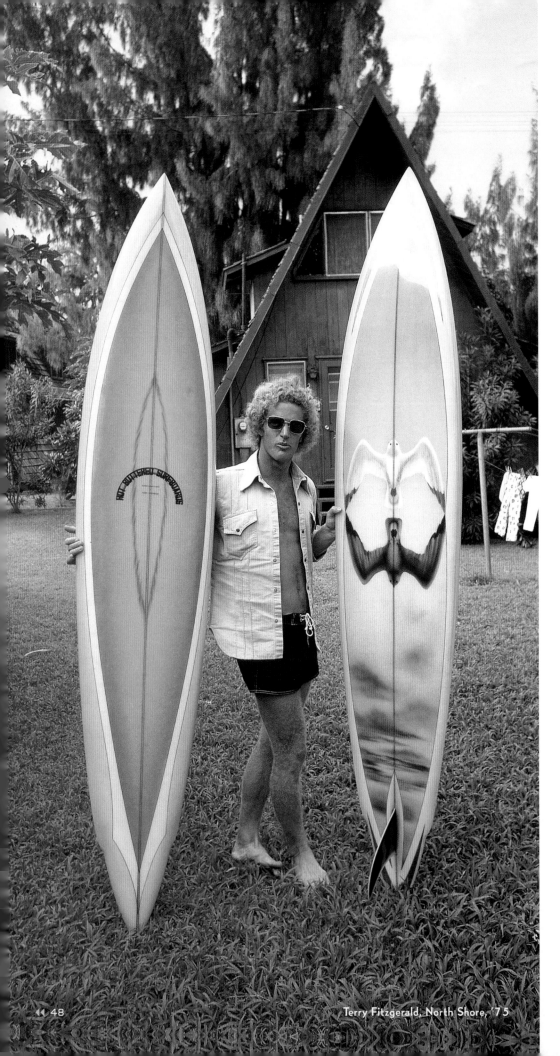

Terry Fitzgerald, North Shore, '75

NORTH SHORE AS HOLY GRAIL

The North Shore of Oahu became surfing's primary focus with Sunset and Pipeline as the spots that mattered most. It didn't matter how good you were; if you couldn't cut it in Hawaii then you simply couldn't cut it. "We wanted to surf Pipe and Sunset the way we surfed small waves," remembers 1978 world champion Shaun Tomson. The North Shore became a kind of aquatic laboratory for both surfers and shapers. Barry Kanaiapuni's legendary Sunset bottom turn was so hard it demanded that board design evolve. And Jeff Hakman, Jock Sutherland, Eddie Aikau, Owl Chapman, Reno Abellira, Terry Fitzgerald, Jimmy Blears, and Sam Hawk all test-piloted a rainbow of slick new shapes, with Dick Brewer and Tom Parrish creating the boards that took things to the next level.

PIPELINE IS THE PLACE

With the help of the more blade-like board shapes that became standard issue by 1975, waves that had once been deemed unrideable were now fair game. The Banzai Pipeline on the North Shore breaks over a shallow reef with a tremendous amount of force. It doesn't roll, it heaves—offering up a bubble of space between the wall of the wave and the lip. Pipe is as stripped down and simplified as it gets. You either make it down the steep wave face or you don't, and if you do, you pull into the tube and either come out or don't. To make matters even better, the waves break close to shore, turning it into a coliseumlike atmosphere that's perfect for spectators. Pipeline could rip you in half or it could turn you into a superstar. And it did the latter in the case of one Mr. Gerry Lopez.

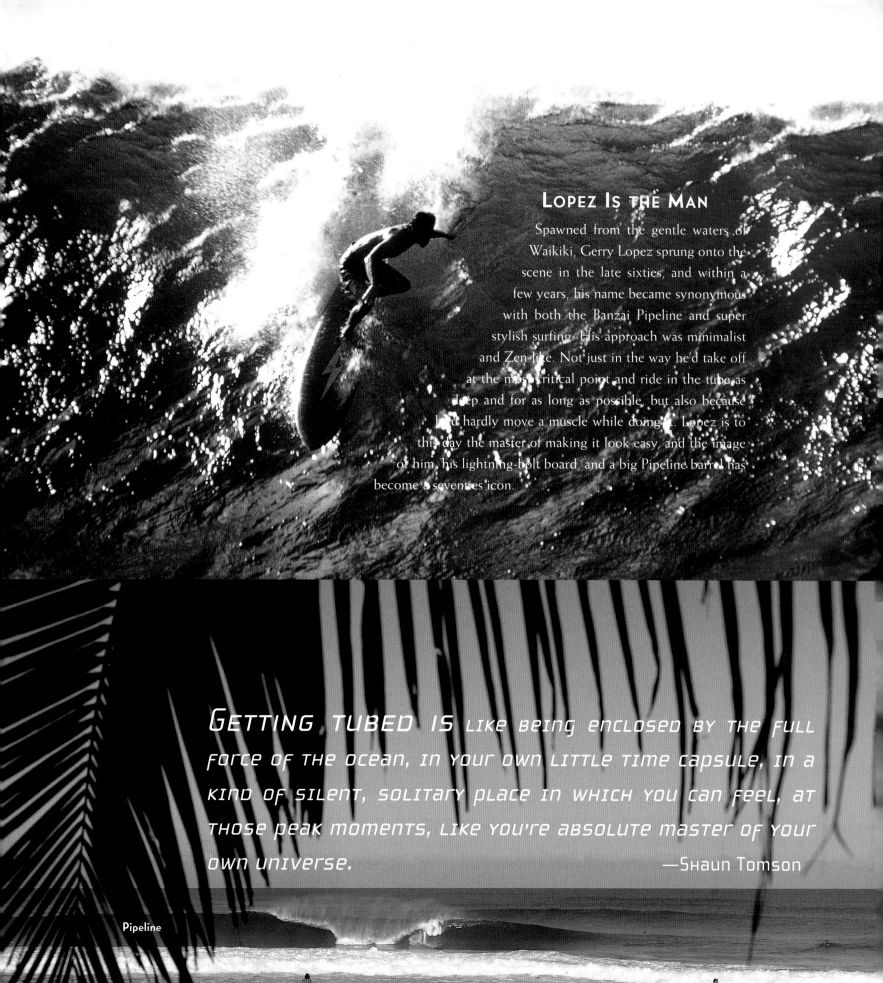

LOPEZ IS THE MAN

Spawned from the gentle waters of Waikiki, Gerry Lopez sprung onto the scene in the late sixties, and within a few years, his name became synonymous with both the Banzai Pipeline and super stylish surfing. His approach was minimalist and Zen-like. Not just in the way he'd take off at the most critical point and ride in the tube as deep and for as long as possible, but also because he'd hardly move a muscle while doing it. Lopez is to this day the master of making it look easy, and the image of him, his lightning-bolt board, and a big Pipeline barrel has become a seventies icon.

GETTING TUBED IS like being enclosed by the full force of the ocean, in your own little time capsule, in a kind of silent, solitary place in which you can feel, at those peak moments, like you're absolute master of your own universe.
—Shaun Tomson

Pipeline

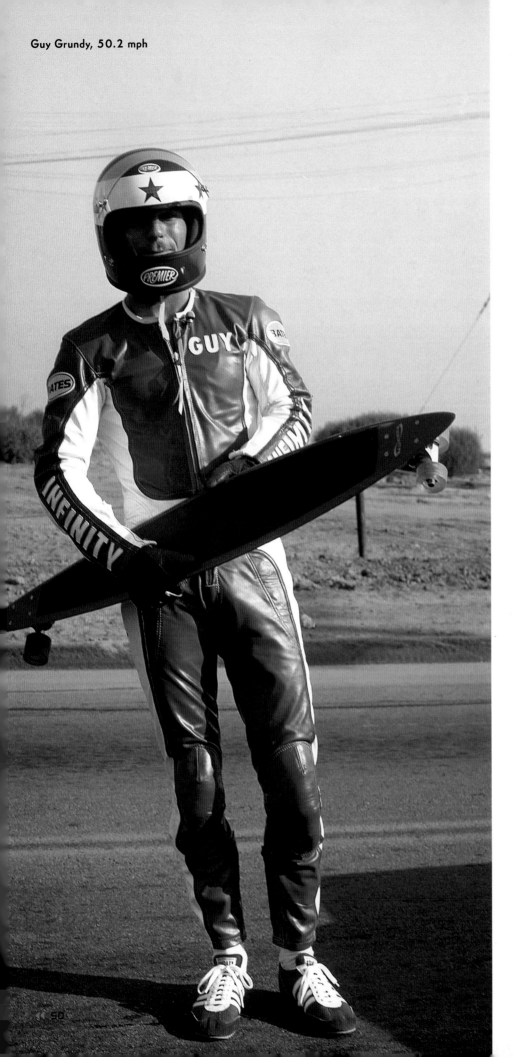

Guy Grundy, 50.2 mph

SERIOUS DOWNHILL

Signal Hill was all about downhill. It was a smooth, straight street down a hill in Long Beach, California, that attracted speed-hungry skaters in droves. The United States Skateboard Association's annual events there were legendary. They brought out the latest, weirdest, high-speed/luge-style getups of the day as well as the strangest riders. One of the all-time Signal Hill heroes was Guy Grundy, who wore Evil Knievel–like leathers and rode in a bullet-like Quasimodo tuck. Another was some guy nobody knew. The story goes like this: Skaters were bombing the hill to the cheers of spectators lining the street. The sun was out and the contest was doing what all contests should—upping the ante. All of a sudden, from out of the crowd jumps this drunk guy. He's wearing nothing but a pair of shorts, his face and back are sunburned red, and in one hand he's holding a can of beer, in the other a kid's Big Wheel. He walks up to the starting gate and then proceeds to charge straight down Signal Hill. The crowd goes nuts as he nearly eats the pavement but somehow pulls it, stealing the thunder from every leather-clad, serious skateboarder in the contest. The moment spoke volumes about the way skaters think—originality is the key, and to do it right is to do it your own way.

BREAKING RECORDS

In a small park overlooking San Pedro, California, the Guinness folks documented history. In a contest all about speed, height, and distance, Guy Grundy went 50.2 miles per hour, Tom Sims and Brian Beardsly both jumped a bar set four feet two inches off the ground, and Steve Brown leaped sixteen barrels, each etching their name into the illustrious *Guinness Book of World Records*. Other undocumented tricks include jump-roping on a skateboard and launching a hang glider via skateboard.

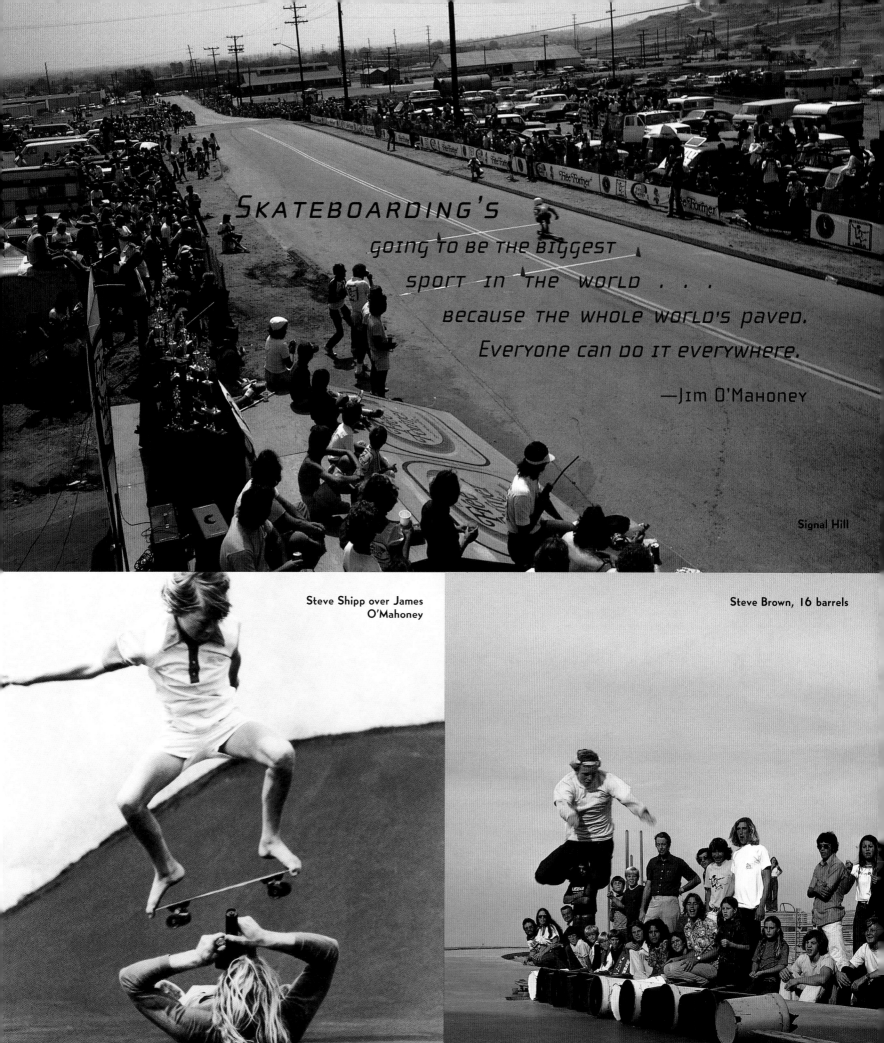

SKATEBOARDING'S
going to be the biggest
sport in the world . . .
because the whole world's paved.
Everyone can do it everywhere.

—Jim O'Mahoney

Signal Hill

Steve Shipp over James
O'Mahoney

Steve Brown, 16 barrels

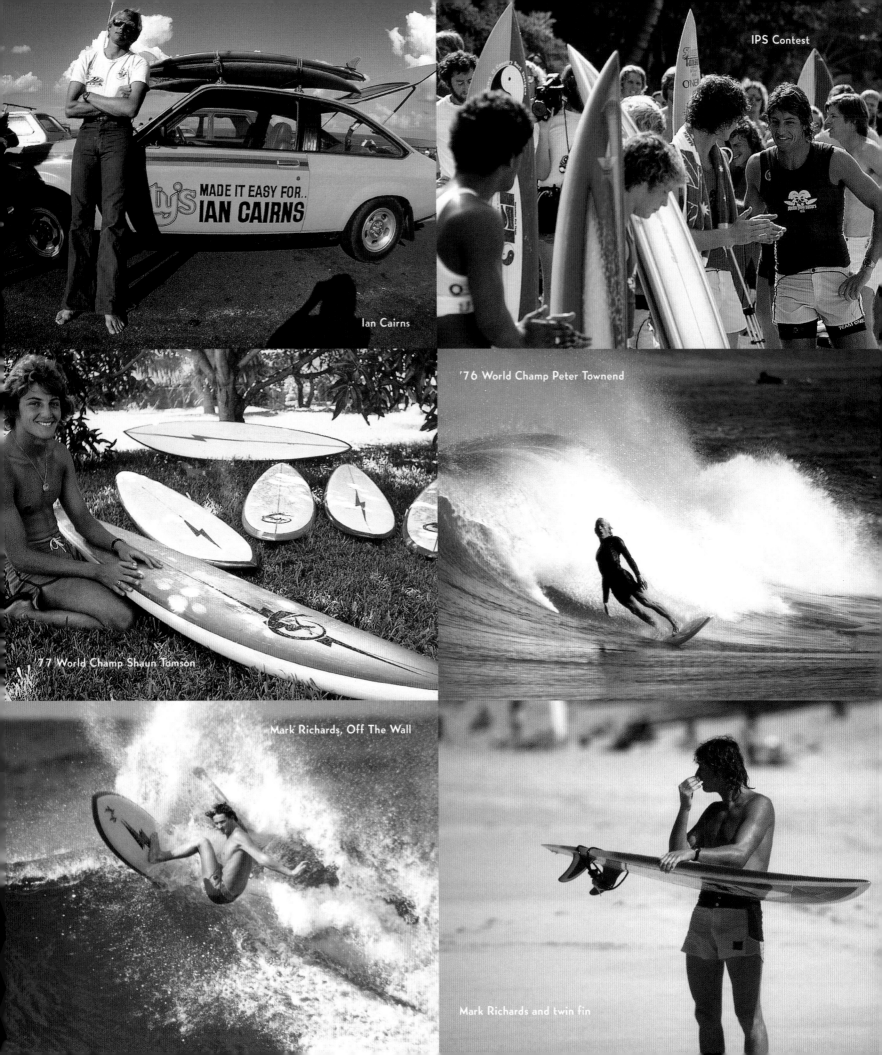

MADE IT EASY FOR.. IAN CAIRNS

Ian Cairns

IPS Contest

'76 World Champ Peter Townend

'77 World Champ Shaun Tomson

Mark Richards, Off The Wall

Mark Richards and twin fin

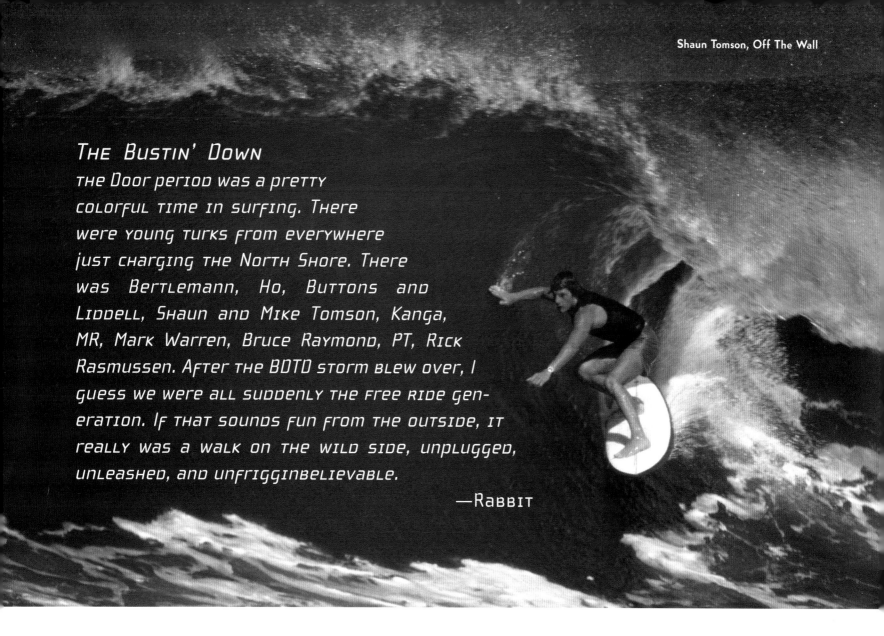

THE BUSTIN' DOWN

THE DOOR period was a pretty colorful time in surfing. There were young turks from everywhere just charging the North Shore. There was Bertlemann, Ho, Buttons and Liddell, Shaun and Mike Tomson, Kanga, MR, Mark Warren, Bruce Raymond, PT, Rick Rasmussen. After the BDTD storm blew over, I guess we were all suddenly the free ride generation. If that sounds fun from the outside, it really was a walk on the wild side, unplugged, unleashed, and unfrigginbelievable.

—RABBIT

BIRTH OF A WORLD TOUR

In the fall of 1976, at a time when top surfers had become increasingly aware of their sport's commercial potential, the International Professional Surfers (IPS) was formed. Founded by a competitive surfer from Hawaii named Fred Hemmings, the IPS was all about presenting surfing to the masses as a healthy, exciting, and legitimate sport. The format was based on the pro golf tour paradigm—there'd be a series of events around the globe, surfers would earn accumulated points along the way, and the one with the most points at the end of the season would be the crowned world champ. It all made perfect sense, and surfers did the best they could to carry themselves like professionals. But it didn't come easy, as 1977 world champ Shaun Tomson remembers. "All of us had this dream that we could make a living being surfers. But they call that time the 'Bustin' Down the Door/Free Ride period'. . . . Man, the ride wasn't free. We had to pay for it—and pay for it with blood!"

BUSTIN' DOWN THE DOOR

The first events of the IPS world tour were held on the North Shore in the winter of 1976, causing the place to illuminate like some kind of water-powered Las Vegas. There were suddenly dollars at stake, and surfers the world over made the pilgrimage, with dreams of cracking the big time. The Aussies led the charge, with the mainland Americans, South Africans, and Brazilians all making their presence felt. The Hawaiians both hated and loved seeing all the new faces in the lineup; they hated it 'cause it meant more crowds but they loved it 'cause it meant the performance bar was lifting by the millisecond.

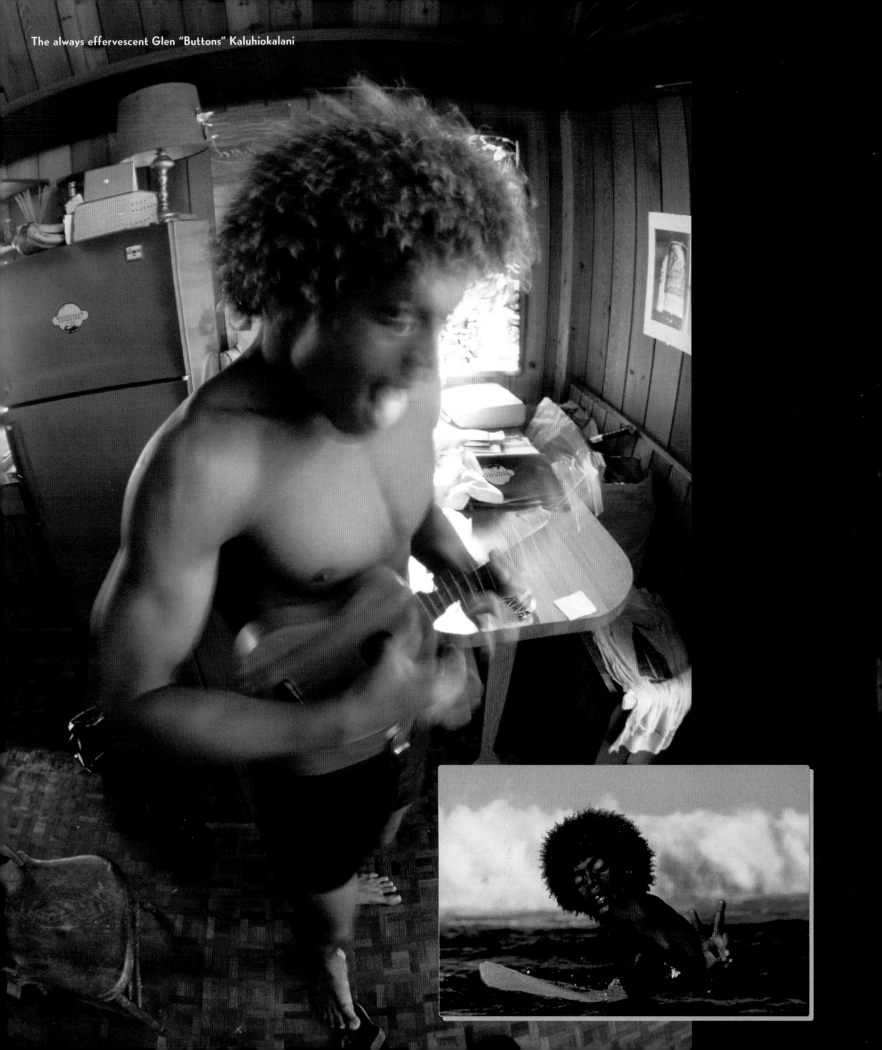

The always effervescent Glen "Buttons" Kaluhiokalani

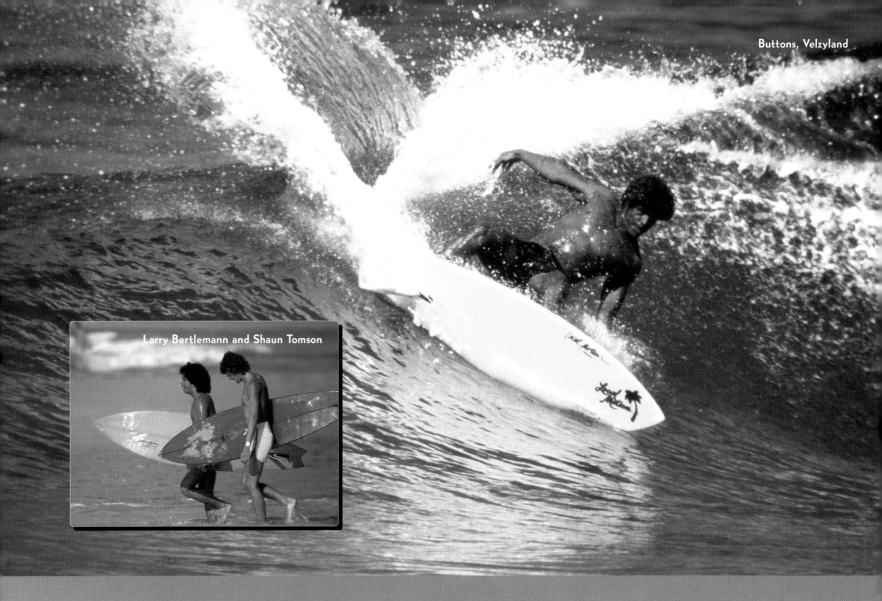

Larry Bertlemann and Shaun Tomson

SKATE GRAPHICS

Deep in the heart of Dogtown, in a single-car garage set a few blocks back from the beach, a young skater/artist named Wes Humpston made wooden decks for his friends and drew graffiti-like crosses and rat bones on the bottoms of them. Humpston's designs marked the beginning of board graphics, and to this day skateboards are as much specimens of fine art as they are functional.

BUTTONS, BERTLEMANN & CO.

A band of Hawaiian rascals emerged in the mid-seventies with a new and super-radical style. Glen "Buttons" Kaluhiokalani, Mark Liddell, and Larry Bertlemann surfed like human Slinkies. They rode smaller boards and dominated them as though they were merely extensions of their feet. Bertlemann became famous for his sharp 180 turns, known as cutbacks. He'd pivot off his front hand while arcing his board around with his feet, making it much like a skateboard move. In turn, skaters adapted this one straight to the pavement.

THE BIG BOOM

By mid-decade *Skateboarder* magazine was back in full force thanks to a huge boom in the marketplace. At around the same time, slalom maestro Jim O'Mahoney submitted the word *skateboard* to *Webster's* dictionary, making official the four-wheeled wonder's existence in the world. Sponsors began throwing money at top skaters to endorse their products. The first hints of the rock-star lifestyle entered the sport, with "Skateboarder of the Year" Tony Alva leading the pack. Performance aspects progressed at hyperspeed, with vertical at the forefront and downhill, slalom, and freestyle in its wake. By 1977 there was a reported twenty million skateboards rolling around in the world, and skaters were going beyond vertical in full pipes.

A WAVE OF CHANGE

The waves were six to eight feet, the skies sunny, and the cameras out in full force the day Mark Richards and Shaun Tomson rode a historical wave together at Off The Wall, a heavily photographed spot just a short paddle down from Pipeline. Story has it, MR was paying Shaun back for a previous drop in, but whatever the case, MR took off in front and Shaun in back, and as MR swept a delayed bottom turn, so did Shaun, pulling up right behind MR in the tube. The shutters clicked and cameras rolled as a couple of the best surfers in the world shared an absolutely sublime blue barrel, their styles different, their eyes fixed upon the same place. And when the two riders exited cleanly, the entire beach erupted, knowing full well that they had just witnessed history in the making. What made the wave even more historical was the fact that Shaun was riding a single fin (standard issue up to that point) and MR was riding a twin (the design about to become the choice of most top pros). Shaun remembers: "To me, that was the high point of the single, but at the same time, the emergence of the twin. After '77, we all began hopping on twins."

Tapping the Mainstream

In the mid-seventies, skateboarding was popping up all over the place. On the big screen, Tony Alva could be seen playing alongside teen idol Leif Garrett in the movie *Skateboard*. At Cal Jam II, a Plexiglas half pipe was set up not far from the stage while a crowd of thousands gathered in the sunshine, torn between watching Ted Nugent or Ty Page. Alongside a Rolling Stones concert, they demo'd skateboarding. In tandem with an Olympic track athlete event, they showcased skateboarding. Between races at the Long Beach Grand Prix, there was skateboarding. It reached a zenith with Skateboard Mania, an Ice Follies–like skate demo that traveled the country, spreading the pollen and sharing the message in a fun-for-the-whole-family style.

McDonald's Takes a Bite

The city is L.A. The school: Bellagio. The fifteen-foot blacktop banks are littered with what appears to be a major Hollywood production. There's gaffers, boomers, PAs, ADs, DPs, a director and a producer, all focused on something stage left. And then someone yells "Action!" A skateboarding Ronald McDonald rolls through the scene, jumps a fence, lands on another board, and skates off with a couple of kids. Yep. You guessed it. The biggest fast-food chain in America had jumped on the bandwagon with a sidewalk surfing R.M. to keep the kids in hamburgers. And after one and only one perfect take, the wig, makeup, clown suit, and clown shoes came off to reveal slalom champion James O'Mahoney, who can only laugh at it all.

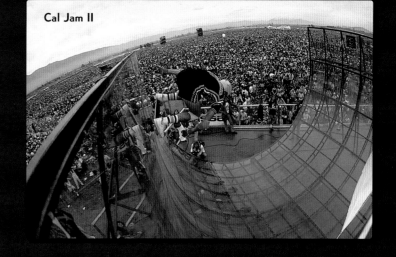

Cal Jam II

> *WE WENT FROM BEING these rats on the street, and the next thing you know we're making more money than our parents.* —Stacy Peralta

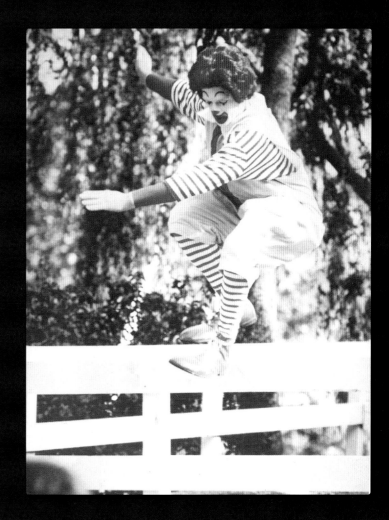

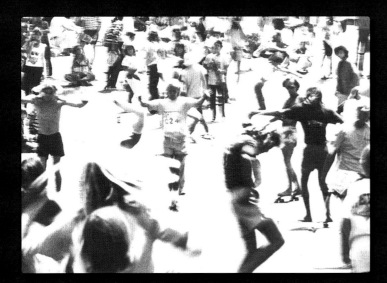

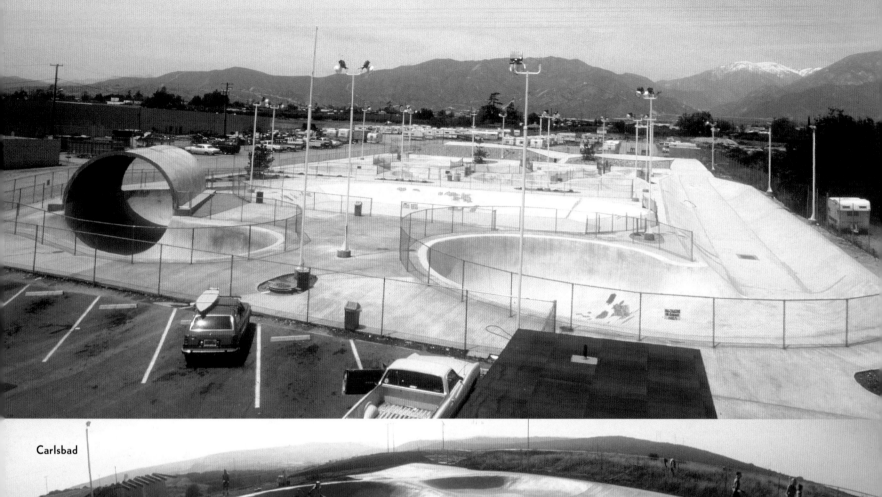

Carlsbad

THE PARKS

As much as its popularity rose, so did the notion that skateboarding was indeed a crime, or at the very least, annoying. The powers that be used what powers they had to put a stop to the fun, and some of the best drainage ditches of the time were speed-bumped. Throughout the mid-seventies it wasn't rare to find that your favorite Department of Water and Power—sanctioned playground had just been destroyed via three-inch-high ribbons of cement. But not all bad came from this. In 1976, the first skatepark opened up in Carlsbad, California. More followed, with Skatercross, Upland, Paramount, the Runway, Colton, Oasis, Steve's South Bay, the Endless Wave, Winchester, Spring Valley, and Marina Del Rey among the best. The parks were generally modeled after spots made famous by *Skateboarder* magazine. Upland had its illustrious full pipe, Marina had its Dogbowl and Keyhole, complete with tiles and coping, and the Endless Wave had its half pipe, with almost no transition and a dangerously high stretch of vertical. By the end of the decade, upwards of two hundred parks had been opened in the United States.

Surf vs. Skate: Take One

Though skating's roots trace straight back to surfing, there is one massive difference: Surfing's playground is everchanging and in flux. In other words, you can't step twice on the same piece of water. Skateboarding, on the other hand, happens on cement, concrete, wood, Plexiglas, i.e., a static, nonmoving playing field. Therefore, skateboarders can spend hours, days, even weeks perfecting the same trick on the same terrain, whereas surfers really can't. And this, ladies and gentlemen, is distinct difference number one between surfing and skateboarding.

The First Skate God

Tony Alva embodied all the things that made skating cool. He had style, he had attitude, and best of all, he didn't care. And when skateboarding blew up in the mid-seventies, Alva was there to reap all the benefits. He became a kind of ambassador for the sport—not in a shaking hands, kissing babies way, but in an uncompromising, "I'm a skateboarder—fuck you!" kind of way. Alva was one of the first skaters ever to start his own company, a trend that would blossom with the do-it-yourself mentality that pervaded the coming decade.

Enter the Industry

As Steve Pezman once said, "The early seventies were when sewing machines replaced the Skil Planer." In other words, what had once been a tiny scattering of garage and backyard surfboard builders all of a sudden evolved into a small cluster of board, clothing, and wetsuit manufacturers. The industry had arrived. And with it came its own customs, codes, identities, and idiosyncrasies. Early surf brands were generally founded by actual surfers and authenticity was never a question. But as the ball got rolling, more and more dollar-driven, mainstream brands wanted a piece of the action, in turn offending long-time surfers who saw their sport as sacred. At certain spots, a "locals only" vibe filled the lineup that was both unpleasant and very uncool.

Skateboards Swell

As far as decks go, plywood became the material of choice, with curved kicktails on the back to assist kickturning. Peralta's G&S Warptail sold huge numbers as did Sims, Dogtown, Alva, and Z-Flex. Kryptonics and OJ made big colorful wheels and Rector came out with plastic-cupped pads designed to slide rather than tear your kneecaps apart. The sport was getting bigger, in terms of both boards and mass appeal. Skateboarding was featured in an episode of *Charlie's Angels,* a major TV show of the time that starred Farrah Fawcett, the Pamela Anderson of the seventies. By the end of the decade, skaters often had two-board quivers: a vert ten-inch-wide "pig," and a narrower, more street-oriented board with looser trucks and smaller wheels.

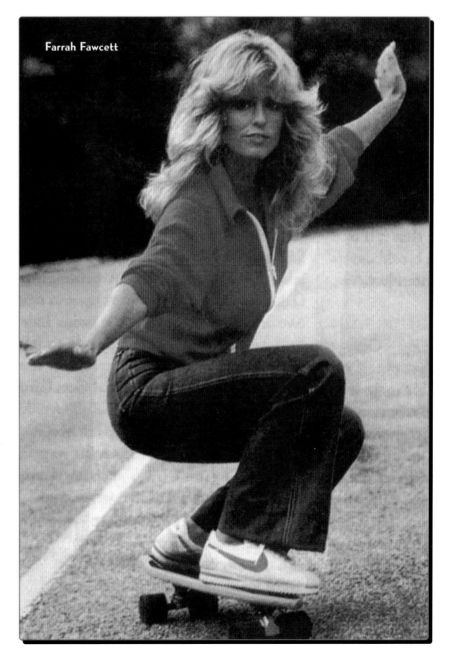

Farrah Fawcett

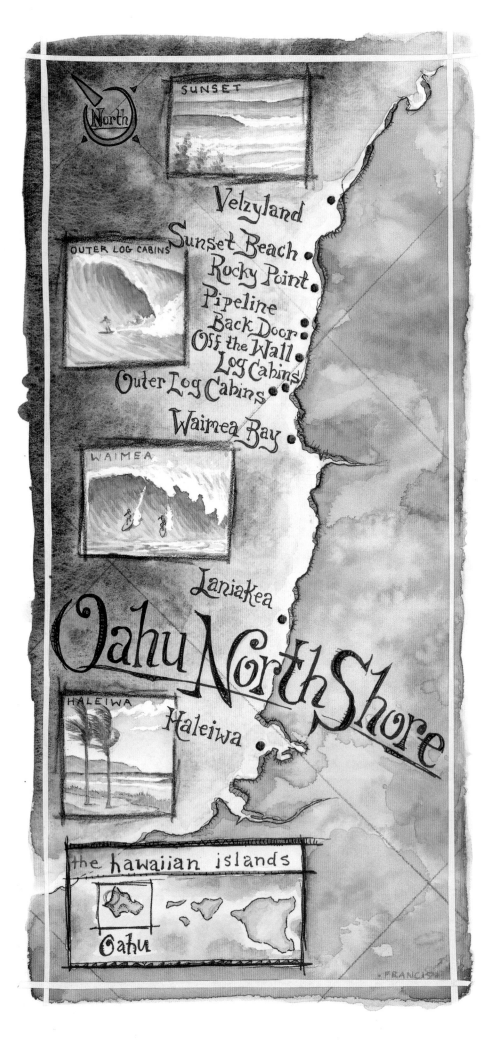

North

SUNSET

Velzyland

Sunset Beach

OUTER LOG CABINS

Rocky Point

Pipeline

Back Door

Off the Wall

Log Cabins

Outer Log Cabins

Waimea Bay

WAIMEA

Laniakea

Oahu North Shore

HALEIWA

Haleiwa

the hawaiian islands

Oahu

FRANCIS

Eddie Would Go

Of all the memorable surfers of the seventies, none will go down in the history books quite like Eddie Aikau. Hailing from a full-blooded, six-sibling Hawaiian family, Aikau took to surfing in the mid-sixties with a prodigious flair. He quickly graduated on to the bigger surf of the North Shore. In 1967, at the age of nineteen, Aikau paddled out into massive waves at Waimea Bay and rode like a champion. His picture showed up in *Life* magazine and he became an instant surf star. A year later he took a job as a North Shore lifeguard, patrolling some of the most dangerous beaches in the world. Aikau was a godsend. He knew the ocean like the back of his hand and saved hundreds of lives. He eventually found himself stationed at Waimea Bay, a wave he loved like no other. In 1977, Aikau won the Waimea Bay Duke Classic, a huge competitive feat both professionally and personally. But surf contests and lifeguarding were only a small part of the package. Aikau took a deep interest in his Hawaiian ancestry, and when the opportunity came to retrace the Polynesian migration passage between Hawaii and Tahiti—a 2,400-mile voyage—Aikau was all over it. The *Hokule'a* set sail on the night of March 16, 1978. There was a strong northeast trade wind blowing and it was not a good night to be at sea. Things went bad real quick. Somewhere between Oahu and Lanai, a leak in the starboard hull caused the vessel to capsize. Familiar with these sorts of emergencies, Aikau instructed his fellow passengers to stay put. In an act of selflessness and heroic valor, he then proceeded to paddle a surfboard off into the night with the hopes of finding help. In his absence, a Hawaiian airjet pilot somehow spotted the *Hokule'a* and radioed the Coast Guard. The passengers and crew members of the *Hokule'a* were saved. Eddie Aikau, however, was never seen again. In 1986, the annual Quiksilver In Memory of Eddie Aikau was created, a big-wave event that pays homage to Aikau. "The Eddie" happens in waves no smaller than twenty feet, hence the expression "Eddie Would Go."

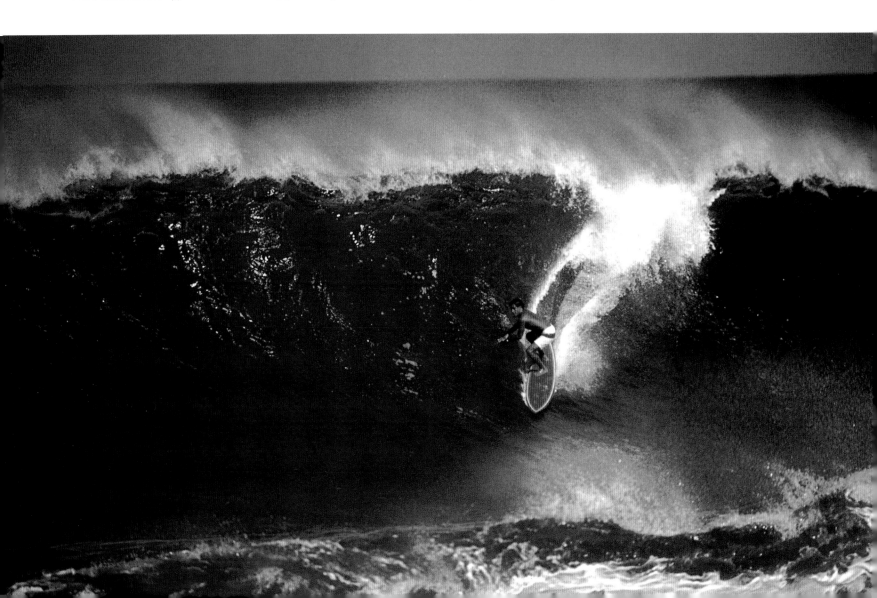

RIP RABBIT RIP

Australian Wayne "Rabbit" Bartholomew burst on the scene in the mid-seventies with an enthusiasm, stoke, and prizefighter spirit that illuminated anyone he came into contact with, his fellow pros included. Bugs's backhand attack at big Pipe, at a time when most regular foots were baffled out there, goes down in the history books as far ahead of its time, and his cat-like, supple, and springy style set the pace for much of what would come later. In 1978, he won a world title, and for the next ten years he brought a level of games-manship to surfing that was more like something you see in chess, tennis, or boxing.

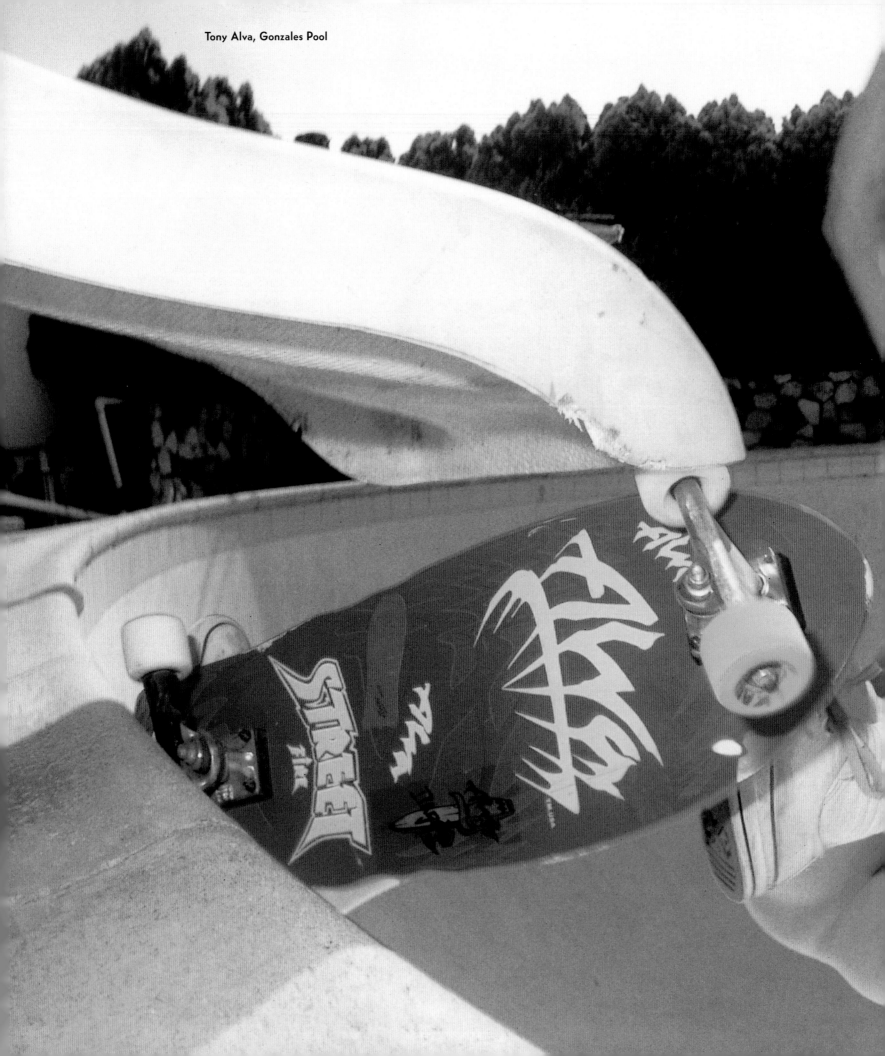
Tony Alva, Gonzales Pool

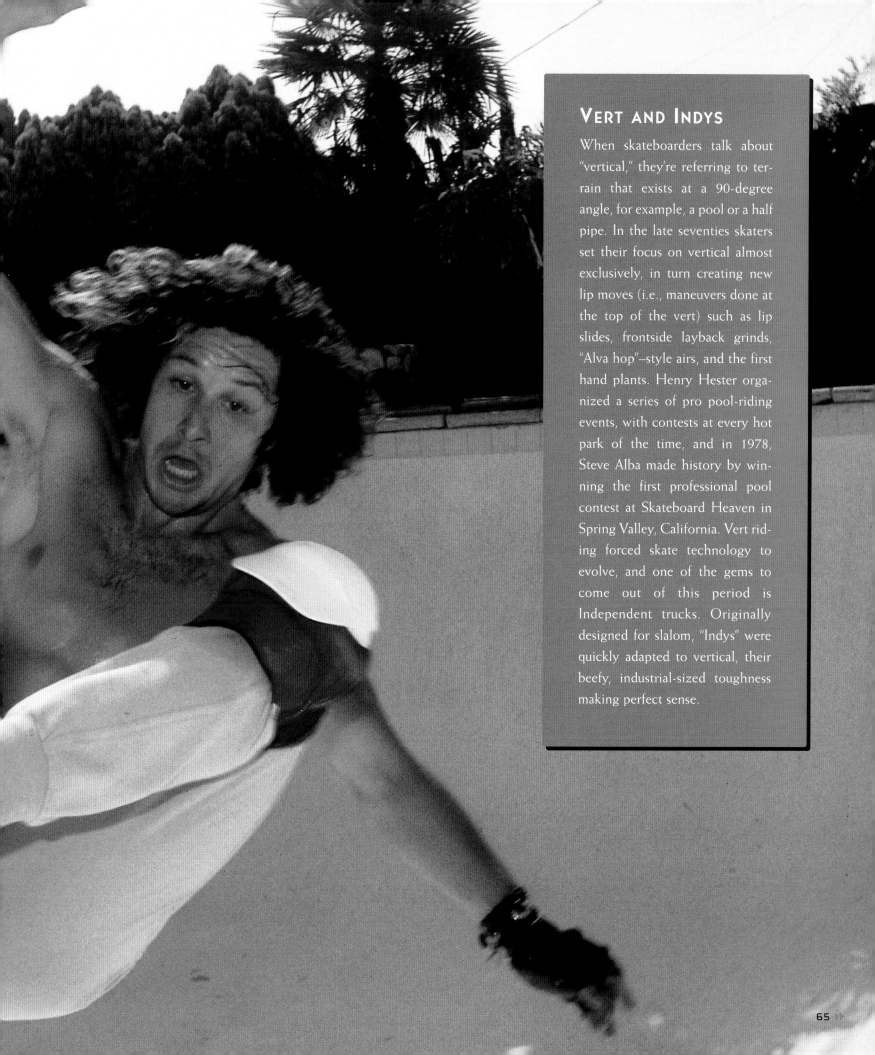

VERT AND INDYS

When skateboarders talk about "vertical," they're referring to terrain that exists at a 90-degree angle, for example, a pool or a half pipe. In the late seventies skaters set their focus on vertical almost exclusively, in turn creating new lip moves (i.e., maneuvers done at the top of the vert) such as lip slides, frontside layback grinds, "Alva hop"–style airs, and the first hand plants. Henry Hester organized a series of pro pool-riding events, with contests at every hot park of the time, and in 1978, Steve Alba made history by winning the first professional pool contest at Skateboard Heaven in Spring Valley, California. Vert riding forced skate technology to evolve, and one of the gems to come out of this period is Independent trucks. Originally designed for slalom, "Indys" were quickly adapted to vertical, their beefy, industrial-sized toughness making perfect sense.

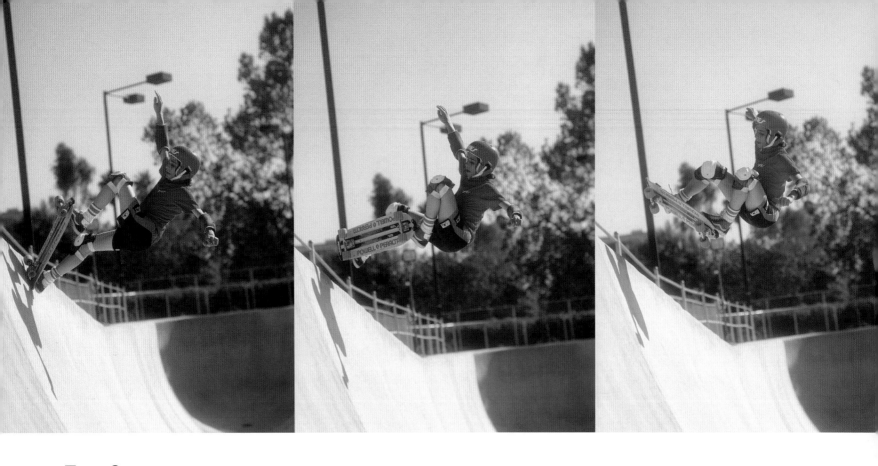

THE OLLIE

Meanwhile on the East Coast, a hot young Floridian named Alan "Ollie" Gelfand was popping little airs as he'd enter into his lip slides. Stomping with his back foot and pulling up with his front, Gelfand figured out a way to get the board into the air with no hands. Little did he know he was inventing the trick that would transform the sport. The "Ollie" started off as more a vert trick than flat-land, but in the next few years this would change, and consequently, so would skateboarding.

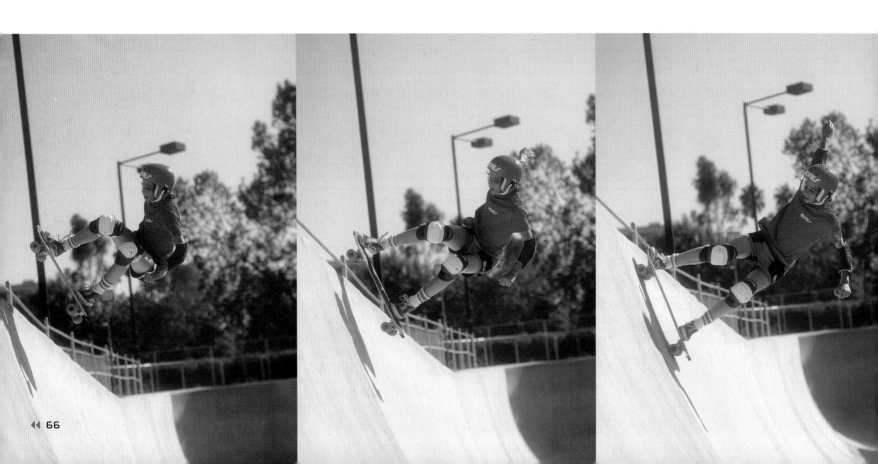

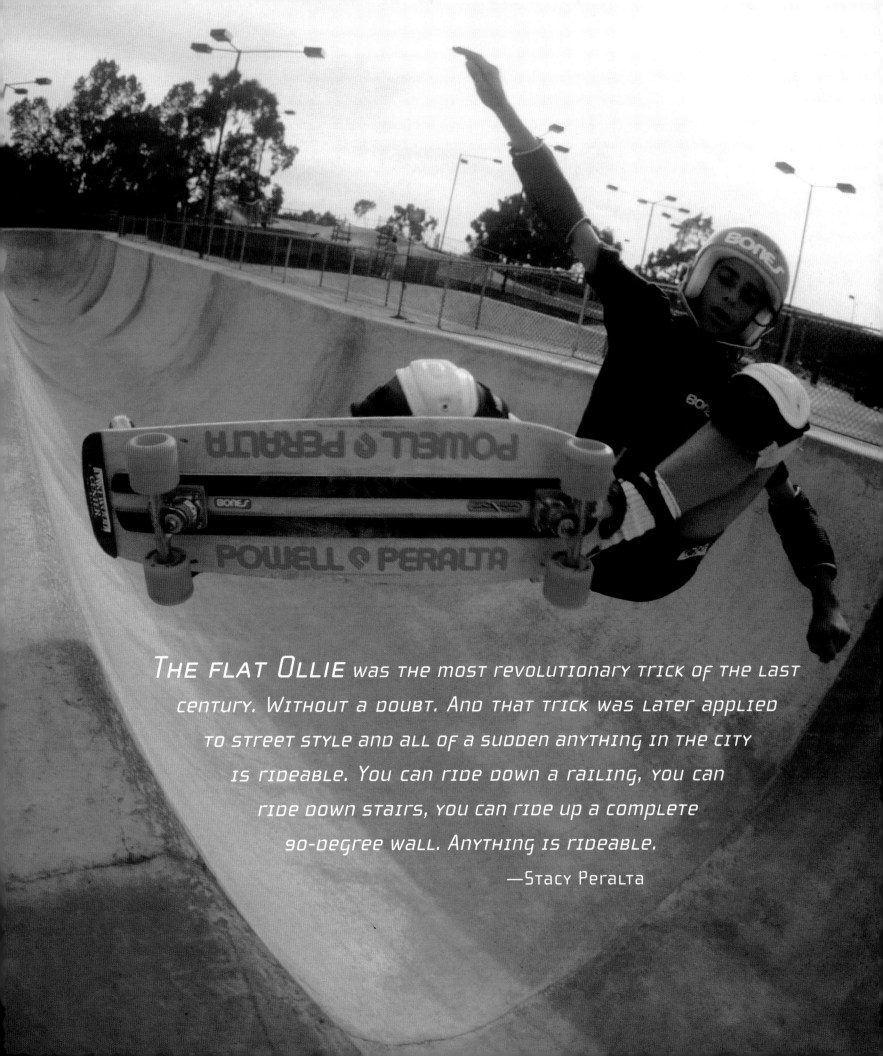

THE FLAT OLLIE was the most revolutionary trick of the last century. Without a doubt. And that trick was later applied to street style and all of a sudden anything in the city is rideable. You can ride down a railing, you can ride down stairs, you can ride up a complete 90-degree wall. Anything is rideable.

—Stacy Peralta

SLICING ON SNOW

the pact with gravity
that is snowboarding

IT'S IMPORTANT TO RECOGNIZE how important a role snowboarding played in bringing the two other sports together. I think if snowboarding hadn't come up the two cultures maybe would have veered off from each other. Farther away than what they already were. Because surfing and skateboarding were very distinct cultures. And neither one wanted to jump into the other's pool. They were kind of on their own wavelengths. And then when snowboarding came in it brought the youth to really acknowledge both sports and accept both sports. I think snowboarding is a great glue between surfing and skateboarding.

—RICHARD WOOLCOTT, VOLCOM

Tom Burt

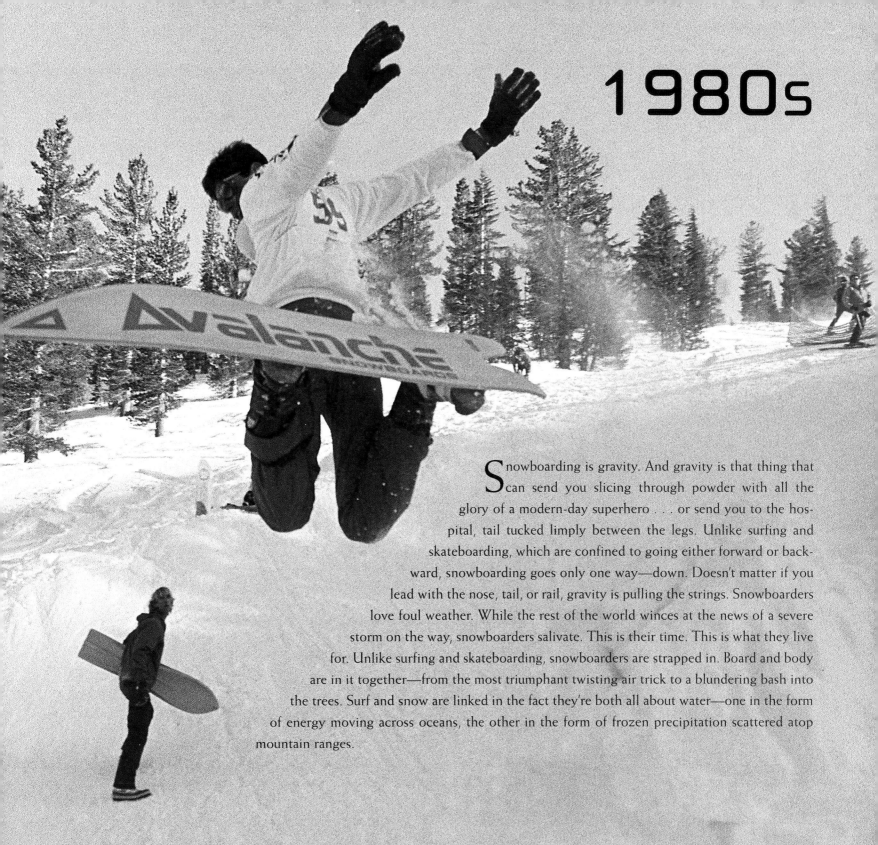

Snowboarding is gravity. And gravity is that thing that can send you slicing through powder with all the glory of a modern-day superhero . . . or send you to the hospital, tail tucked limply between the legs. Unlike surfing and skateboarding, which are confined to going either forward or backward, snowboarding goes only one way—down. Doesn't matter if you lead with the nose, tail, or rail, gravity is pulling the strings. Snowboarders love foul weather. While the rest of the world winces at the news of a severe storm on the way, snowboarders salivate. This is their time. This is what they live for. Unlike surfing and skateboarding, snowboarders are strapped in. Board and body are in it together—from the most triumphant twisting air trick to a blundering bash into the trees. Surf and snow are linked in the fact they're both all about water—one in the form of energy moving across oceans, the other in the form of frozen precipitation scattered atop mountain ranges.

ENTER SNOWBOARDING

Above all else, it was an expansion of surfing and skateboarding, a way to explore different terrain with the same mind-set. Snowboarding blasted onto the scene in the early eighties, taking every kid in the know to the top of the mountain, both literally and metaphorically. It was more than just an underground movement, it was a contagious virus, and hubs of riders cropped up in places like California, Vermont, Washington, and Colorado, taking to the snow with a pioneering spirit and laying the tracks for what would soon become a worldwide phenomenon.

Duane Peters

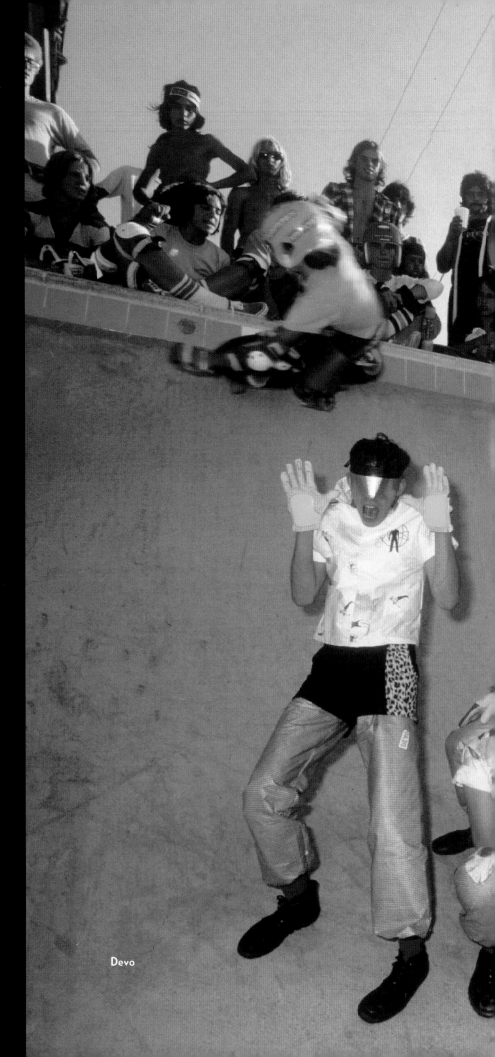

Devo

GOING UNDERGROUND

Devo, B-52s, 999, Buzzcocks, X, Dead Kennedys, Adolescents, Social D., and Circle Jerks would be the most appropriate bands to soundtrack early-eighties skateboarding. Hairstyles were short, spiky, and often brightly colored; skate shoes had yet to be invented, so typical kicks wore Converse All-Stars or Vans high-tops; plaid bermudas (like the kind your grandpa would wear) were supercool; and the DIY mind-set was a big part of the package, hence all the backyard ramps popping up. Boards were piggish, trucks were wide, wheels were soft and oversized. Duane Peters grinded with menace. Steve Olson laid back with style. Jay Adams carved with savage aggression. Steve Caballero and Eddie "El Gato" Elguera brought all kinds of acrobatics to air moves. And then all of a sudden the American public lost interest in skating. In fact, right about the time MTV began showing up on the screen, skateboarding burrowed its head into the underground. Because of insurance policy complications, skate parks shut down. Because of the lack of advertisers, *Skateboarder* magazine transformed into *Action Now*, diluting skateboarding with BMX, surfing, and music. And because of its marginalized, below-the-radar position in the world, skaters just carried on doing what they were doing, making it up as they went along.

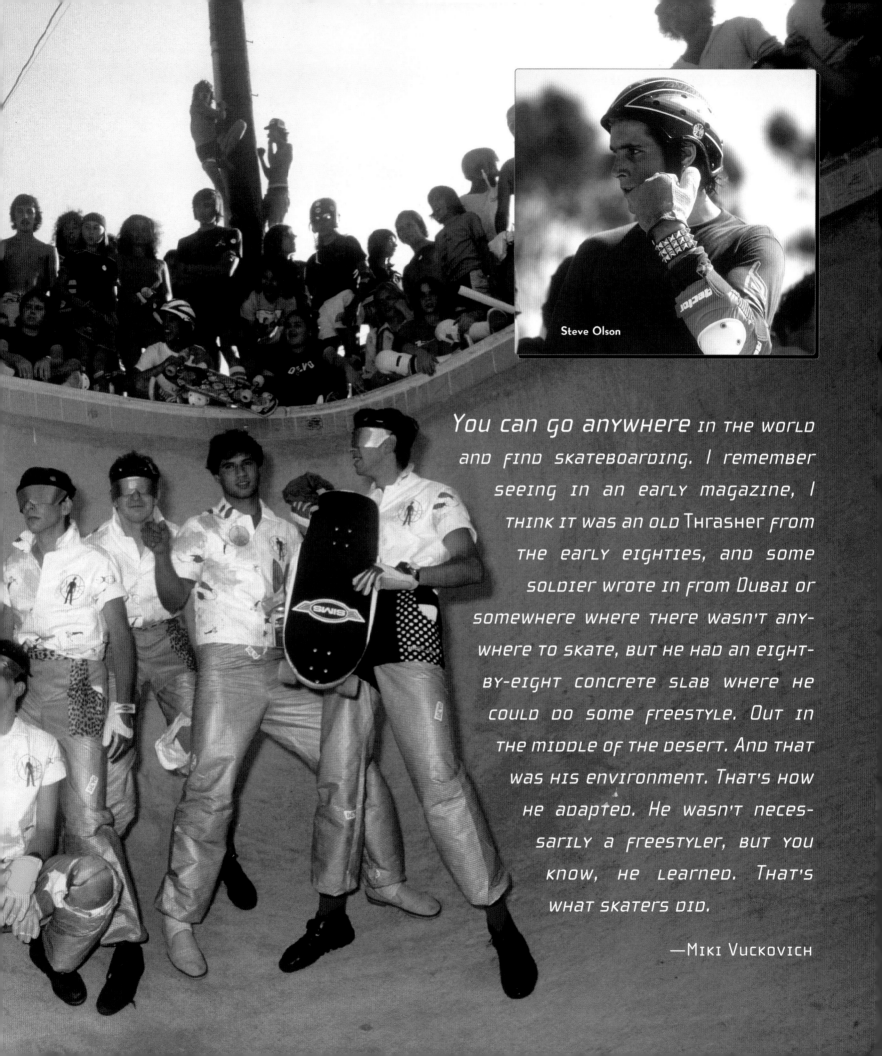

Steve Olson

You can go anywhere in the world and find skateboarding. I remember seeing in an early magazine, I think it was an old Thrasher from the early eighties, and some soldier wrote in from Dubai or somewhere where there wasn't anywhere to skate, but he had an eight-by-eight concrete slab where he could do some freestyle. Out in the middle of the desert. And that was his environment. That's how he adapted. He wasn't necessarily a freestyler, but you know, he learned. That's what skaters did.

—Miki Vuckovich

THE THRUSTER IS BORN

Simon Anderson was a bigger-than-average bloke struggling in small waves on the IPS world tour when he came up with the Thruster, undoubtedly the biggest design breakthrough since foam and fiberglass back in the late fifties. Up until the early eighties the typical board was either a single or twin fin. The single fins had strong holding power (traction), but they lacked speed in small surf. The twin fin, on the other hand, was like a little Ferrari, only a Ferrari on a very slick surface. When you turned them really hard or rode them in big waves, they slid out. What many surfers of the time did was keep a twin fin in their quiver for when the waves were small and a longer, gunnier single for when it got big. But there was a hurdle—jumping from one design to another was a tough transition. Anderson solved this problem in 1981. He showed up at the Bells Beach Easter contest with one board, this strange three-finned device he called the Thruster. Simon was both a surfer and a shaper, and the Thruster came about more as a way for him to lift his own game than to revolutionize surfing. "It was obvious from the beginning that it was a huge leap forward," he recalls. "But I had a little bit of trouble convincing other people. So I figured that maybe it wasn't going to be that big." Not unlike Tom Blake when he paddled his hollow board to victory back in the late twenties, Simon Anderson proved the validity of his three-finned invention by winning the Bells Easter event and the Coke Surfabout back-to-back and then the Pipeline Masters later in the season. There was no doubt about it, the Thruster was the best all-around design out there, and at the time of writing, the Thruster is still the most widely used board in the water today.

THRUSTERS COMBINED THE BEST of the single and the best of the twin. They were very forgiving, very easy to ride.

—Shaun Tomson

Simon Anderson

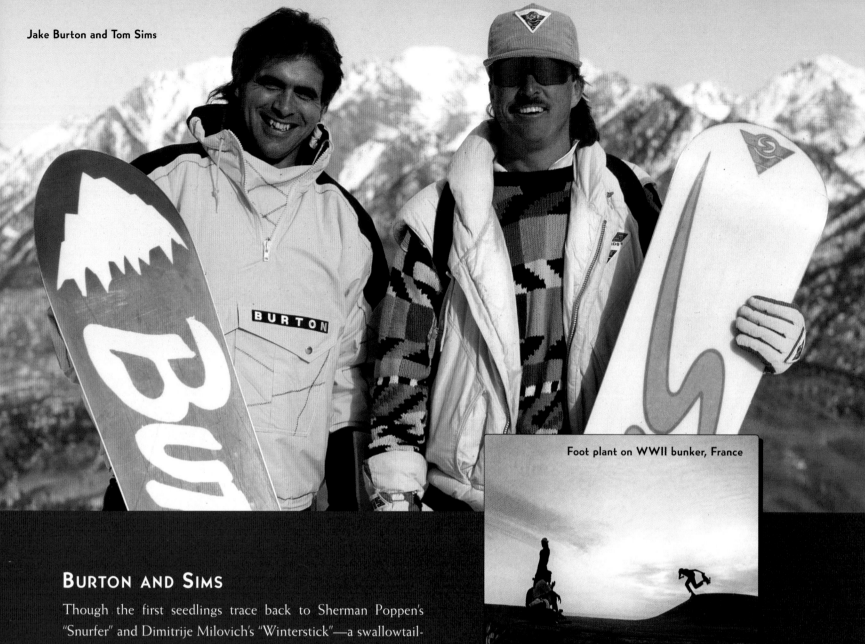

Jake Burton and Tom Sims

Foot plant on WWII bunker, France

BURTON AND SIMS

Though the first seedlings trace back to Sherman Poppen's "Snurfer" and Dimitrije Milovich's "Winterstick"—a swallowtail-shaped board that utilized ski technology long before it became standard issue—it was Jake Burton Carpenter, Tom Sims, and Chuck Barfoot who really expanded on what had come before and created the snowboard as we know it today. Burton was in Vermont, a Snurfer rider from the beginning and a talented skier. Sims lived in California, a competitive skateboarder/skateboard manufacturer. Barfoot was California-based and in business with Sims making skateboards. The three saw the potential of snowboarding from the get-go, and through trial, error, and the kind of vision that creates historical revolution, they jointly cultivated both snowboards and snowboarding. Burton founded his company in 1978, and the first Burton Backhills were a far cry from boards today, but they did have a front-foot binding. Sims's approach was all about adapting surfing to snow, and his earliest boards resembled single-fin surfboards, with rubber straps to hook your feet into.

GOING GLOBAL

Throughout the first half of the eighties, skateboarding continued to be influenced by punk rock, giving it an edgy luster that captivated teenagers globally. Enter Australia, Japan, South America, and Europe into the mix—a few continents that would later produce a heap of world-class riders.

THE WOUNDED GULL

Mark Richard's soaring, sweeping, big-turns approach earned him the moniker "Wounded Gull." He was one of the first pros to make a big chunk of change out of surfing. He drove a silver 911 Porsche. He appeared on the cover of *Surfing* magazine with bright wetsuit and board, leaning against a Sunset Boulevard street sign, hinting at things to come. Spawned from the surf-infested shores of Newcastle, Australia, "MR" won four consecutive world titles from 1979 to 1982. Famous for his brightly colored boards and religious devotion to twin fins, he exuded an aura of calm and collectedness, never losing his composure and always handling himself like a true professional.

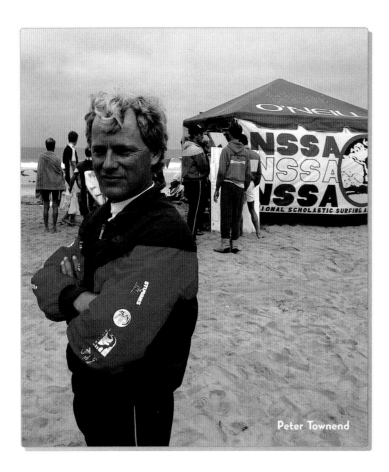

Peter Townend

AMATEUR SURFING GETS SERIOUS

By the early eighties, the idea that surfing could be a viable professional sport, one that you could actually earn a living from, became more and more of a reality. For every IPS pro that showed up in the mags, there were a hundred kids believing in the dream and wanting to one day be there themselves. To facilitate this there were amateur organizations on the East, West, and Gulf coasts, as well as Hawaii. Once a year they'd meet to determine the U.S. champs. From out of this came the National Scholastic Surfing Association. Spearheaded by Australians Ian Cairns and 1976 world champ Peter Townend, the NSSA was all about spreading surfing to a wider audience, presenting it in a professional manner, much like golf or tennis. To be a member of the coveted NSSA National Team not only did you have to rip hard, you had to attend school, get above-average grades, and avoid "unsportsmanlike conduct." The NSSA bred some of the best American surfers throughout the eighties and nineties, the finest examples being three-time world champ Tom Curren and six-time world champ Kelly Slater.

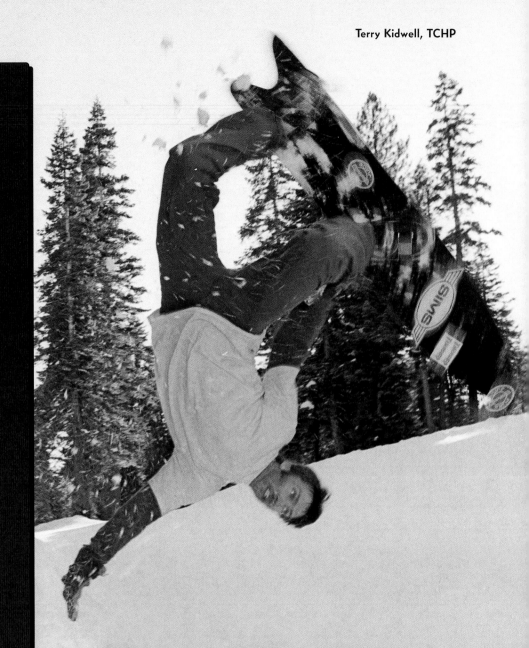

SNOWBOARDING'S FIRST HALF PIPE

It was nothing more than a gully behind a garbage dump, but nonetheless, it goes down in the record books as the world's first snowboarding half pipe. The story goes like this: In 1978, a crew of North Shore High School kids were onto Wintersticks. Whenever it snowed, Terry Kidwell, Allen Arnbrister, and Bob Klein would race from school to the gully, shovel the snow around to make it deep enough to ride, and then proceed to pull skate-influenced moves on this new white wonderland. In 1982, Tom Sims got wind of the Tahoe City half pipe and showed up on the scene with a bunch of skateboarders. Again, it was all about skate moves in the snow. As the winter kicked on, more and more kids gravitated there, creating both the birth of freestyle riding and the legend of the TC half pipe in the process.

SKATE BAGGAGE

Skateboards were big, fat, clunky things in the early eighties, measuring around thirty inches long by ten inches wide, eventually becoming concave. Noses had nose guards, tails had skid plates, rails had rib bones, trucks had copers and lapers, and wheels were beveled to roll over coping smoothly. To add even more accessories into the package, skaters wore Pro-Tec helmets and Rector pads along with the legendary Rector cord shorts with built-in hip pads.

It's as if the snowboarding crowd showed up and said, "Wow, look at all these maneuvers that we can take." And they just took all of 'em. Kept the names, kept the terrain, and just said, "We're going to apply this to this."

—Stacy Peralta

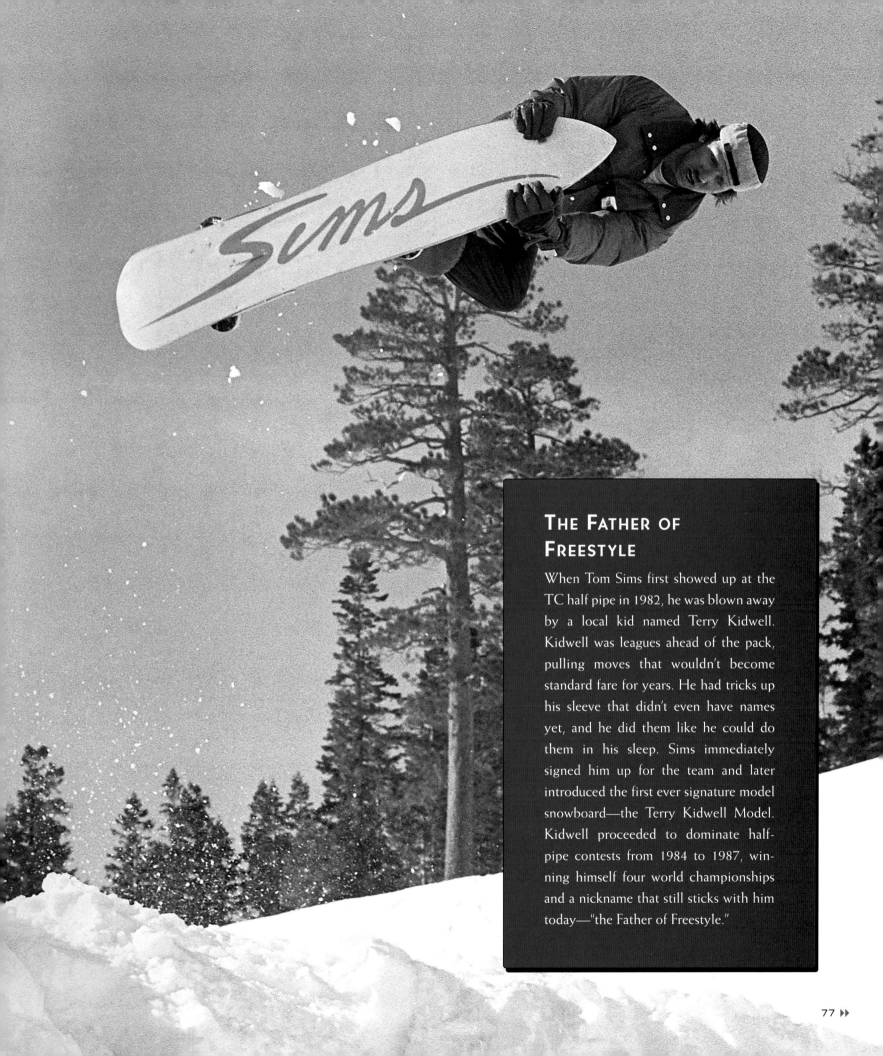

THE FATHER OF FREESTYLE

When Tom Sims first showed up at the TC half pipe in 1982, he was blown away by a local kid named Terry Kidwell. Kidwell was leagues ahead of the pack, pulling moves that wouldn't become standard fare for years. He had tricks up his sleeve that didn't even have names yet, and he did them like he could do them in his sleep. Sims immediately signed him up for the team and later introduced the first ever signature model snowboard—the Terry Kidwell Model. Kidwell proceeded to dominate half-pipe contests from 1984 to 1987, winning himself four world championships and a nickname that still sticks with him today—"the Father of Freestyle."

THRASHER AND TWS

Skateboarding's underground profile created the perfect platform for the launching of *Thrasher* magazine, first hatched out of San Francisco in 1981 with "skate and destroy" as their credo. There was nothing watered down or mass-marketed about *Thrasher*. It came straight from the source, with articles explaining where to find ditches, bowls, storm drains, and how to build your own ramp. In 1983, *Transworld Skateboarding* came into being, offering an alternative to the punk rockishness of *Thrasher* and a mission to contribute to the sport's growth. *TWS* was vibrant and ripe with potential. Within two years they doubled in size.

THE IPS BECOMES THE ASP

During the North Shore winter of 1982/1983, Ian Cairns wrestled the International Professional Surfers association away from Hemmings (page 75) and formed the Association of Surfing Professionals. The ASP flourished from the get-go, with a world tour designed to stimulate surfing's growth. This meant that events were held in high-profile, easy-access venues where surfing could get as much exposure as possible. Unfortunately for the surfers though, this also meant wave quality was compromised. In fact, some contests were held in such tiny, poor-quality surf that competitors protested, forcing the ASP to instigate an eighteen-inch wave height minimum.

SNOWBOARDERS VS. SKIERS

When snowboarders first showed up on the ski slopes, they were looked upon with scorn and contempt. The reasons for this were threefold: (1) The sport was still young and the equipment crude, hence the riders were not fully in command of their boards and scared the pants off the skiers; (2) their lines were different—snowboarder S-turns consumed a lot more square footage and tore up the snow, so as far as skiers were concerned, they were "powder hogs"; (3) snowboarding had the "young, loud, and snotty" vibe going, whereas skiers were generally more country club–minded. But here's the good news: In the late seventies skiing's popularity faded and by the early eighties the ski resorts were hard up for cash. To turn away snowboarder revenue would be to shoot themselves in the foot. So they let them in, much to the chagrin of the skiers.

SKATEBOARDING GETS ORGANIZED

Early-eighties skateboarding had been scattered and fragmented, with no unified series of events and no governing body to oversee the sport's growth. This changed in 1983 when the National Skateboard Association came into being, founded by Frank Hawk, father of Tony. The NSA presented skateboarding as a healthy and legitimate sport, organizing contests and drumming up respectable prize-money purses, as well as helping to rally skate parks back on the scene. Most skaters loved and prospered from the NSA. It brought a forum, a focus. There were others, however, who loathed it, feeling it stole from skating's renegade soul.

SURFING HAS BEEN put across as a cult, and it is a cult. I've been on this tribal thing for a long time. As a tribe, surfers are all after something the normal man in the street doesn't have a bloody clue about. I mean, surfers are becoming respectable now, a lot of people have put a lot of effort into that and that's great. But we know we're into some-thing different.

—Nat Young, *Surfers*

Dane Kealoha

Cheyne Horan

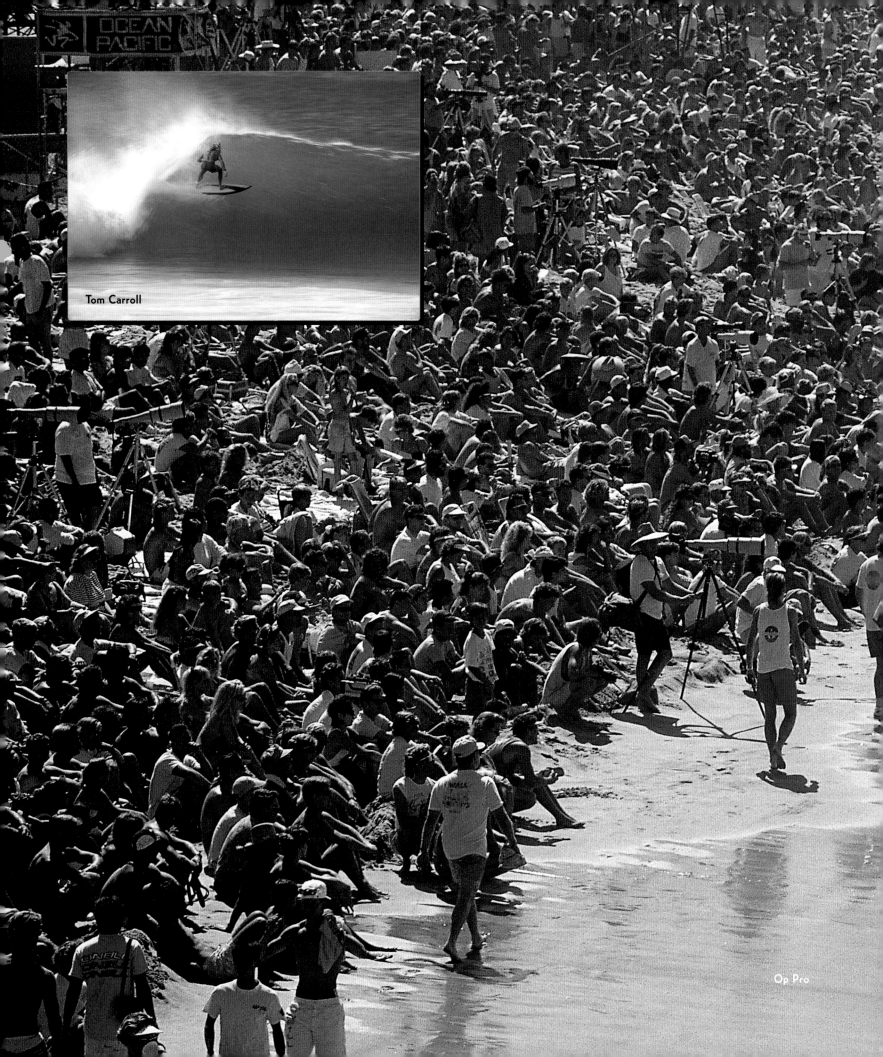

Tom Carroll

Op Pro

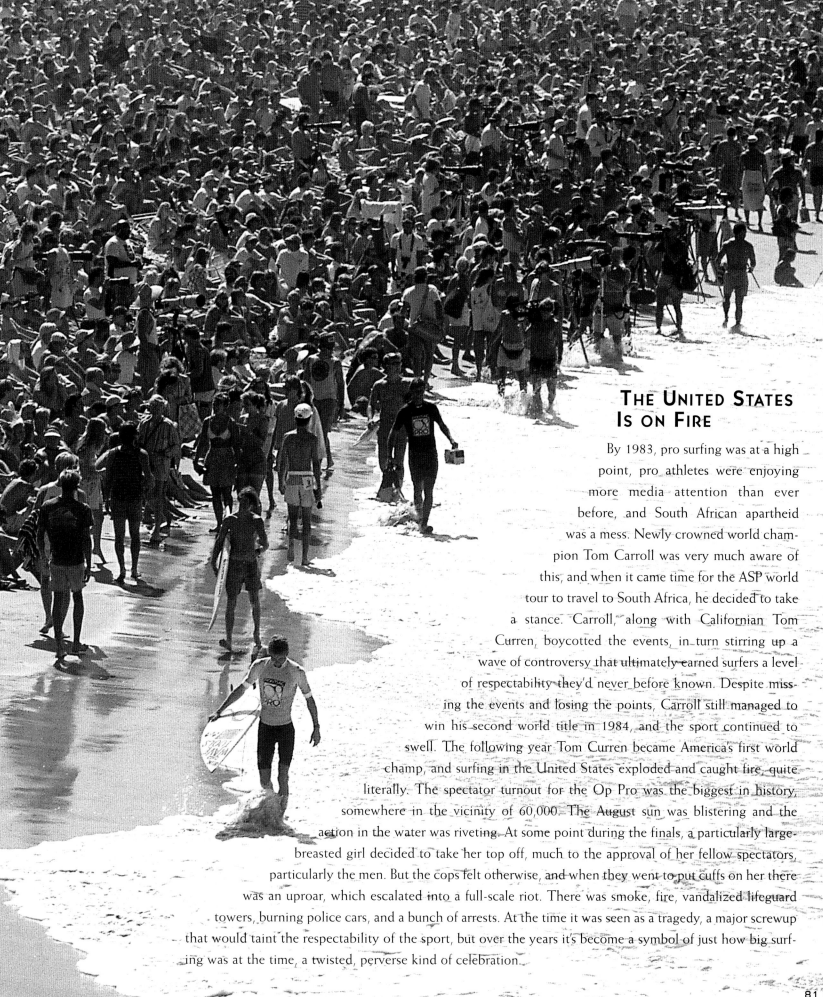

THE UNITED STATES IS ON FIRE

By 1983, pro surfing was at a high point, pro athletes were enjoying more media attention than ever before, and South African apartheid was a mess. Newly crowned world champion Tom Carroll was very much aware of this, and when it came time for the ASP world tour to travel to South Africa, he decided to take a stance. Carroll, along with Californian Tom Curren, boycotted the events, in turn stirring up a wave of controversy that ultimately earned surfers a level of respectability they'd never before known. Despite missing the events and losing the points, Carroll still managed to win his second world title in 1984, and the sport continued to swell. The following year Tom Curren became America's first world champ, and surfing in the United States exploded and caught fire, quite literally. The spectator turnout for the Op Pro was the biggest in history, somewhere in the vicinity of 60,000. The August sun was blistering and the action in the water was riveting. At some point during the finals, a particularly large-breasted girl decided to take her top off, much to the approval of her fellow spectators, particularly the men. But the cops felt otherwise, and when they went to put cuffs on her there was an uproar, which escalated into a full-scale riot. There was smoke, fire, vandalized lifeguard towers, burning police cars, and a bunch of arrests. At the time it was seen as a tragedy, a major screwup that would taint the respectability of the sport, but over the years it's become a symbol of just how big surfing was at the time, a twisted, perverse kind of celebration.

CERTIFIED SNOWBOARDING

In an effort to ease skier–snowboarder tension, a few big picture–minded riders embarked upon a project that would help to insure that their tribe behaved respectably. Certification programs were all about common courtesy and competency. No cutting lift lines and no foul language. And if you wanted to use the mountain you had to know what you were doing. Jake Burton set up the Burton Test, and Bev and Chris Sanders organized the Slide Safety Certification Program. They were a little bit like the tests you go through to get a driver's license and had an initial police state feel, but they definitely helped the cause. And to legitimize snowboarding all the more, Jake Burton and Tom Sims gave firsthand demonstrations of their newfound craze, bustin' the doors down one resort at a time.

COMPETITIVE SNOWBOARDING

The first National Snowboarding Championships were put on by Burton in the winter of 1982 at Suicide Six in Vermont. Riders from Rhode Island, Utah, Colorado, Michigan, and California made the scene, and the contest provided a great opportunity for snowboarders to talk shop, swap ideas, and decide who was ripping the hardest. The Burton guys were using heelstraps, which meant their entire foot was attached to the board as opposed to just the toes, a design advancement that echoed throughout the country. The following spring Sims hosted the World Snowboarding Championships at Soda Springs, California. The two contests highlighted the differences in east and west snowboarding. Where the Burton event was more race-oriented, the Sims contest was all about skateboarding. Sims had a half pipe built specifically for the event, which was foreign to the easterners, causing a huge dispute between Tom Sims and Jake Burton. Sims thought the half pipe completely legitimate. Burton felt it was a ploy to create a "home court advantage." In the end it was a good thing—it called into question the direction of the sport, pushed board design, and forced everyone to think about the future.

TRANSITIONAL IMPROVEMENTS

Sometime during the first half of the eighties, skaters realized that to really focus their momentum and prepare for their liftoffs, they'd need some flat in the middle of their half pipes. Most of the skate parks had been poorly designed with abrupt transitions and no flat, with the exception of Winchester and its famous Keyhole pool with the first flat bottom, created back in the late seventies. The advancement of good tranny and flat in between worked like a miracle. Skaters boosted higher than they'd ever thought possible, and in turn, a mass of new aerial tricks developed. Enter the Mute Air, Method Grab, Stale Fish, Finger Flip, Miller Flip, Japan Air, Christ Air, Rocket Air, 360 Indy Air, Elguerial, Gay Twist, McTwist, Eggplant, and many, many more that would be tweaked, hybridized, and bastardized in years to come.

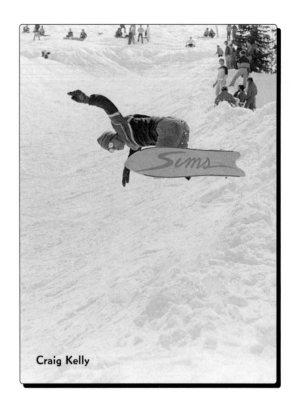

Craig Kelly

Allen Arnbrister

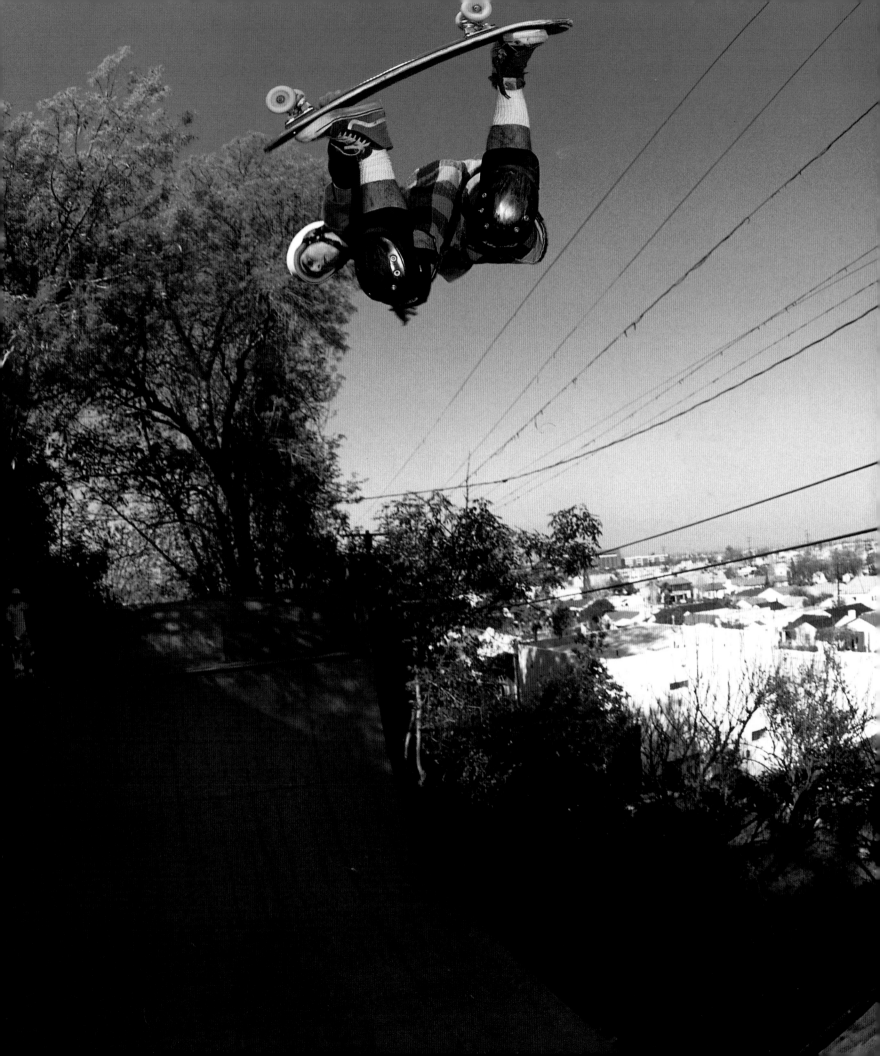

Snow Evolution

In its infancy, snowboarding had been fairly raw and uncertain. Was it surfing on snow? Skating on snow? Punk rock skiing? No one was exactly sure, and equipment reflected this. There were toe straps borrowed from water skis, skate decks mounted to sleds, sidecut that honored snow, and swallowtails and fins that pointed toward surfing. But by the mid-eighties the sport had defined itself, and snowboard manufacturers like Flite and Avalanche borrowed from ski technology to advance design. Enter steel edges, P-tex, camber, sidecut, and baseplate-connected highback bindings. Not only did performance levels advance among the initiated, but the new and improved boards and bindings made the sport a lot easier to learn, in turn rallying flocks of new converts.

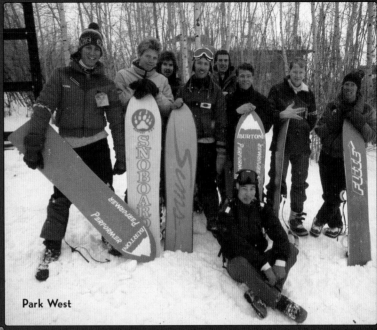

Park West

Highback Bindings

In the early days of snowboarding, riders were at a severe disadvantage when it came to heel-side turns. There was nothing to support the ankles and calves, making it difficult to really lay into turns. This problem was fixed when Jeff Grell invented the highback binding in 1983, a major evolutionary breakthrough. With the help of highbacks, riders connected more deeply with their boards, carving tighter arcs and boosting bigger airs.

Highbacks

Athleticism Emerges

By the middle of the decade, pro surfing was big business and pro surfers were taking it very seriously. They trained, watched their diets, and practiced creative visualization. The irreverent, rebellious attitude once inherent to the sport began to dissipate, giving way to a more tennis player–like mentality. Tom Carroll did weights, rode bikes, and swam like a monster to earn his world titles in 1983 and 1984. Tom Curren quickened his reflexes through plyometrics. Cheyne Horan did yoga. Damien Hardman boxed. Gary Elkerton snowboarded. And consequently, levels of performance soared skyward.

Cheyne Horan

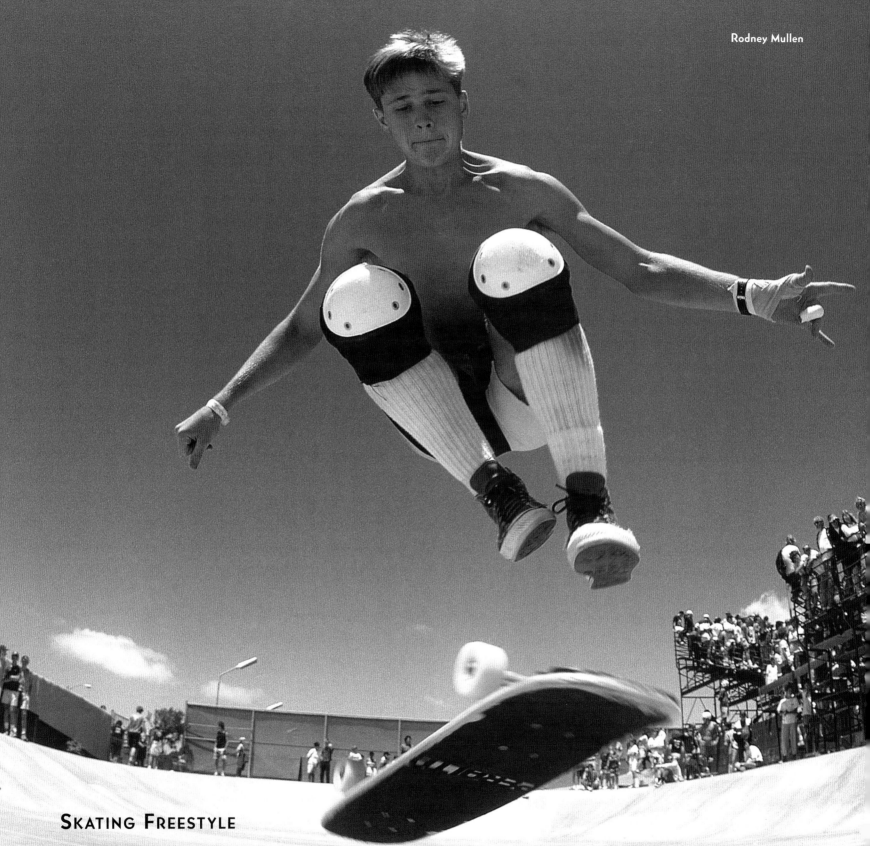

SKATING FREESTYLE

Although vert skating was dominating the sport, freestylists made a quiet charge forward, with Rodney Mullen, Steve Rocco, Per Welinder, Lance Mountain, and John Lucero whipping up all kinds of new tricks. Freestyle became more funky and dancelike. And you could do it anywhere. Think about this: Vert skating required specific terrain—a ramp, a half pipe, a pool, or a park. Freestyle required nothing but flat ground. If skateboarding could be stripped down to simply a street, a board, and a little imagination, then virtually everyone everywhere could do it, which would mean a Gold Rush as far as the industry was concerned.

SURF LIKE TOM CURREN

In 1985, nineteen-year-old Tom Curren from Santa Barbara, California, won his first of three ASP world titles, inspiring an entire generation's worth of "Curren clones." Tom was the son of sixties big-wave legend Pat Curren, and saltwater flowed through his veins. His "oneness" with the ocean was uncanny. He had a knack for finding exactly the right wave at exactly the right time. Curren was all about great surfing. The other duties that come with being a pro—the media hype, the sponsorship hoopla, the autograph-signing hassles—were never his style. He contributed to the sport by pushing performance levels out into the great unknown and being exactly himself, despite pressures to play the role of "media darling."

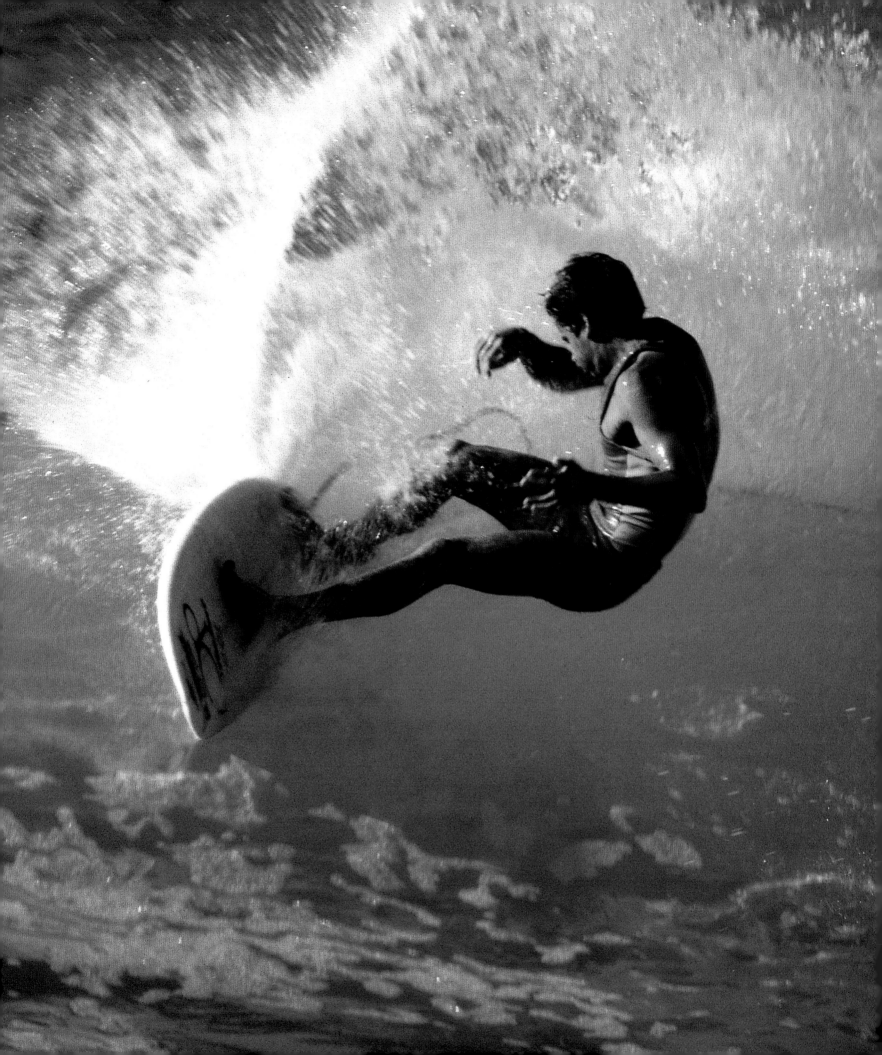

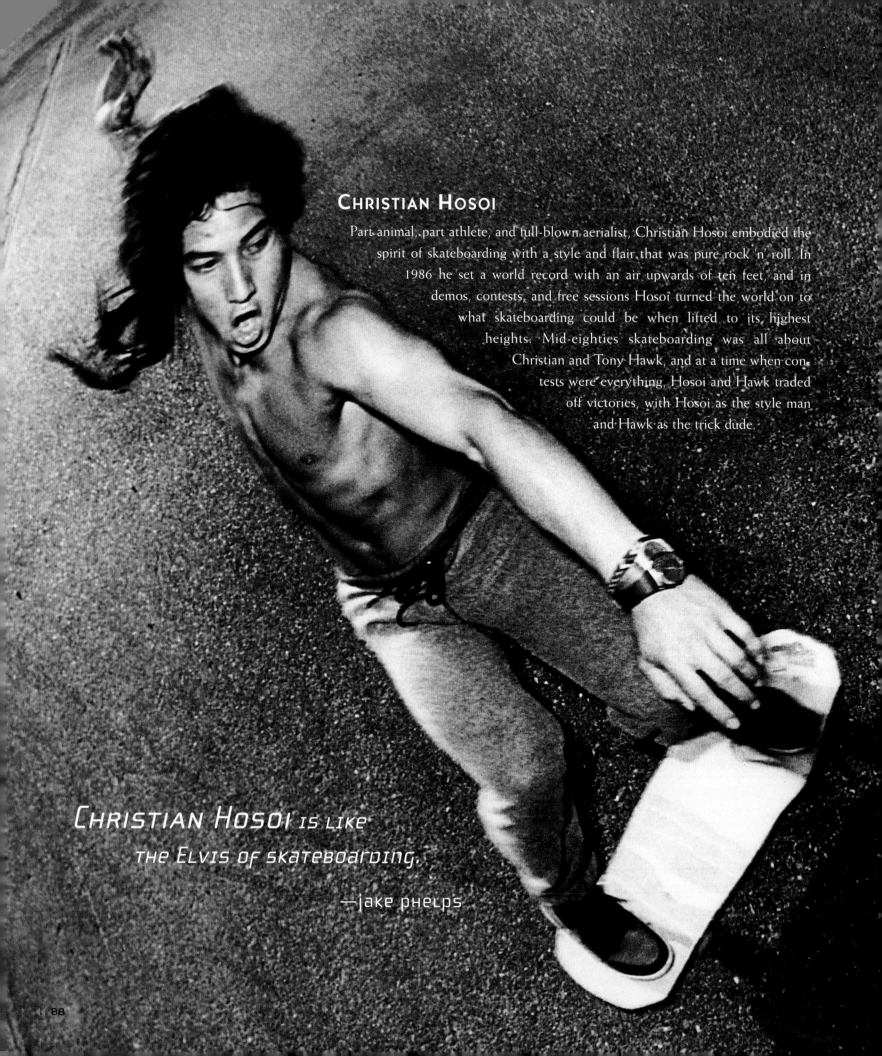

CHRISTIAN HOSOI

Part animal, part athlete, and full-blown aerialist, Christian Hosoi embodied the spirit of skateboarding with a style and flair that was pure rock 'n' roll. In 1986 he set a world record with an air upwards of ten feet, and in demos, contests, and free sessions Hosoi turned the world on to what skateboarding could be when lifted to its highest heights. Mid-eighties skateboarding was all about Christian and Tony Hawk, and at a time when contests were everything, Hosoi and Hawk traded off victories, with Hosoi as the style man and Hawk as the trick dude.

CHRISTIAN HOSOI IS LIKE THE ELVIS OF SKATEBOARDING.

—JAKE PHELPS

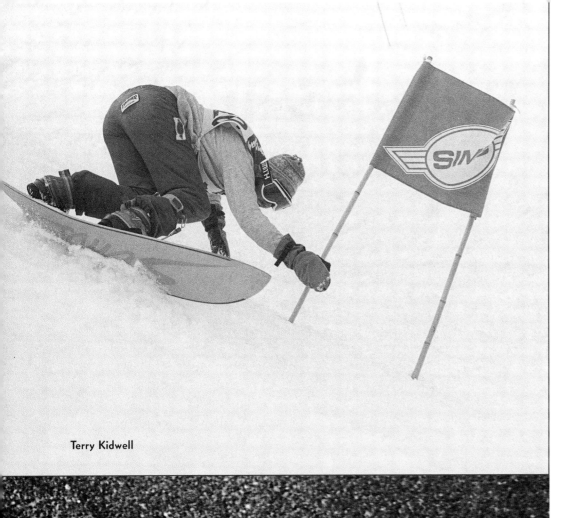

Terry Kidwell

BAKER BANKED SLALOM

The Banked Slalom event at Mount Baker was the first contest to present a terrain that was uniquely adapted to snowboarding—a banked ravine, incorporating elements of both slalom and half pipe. Inaugurated in 1985, the first event was a huge success, with Craig Kelly of the MBHC crew taking top honors and earning himself a spot on the coveted Sims team along the way. Held on Superbowl Sunday of each year, the Banked Slalom event has since become the most anticipated annual event in the sport—less a money/fame deal and more a chance to celebrate what it means to be a snowboarder.

STREET STYLE

In 1983, *Thrasher* magazine put on a contest in San Francisco's Golden Gate Park that was not about vertical, not about freestyle, and certainly not about downhill. The "Street Style" contest was about imagination and inventiveness. It was about riding everyday streets and sidewalks as though they were designed specifically to skate. Tommy Guerrero pulled things no one had ever seen before. He also became the first amateur ever to win a pro contest. Guerrero's win came with a warning: the times they were a-rapidly changing.

THE BANKED SLALOM event highlighted the combination of the skate, the surfy, and the alpine aspects of the snowboarding. And it's still a competition to this day that a lot of people swear by as being the true essence of snowboarding, even though it's in competition form.

—PAT BRIDGES

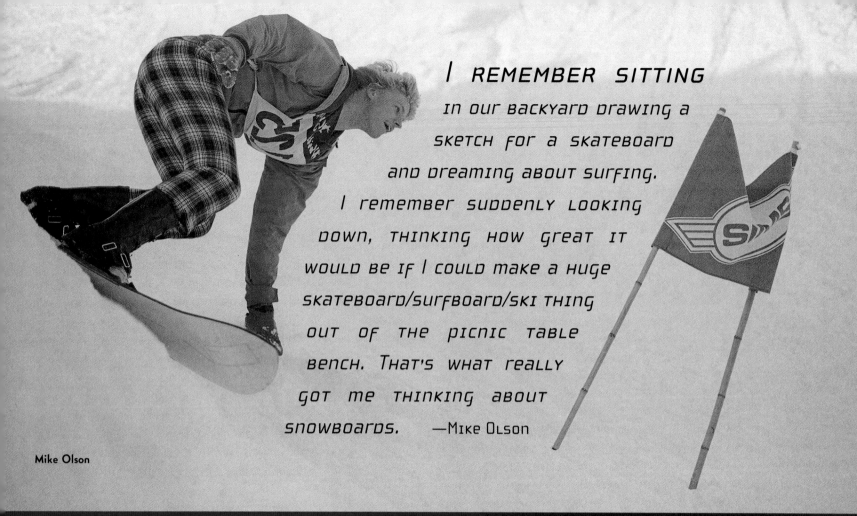

I REMEMBER SITTING IN OUR BACKYARD DRAWING A SKETCH FOR A SKATEBOARD AND DREAMING ABOUT SURFING. I REMEMBER SUDDENLY LOOKING DOWN, THINKING HOW GREAT IT WOULD BE IF I COULD MAKE A HUGE SKATEBOARD/SURFBOARD/SKI THING OUT OF THE PICNIC TABLE BENCH. THAT'S WHAT REALLY GOT ME THINKING ABOUT SNOWBOARDS. —MIKE OLSON

Mike Olson

INTERNATIONAL SNOWBOARD

The first snowboarding articles showed up in *Action Now* and *Transworld Skateboarding* in the early eighties, but the first actual snowboard magazine was *Absolutely Radical*, hitting the scene in March of 1985. Founded by Tom Hseih Jr. *AR* quickly changed its name to *ISM*, i.e., *International Snowboard*, and proceeded to document the early movements of the culture in a straightforward, warts-and-all fashion. *ISM* unified the pioneers, captured the *zeitgeist*, and created a flock of superstars who inspired enough riders nationwide to give rise to two more mags—*Transworld Snowboarding* in 1987 and *Snowboarder* in 1988.

CARVING

Mike Olson had been building snowboards since junior high. He was obsessed with their construction and convinced they could become extensions of the mind rather than the feet. In 1983 he dropped out of college and started Gnu snowboards, launching an early ad campaign that claimed his boards could "carve," a term that was being thrown around quite a bit at the time. Carving refers to turns that are leaned into, often with a hand dragging to guide the direction. Carving meant freedom, the ability to set an edge and stay there, a poetic thought and a new reality as snowboard design moved forward.

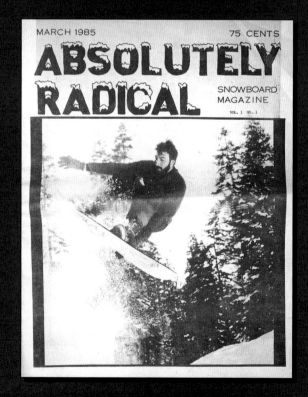

MARCH 1985 75 CENTS

ABSOLUTELY RADICAL

SNOWBOARD MAGAZINE

VOL. 1 NO. 1

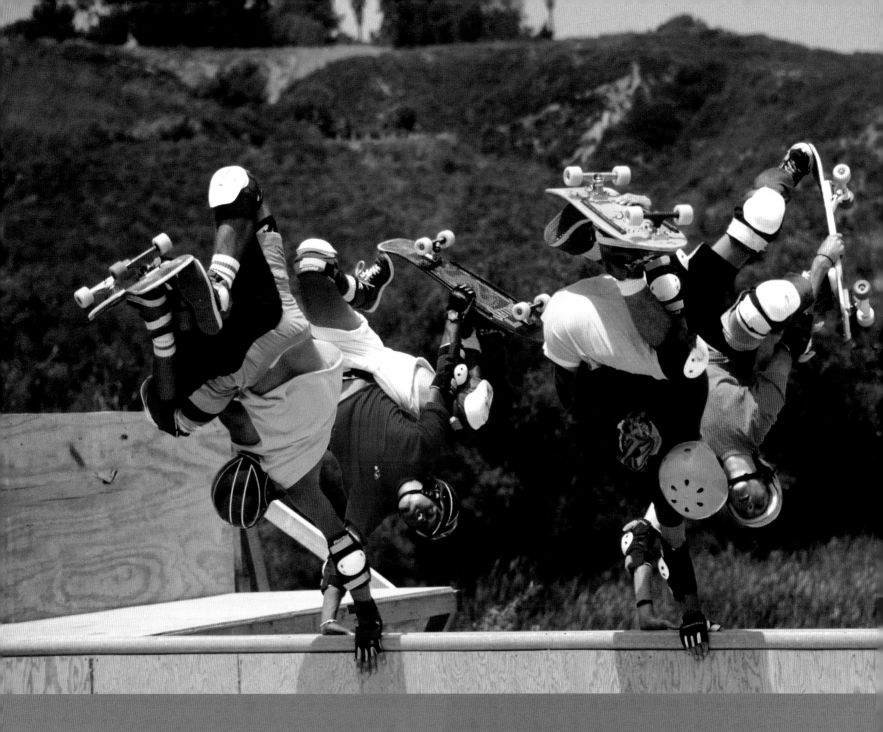

THE BONES BRIGADE

After winning a couple world championships and busting both his wrists, Stacy Peralta decided it was time to graduate into the business end of things. He partnered up with George Powell and proceeded to gather up an absolute dream team of skaters. And then, right about the time of the VCR revolution, Peralta began filming this dream team, known as the Bones Brigade, and distributing his videos on a large scale. The first Bones Brigade video hit the scene in 1984, captivating skaters globally. Suddenly kids could study world-class skateboarding in the comfort of their own homes and use that inspiration to

fuel their own riding. Powell Peralta put out a series of Bones Brigade videos, the most famous being *The Search for Animal Chin*, featuring Steve Caballero, Tommy Guerrero, Mike McGill, Lance Mountain, a young Tony Hawk, and a legendary spine-against-spine double half pipe built by ramp architect Tim Payne. In an era when skateboarding was as big as it had ever been, with thousands of hungry kids clawing for sponsorships, *Animal Chin* came with a message: Enjoy skateboarding for the sake of skateboarding. Focus on the journey and not the destination.

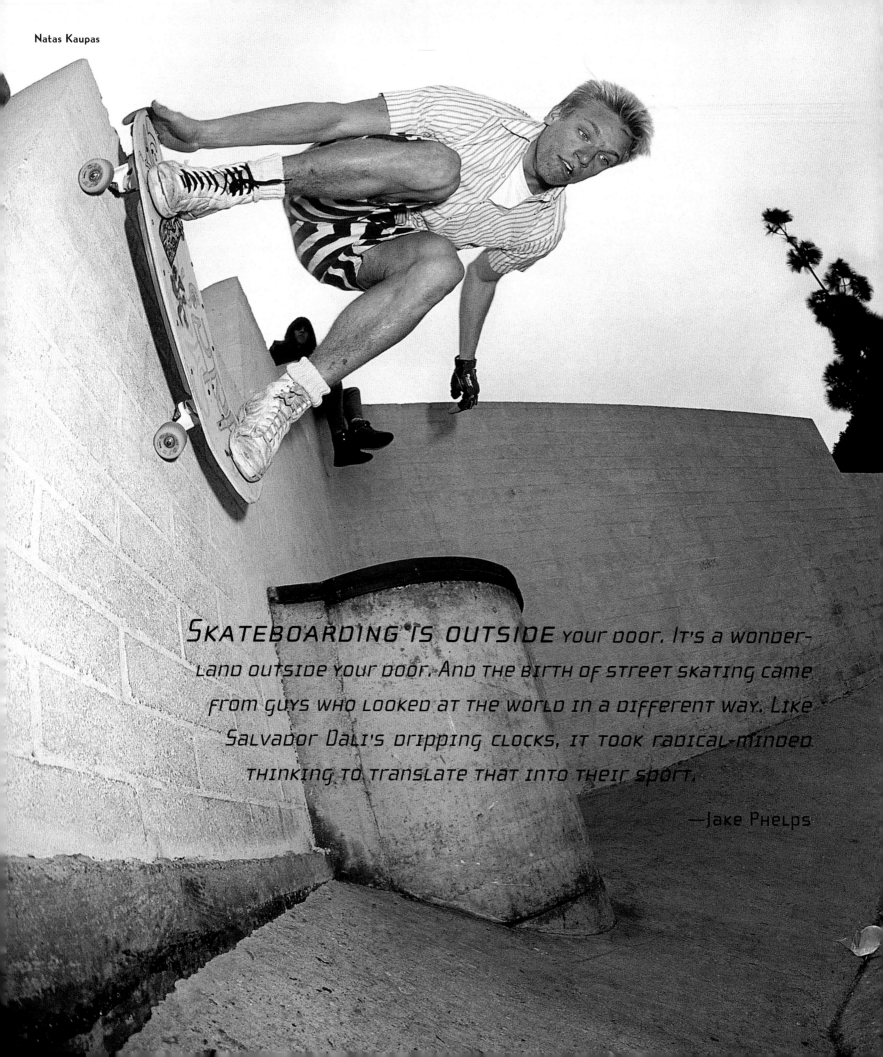

SKATEBOARDING IS OUTSIDE your door. It's a wonderland outside your door. And the birth of street skating came from guys who looked at the world in a different way. Like Salvador Dali's dripping clocks, it took radical-minded thinking to translate that into their sport.

—Jake Phelps

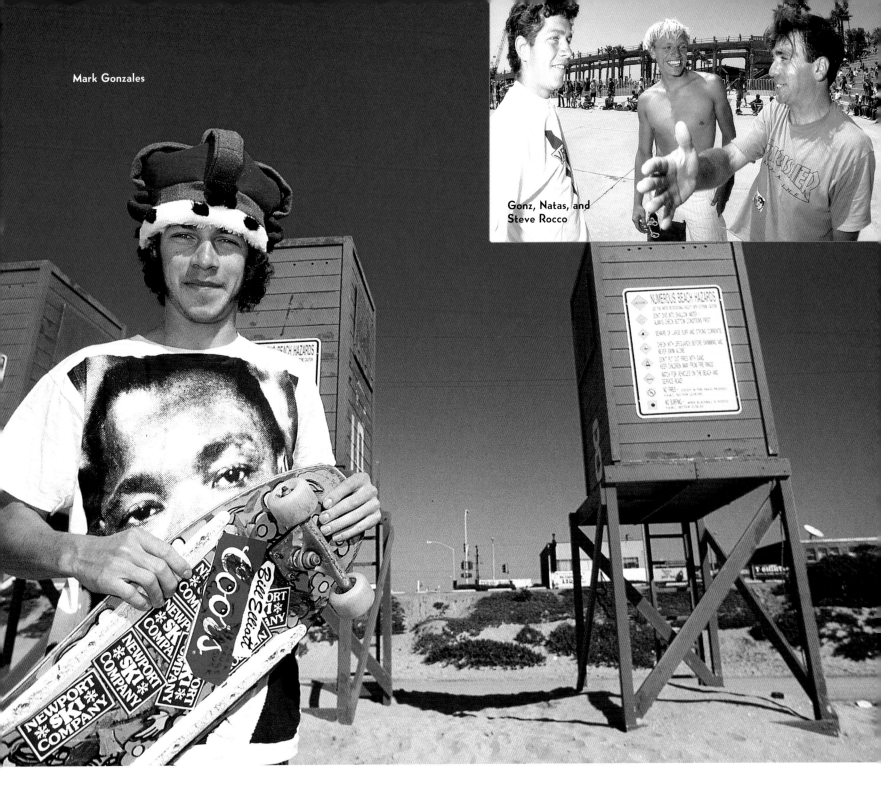

Mark Gonzales

Gonz, Natas, and
Steve Rocco

STREET SKATING

In reaction to parks shutting down, ramps upsetting neighbors, pools being far and few between, cops handing out citations, and whatever else stood in the way of their fun, kids began skating in the street. Terrain moved to walls, benches, ledges, fountains, steps, hand rails, fire hydrants, planters, Dumpsters, curbs, and all else you find strewn about the urban and suburban landscape. It was punk rock translated to four wheels. It was do-it-yourself and democratic. It was a revelation and a revolution. And at the forefront were Natas Kaupas and Mark Gonzales, two creative sorts who showed the world that everything is indeed rideable, it's just a matter of having the imagination to see it. Natas and Gonz were the first to board-slide hand rails, a major part of street skating today.

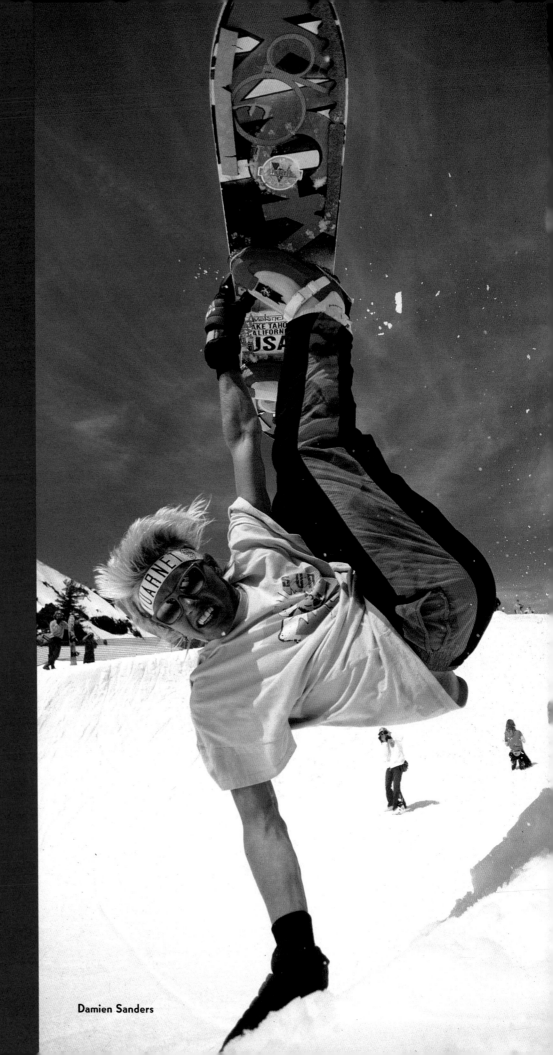

SANDERS AND PALMER

Damien Sanders and Shaun Palmer were snowboarding's biggest superstars in the late eighties/early nineties, helping to shape the sport and culture into what it is today. Both came from Lake Tahoe, both were brash and bursting with confidence, both had the rebellious, punk rock thing going, yet both were distinctly different. Damien Sanders knew how to work the media, earning himself mega magazine coverage, major endorsement deals, and even a spot in a McDonald's commercial. But none of this detracted from his riding skills. Sanders showed up in some of the early snowboarding videos, going heroically apeshit and inspiring kids nationwide. Shaun Palmer, on the other hand, was everything professional athletes are *not* supposed to be. Instead of going to the gym he'd go to the bar. Rather than taking on role model responsibility, he swore and spat and flipped middle fingers at the judges. While his fellow competitors went to bed early on contest nights, Palmer partied till the sun came up, and would go on to win and win and win again. Palmer turned it all upside-down. He led with the heart and not the brain. And consequently, he helped to define the snowboarder archetype in ways every liberally minded rider should be thankful for.

Damien Sanders

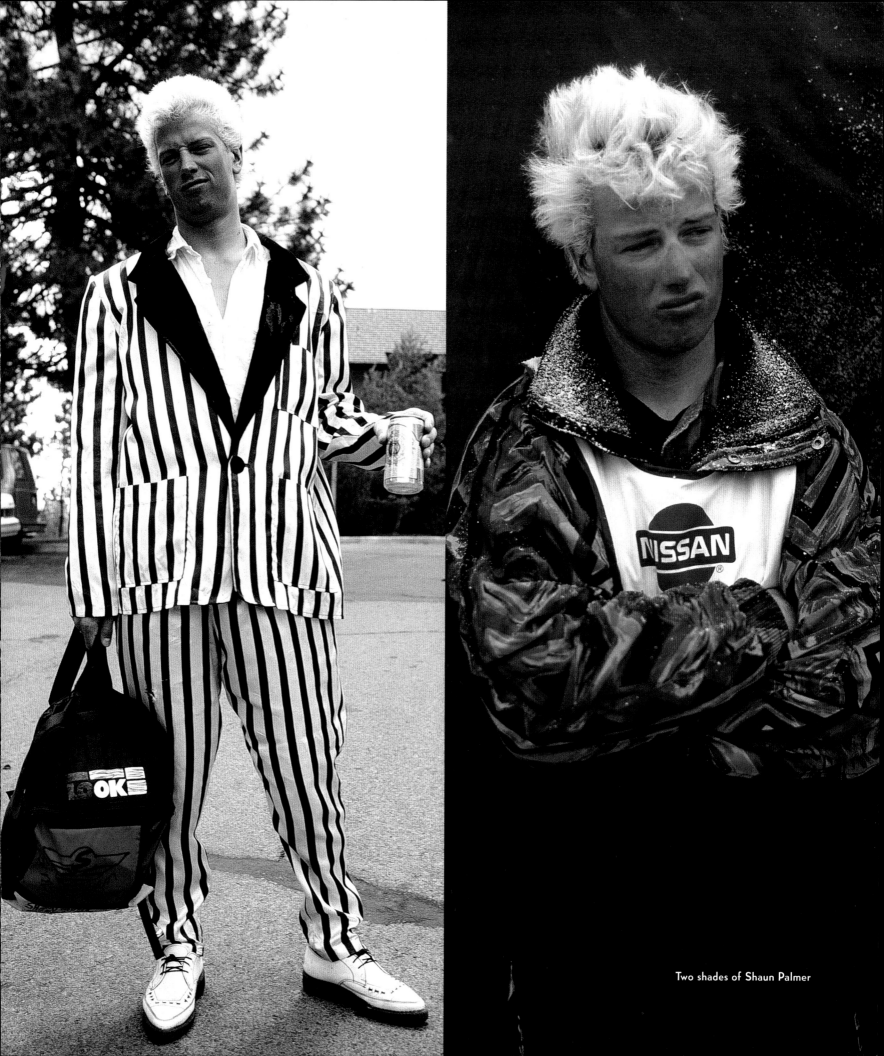

Two shades of Shaun Palmer

THE McTWIST

Mike McGill was in Sweden teaching at a skate camp. He'd been riding the same half pipe for three weeks and had every trick in his repertoire down pat. That's when he started thinking about the 540—a one-and-a-half rotation with a flip in the middle. He knew they were possible. He'd seen roller skaters do them. So one day he put on his hip, elbow, and kneepads, taped up his wrist guards, tightened his helmet, and set about his goal. He knew he had to do them "out," in other words, he had to pull away from the ramp. This way he'd have more time to scramble to his knees if he needed to bail. And after a couple dozen botched attempts, he finally made one. Shortly thereafter, at a vert contest at the Del Mar park, he pulled another one, blowing minds and setting a new standard in the process. Next thing you know, vert riders worldwide were trying the McTwist.

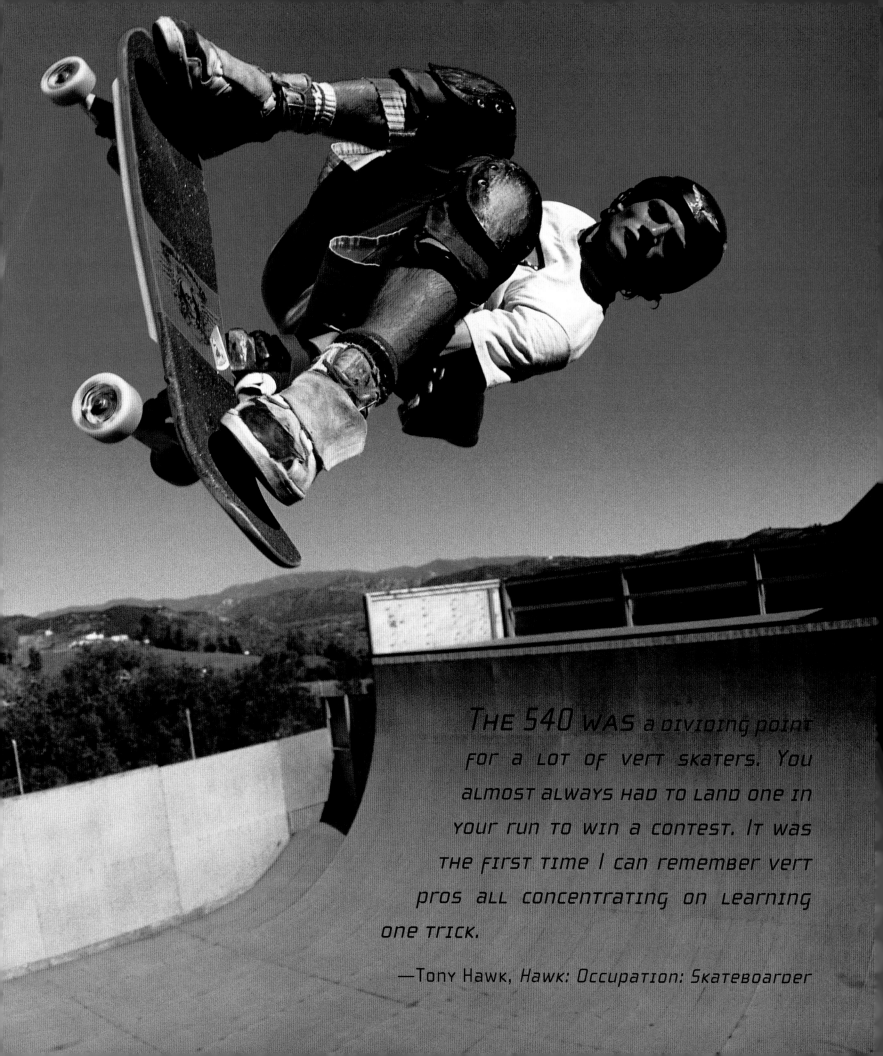

THE 540 WAS a dividing point
for a lot of vert skaters. You
almost always had to land one in
your run to win a contest. It was
the first time I can remember vert
pros all concentrating on learning
one trick.

—Tony Hawk, *Hawk: Occupation: Skateboarder*

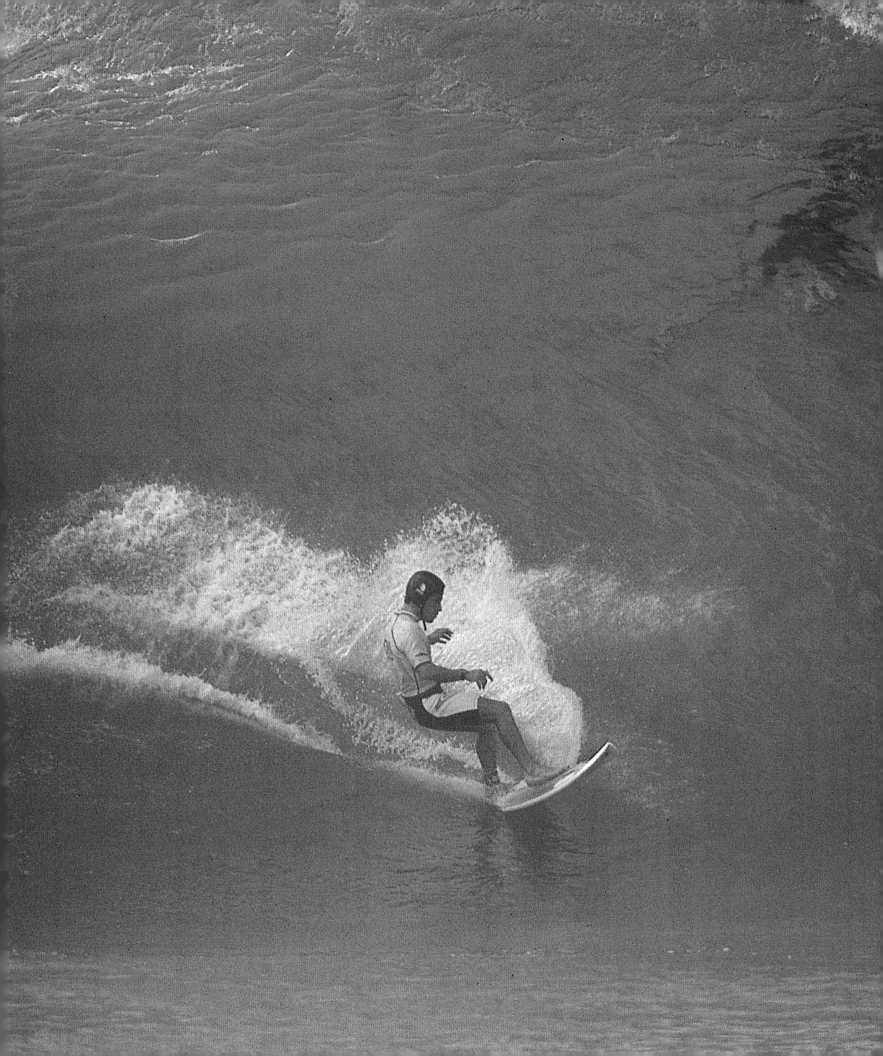

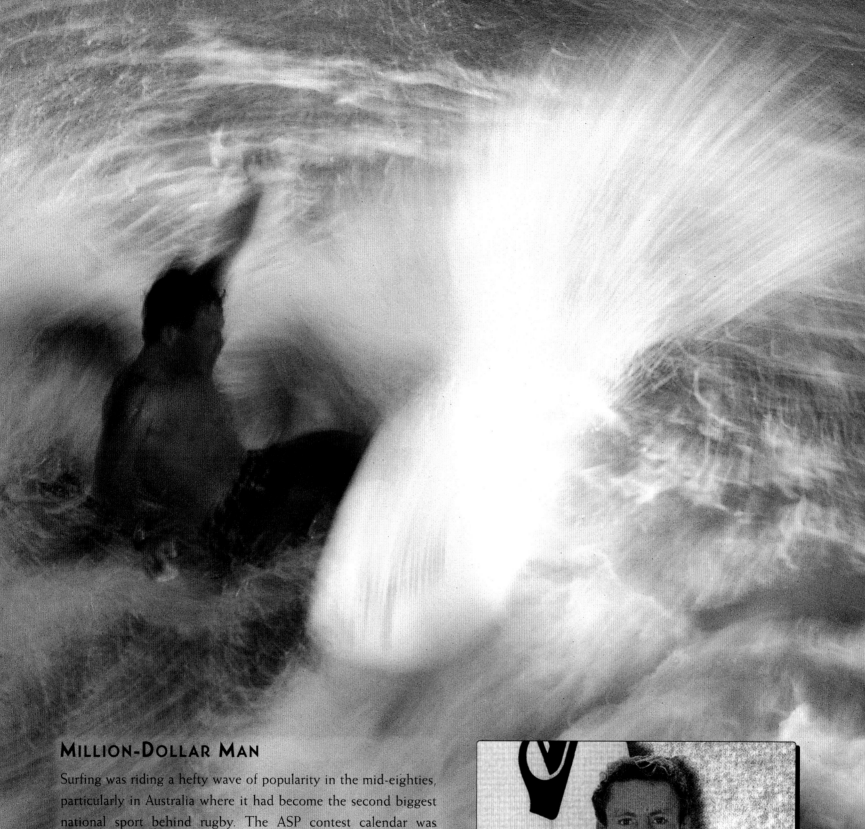

MILLION-DOLLAR MAN

Surfing was riding a hefty wave of popularity in the mid-eighties, particularly in Australia where it had become the second biggest national sport behind rugby. The ASP contest calendar was chocka-block full, with over thirty events per season. Wave-riding approaches were faster, tighter, quicker, more powerful, and more spontaneous than ever before, and surfers were stronger, looser, smarter, more serious, and making more money than ever thought possible. The first million-dollar contract was signed between Quiksilver and Tom Carroll, at the time one of Australia's most popular athletes.

CRAIG KELLY

Hailing from the harsh weather and varied ter-
rain of the Northwest, Craig Kelly has been there
and won that. He burst on the scene at the 1985
Baker Banked Slalom event and continued on
to become a four-time world champ and
snowboarding god. With a swooping, flow-
ing drive that's the dictionary definition of
good style, Kelly kept it close to the
roots, riding for reasons that go far
deeper than money, fame, and first-
place trophies. Where Palmer and
Sanders were much more in your
face, Kelly's relationship with
snowboarding was a more per-
sonal one, and after a long stint
in the limelight, he eventually
bowed out, redirecting his
energy into big-mountain
riding.

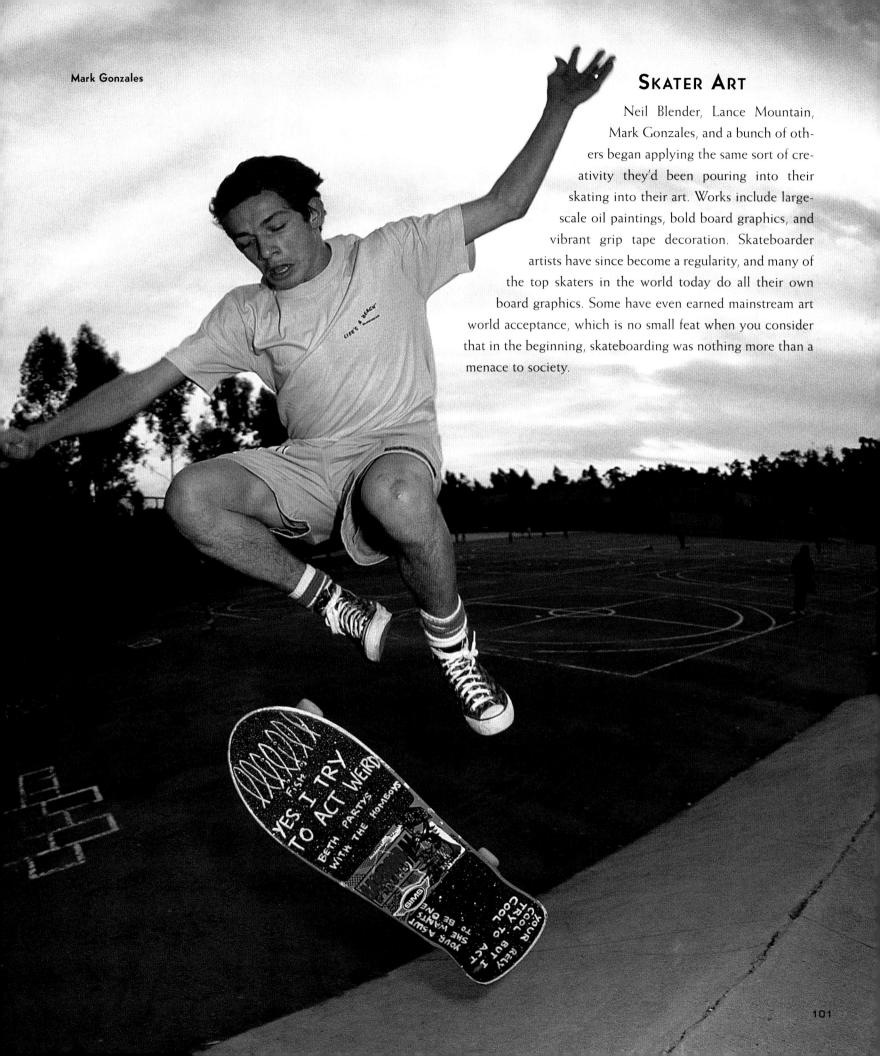

Mark Gonzales

SKATER ART

Neil Blender, Lance Mountain, Mark Gonzales, and a bunch of others began applying the same sort of creativity they'd been pouring into their skating into their art. Works include large-scale oil paintings, bold board graphics, and vibrant grip tape decoration. Skateboarder artists have since become a regularity, and many of the top skaters in the world today do all their own board graphics. Some have even earned mainstream art world acceptance, which is no small feat when you consider that in the beginning, skateboarding was nothing more than a menace to society.

No Contest

In search of new thrills and new ways to make a living out of pro snowboarding, Avalanche team riders Tom Burt, Jim Zellers, and Bonnie Leary bid farewell to contests. They gathered their photographer friends for documentation, ventured out into extreme, back-country terrain, and over the course of the season, proceeded to get more coverage in the magazines than they did when they were competing. Their ballsy foray into the realm of "extreme riding" commanded such respect that they were named "snowboarders of the year" by *International Snowboard* magazine in 1989. It was the beginning of a new pro formula—you didn't have to play the contest game anymore, you could earn your sponsorship dollar through media exposure alone.

Skate Ramps Are a Crime

In Virginia Beach, the city was kind enough to build three public ramps for local skaters to ride. But then they turned around and outlawed backyard skate ramps. Same thing happened in Florida, where Tim Payne built renegade ramps as quick as the city tore them down. Strange, but absolutely true.

Skiing Sidesteps into Snowboarding

As snowboarding became big business throughout the latter half of the eighties, it was pretty much a given that ski companies would eventually want in on the action. And though they were worlds apart on one hand, snowboards and skis did have one very big thing in common—snow. Sure enough, K2, Rossignol, Look, Atomic, Mistral, and Kneissl began producing snowboards, setting off a rainbow of reactions among the tribe. There were purists who resented the growth, opportunists who smelled big bucks, and those in between who realized mainstream intervention meant more snowboard-related career ops, but also more hype, more hoopla, and more riders to clutter the lift lines.

Matt "Ox" Maloley

ALL HAIL POWDER

Much the same way as the tube defines the essence of surfing, powder represents the Holy Grail of snowboarding, the terrain riders aspire to. Powder is virgin snow. No tracks, no man-made blemishes, just pure white, heaven-sent snow that allows for a more carving, surf-style approach than the hardpack, pre-ridden stuff.

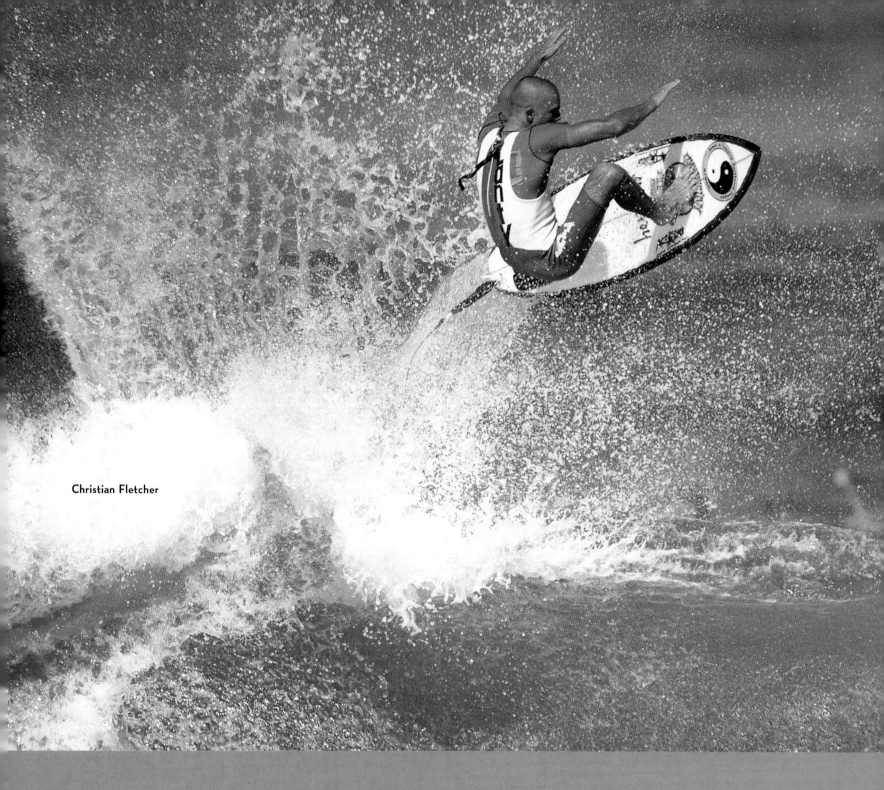

Christian Fletcher

SURFING GOES AIRBORNE

As the eighties wore on, so did the growth of the industry. Surfing became more and more commercialized, crowds grew thicker, and wetsuits got brighter. And with the Thruster becoming standardized and their inherent ability to be dominated, surfing became more and more an extension of the rider's imagination. They had the speed, the maneuverability, and the holding power, and the next thing you know, they were going airborn. Aerials had been happening throughout the late seven-ties/early eighties by the likes of Matt Kechele and Jeff Klugel on the East Coast and Bud Llamas and Kevin Reed on the West Coast, but it wasn't until Californian Christian Fletcher showed up on the cover of *Surfer* magazine boosting a big frontside air in 1988 that the game changed. It was a huge deal, and while most embraced it, others were scared shitless. The old guard couldn't do them and proceeded to discredit them as cheap tricks that lacked integrity.

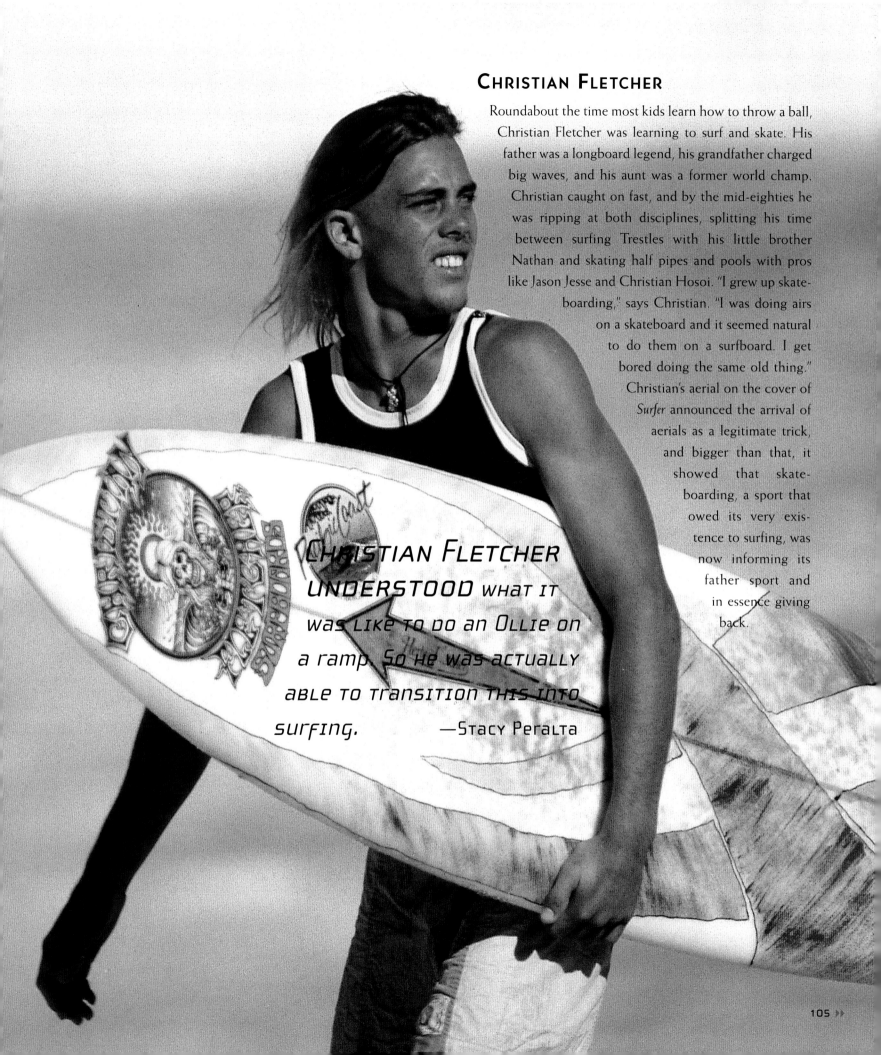

CHRISTIAN FLETCHER

Roundabout the time most kids learn how to throw a ball, Christian Fletcher was learning to surf and skate. His father was a longboard legend, his grandfather charged big waves, and his aunt was a former world champ. Christian caught on fast, and by the mid-eighties he was ripping at both disciplines, splitting his time between surfing Trestles with his little brother Nathan and skating half pipes and pools with pros like Jason Jesse and Christian Hosoi. "I grew up skateboarding," says Christian. "I was doing airs on a skateboard and it seemed natural to do them on a surfboard. I get bored doing the same old thing." Christian's aerial on the cover of *Surfer* announced the arrival of aerials as a legitimate trick, and bigger than that, it showed that skateboarding, a sport that owed its very existence to surfing, was now informing its father sport and in essence giving back.

CHRISTIAN FLETCHER UNDERSTOOD what it was like to do an Ollie on a ramp. So he was actually able to transition this into surfing. —STACY PERALTA

HELIBOARDING

Hailing powder as the be all and end all and "going big" as the name of the game, Burton put out a video called "Winter Waves" in 1987 featuring a spoof scene where a crew of snowboarders hijack a helicopter. Using the chopper to access previously inaccessible mountaintops, the riders then proceed to weave and wind down endless powder, titillating the imaginations of the entire snowboarding community in the process. It was one of the first times "heliboarding" was shown on a mass scale and has since become a rite of passage for advanced riders.

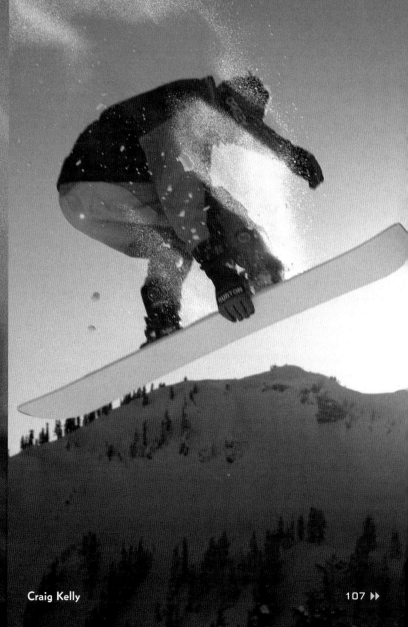

Craig Kelly

POTTZ

Martin Potter burst
on the scene at age fif-
teen, placing second back-to-
back in his first couple of pro
contests. He became an instant
superstar, captivating the world
with his reckless, risk-taking
approach. He moved from
Durban, South Africa, to
Sydney, Australia, in the
mid-eighties and began
focusing on a world title. But
contest surfing is a funny game.
Oftentimes a conservative, consis-
tent approach fares better than a radical one. For a
few years Pottz suffered from this. He'd either win the whole
damn event or drop out early. In 1989, however, he put it all
together. His season was a combination of precision and abandon.
He surfed radically yet never fell off his board. And by the end of
the year he was world champ, ultimately proving that the reckless
approach can indeed pay off.

THE SKATER CEO

In the latter half of the mid-eighties a coup of skaters formed their own
companies, ending the reign of skateboard companies owned by non-
skateboarders. Tony Magnusson and Mike Ternasky started H Street and
Steve Rocco and Rodney Mullen joined forces to start World Industries, in
the process bringing the power back where it belonged—with the skaters.
The whole clean-cut image that had come to represent the mid-eighties
suddenly changed. Skating embraced its upstart, anti-hero personality and
board graphics and ad campaigns became whackier and weirder.

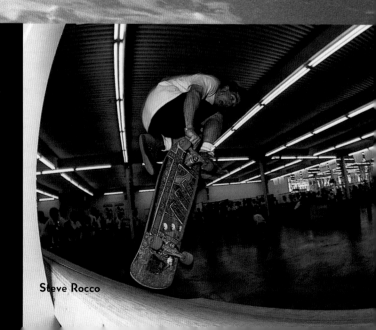

Steve Rocco

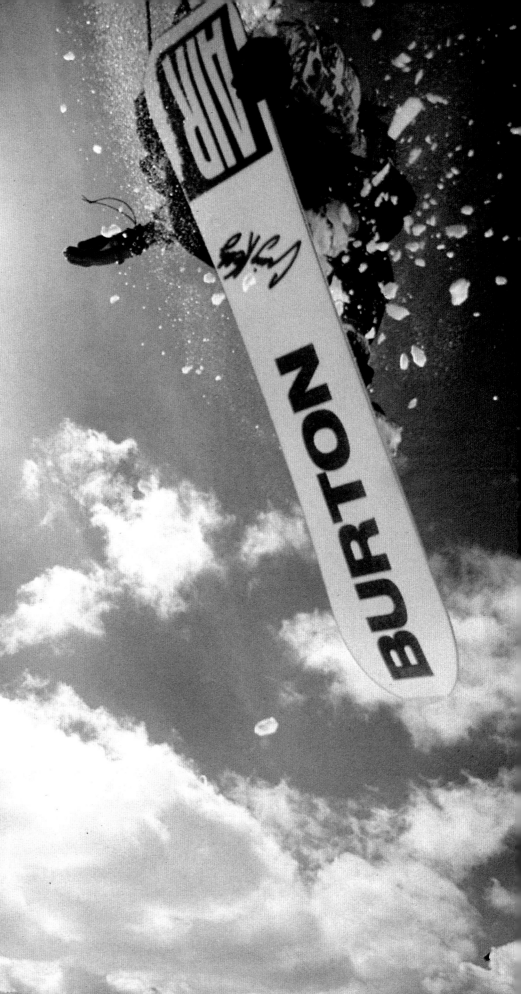

THE END OF THE INNOCENCE

Craig Kelly was a high-profile leader of the sport when he left Sims to ride for Burton (see page 100). At the time there were big bucks on the line and contractual obligations that both "sponsor" and "sponsored athlete" had to fulfill. Still, a certain gentlemanly, we're-all-in-this-together spirit prevailed. Until Sims's distributor Vision hit Kelly with a widely publicized lawsuit that effectively changed everything. "All of a sudden people looked at riders as commodity," remembers *Snowboarder* editor Pat Bridges, "and sales became a driving force in a lot of people's lives." The industry turned to hardball from that point onward. But something good managed to come out of the whole deal. The Craig Kelly Air (the first board Kelly designed when he hooked up with Burton) used refined design techniques that were way ahead of the pack. "That board made everybody who stepped on it twice as good of a snowboarder as they were before," recalls Bridges.

Matt Cummins

STREET SKATING IS KING

By the end of the decade street skating had become more popular than vert. Boards were smaller and lighter than they'd ever been and bottoms were slick for easy sliding. Street moves influenced vert riding, and guys like Danny Way, Alfonzo Rawls, Tony Hawk, and Colin McKay brought flippy, freestyle tricks to half pipes. Riding switch became popular, meaning goofy foots going regular and vice versa. Videos became the vehicle for progress, inspiring kids around the world.

HERE A JIB, THERE A JIB, EVERYWHERE A JIB, JIB

According to pro snowboarder Todd Richards, Breckenridge riders like Andy Hetzel, Brett Johnson, Nick Perata, Zach Bingham, and Shawn Farmer began bouncing off logs and tree stumps in 1988. Early jibbing was all about utilizing terrain that was never meant to be terrain. Riders bailed out on the designated runs and did essentially what street skaters were doing—redefining what's rideable and what's not. Stuff like stumps, rocks, logs, and hand rails were pounced upon, board-slid, and ultimately incorporated into the language of snowboarding. And just as Tony Alva's aerial separated skateboarding from surfing in 1977 (see page 46), jibbing plucked snowboarding from any kind of ski connection and placed it squarely in the family of street skating.

WHEN I SAW IT FOR THE FIRST TIME, JIBBING WAS IN ITS INFANT STAGE. IF YOU COULD OLLIE UP ONTO A LOG AND SLIDE ACROSS IT FOR MORE THAN FIVE FEET WITHOUT CATCHING AN EDGE AND KNOCKING YOUR TEETH OUT, YOU WERE RIPPING. RIDERS BEGAN TO JUMP OFF OF ANYTHING AND EVERYTHING, AND RESORTS BEGAN TO THINK TWICE ABOUT WHERE THEY PUT THEIR PICNIC TABLES. LANDINGS WERE PURELY INCIDENTAL. WHAT HAPPENED IN THE AIR WAS MOST IMPORTANT.
—TODD RICHARDS, *P3: MY ADVENTURES IN THE PIPES, PARKS, AND POWDER*

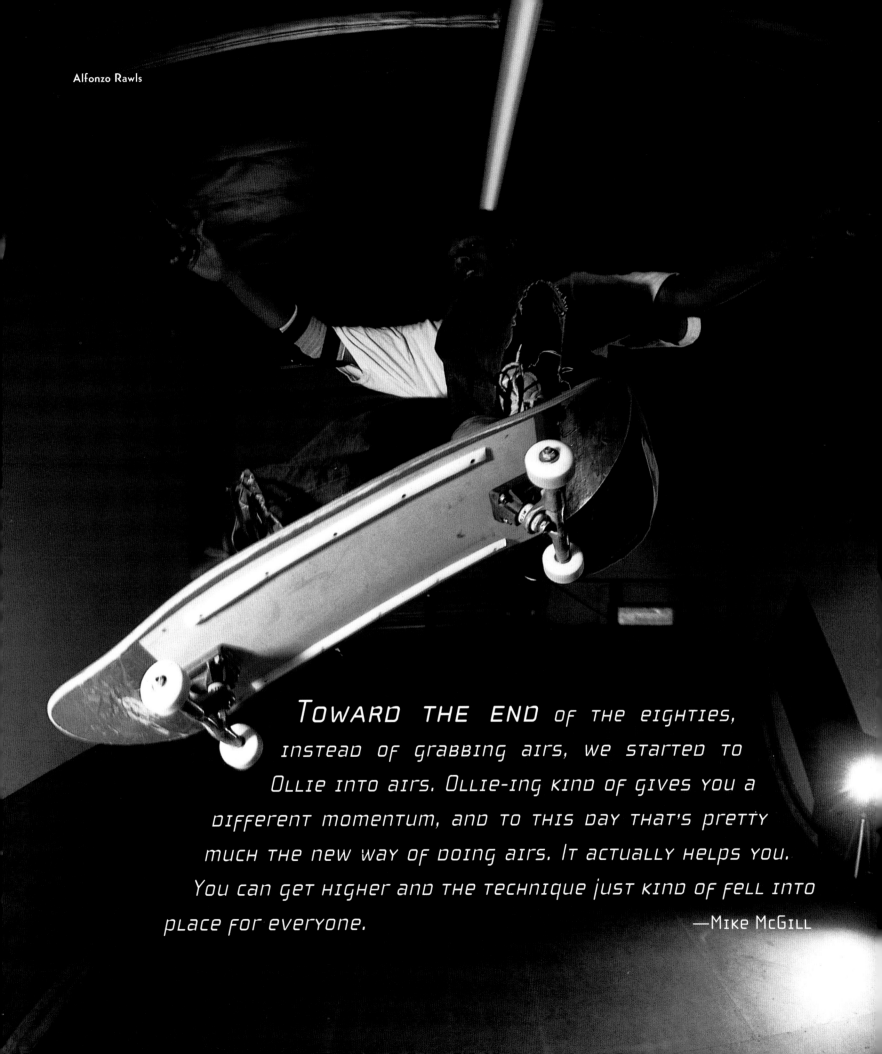

Alfonzo Rawls

TOWARD THE END of the eighties, instead of grabbing airs, we started to Ollie into airs. Ollie-ing kind of gives you a different momentum, and to this day that's pretty much the new way of doing airs. It actually helps you. You can get higher and the technique just kind of fell into place for everyone.

—Mike McGill

1990s

BIG CLOTHES, SMALL WHEELS

Skateboarding rolled into the nineties with a huge emphasis on street. Wheels went small, boards went smaller, and clothing went XXXL, with kids looking more like gangbangers than skateboarders. The low-volume equipment brought everything closer to the ground, and riders learned how to manipulate their boards, turning them into twirling, flipping Ollie-slaves that danced at the tips of their toes.

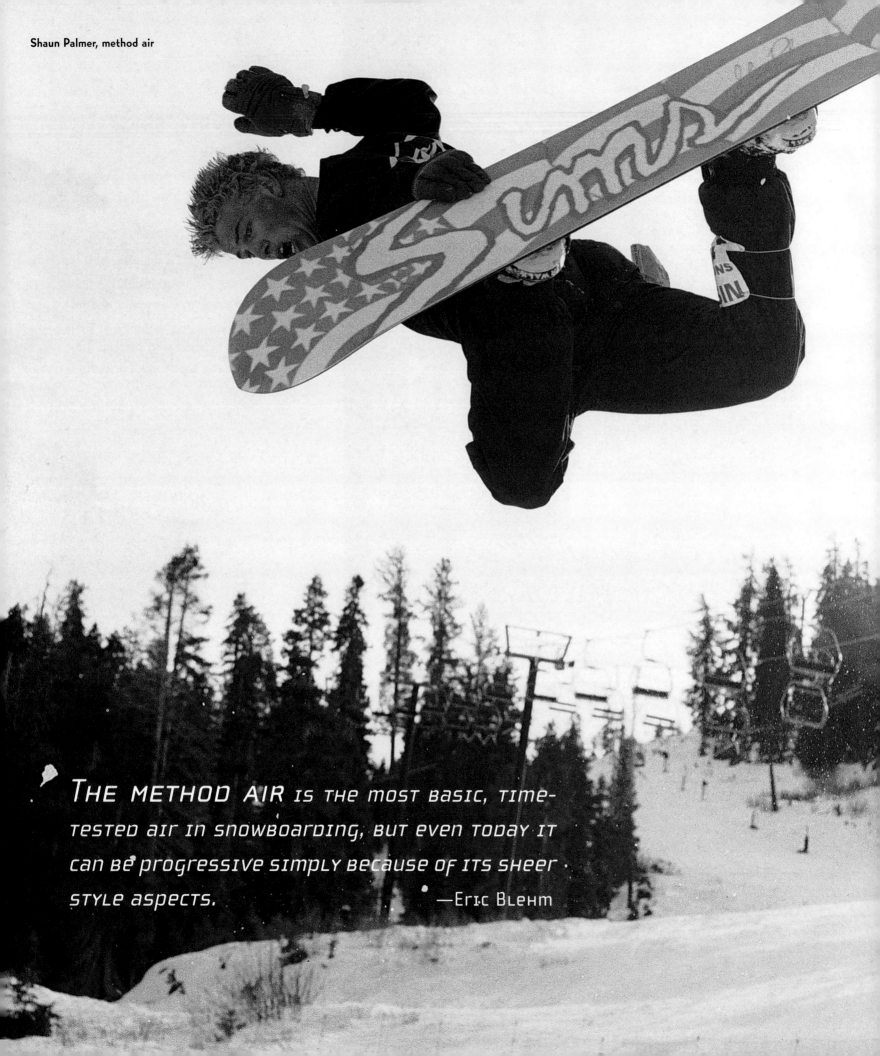

Shaun Palmer, method air

THE METHOD AIR IS THE MOST BASIC, TIME-tested air in snowboarding, but even today it can be progressive simply because of its sheer style aspects.
—Eric Blehm

METHOD AIRS

Method airs are big backside airs—nothing too tech, no flips or spins, just poetry taken to snowless heights. One of those moves that showcases a rider's style and personality above all else. Methods were a big part of Terry Kidwell's pioneering act, and then Shaun Palmer raised them to perfection during his late eighties/early nineties reign of madness. Craig Kelly turned them into his inkless signature and Jamie Lynn's methods have been known to resemble an arcing eagle in flight.

THE JIB GENERATION

The second wave of punk rock cropped up in the early nineties and infiltrated the snowboard culture, bringing a hardcore, baggy-ass-pants edge to it. Riders adapted the new school–street skating style to the slopes and pissed off the skiers like never before. Not only did the jib style defy the social correctness of skiing, but they were doing things skiers couldn't do. Snowboarding was going in a more high-tech direction, and once again like skateboarding, boards were getting smaller, bindings were going lowback, and boots were looking more like high-top sneakers. To meld snow and skate all the more, skateboard companies started making snowboards, earning instant acceptance.

CURREN RISES, THE INDUSTRY FALLS

In 1990, after a short hiatus from the contest scene and consequently a loss of his top-sixteen seed spot, Tom Curren made history by surfing through the trials all the way to his third world title. It was a mega comeback that should have boosted the sport. Unfortunately, it came during a bad time in the national economy. Mainstream interest waned, taking the surf industry's financial figures down with it. Many previously thriving surf brands were forced to scale back, and a few disappeared from the scene altogether. The boom days were over, or at least on hold. Tom Curren's movements during this time were beautiful: If the commercialized surfing world is nosediving, then why not go back to the roots? First he rode a stickerless board in a major pro event, making a huge statement about the "selling your soul" aspects of pro surfing. Then he went searching. Equipped with a quiver of archaic guns, fishes, and logs, Curren ventured out in search of the perfect wave, roaming to far corners of the globe, looking inward and looking backward. His journeys were captured on video, eventually inspiring a huge renaissance of board experimentation.

Schlingmann

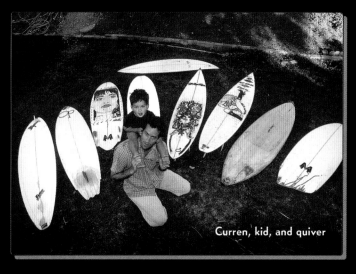
Curren, kid, and quiver

SLATER SAVES THE DAY

Sales figures were down, magazines were thin, there were no surf articles showing up in *Sports Illustrated* or any other mainstream publication for that matter, and then all of a sudden Kelly Slater came into the picture, sparking interest globally. Slater was handsome, articulate, and talented beyond belief. His ascent to number one happened almost immediately, and with his first world title in 1992 and the media interest that followed, there was the distinct possibility that surfing would be catapulted back to its once sailing state. When he appeared in a season's worth of *Baywatch*, TV's most popular show of the time, things got really interesting. And then when he became romantically linked with Pamela Anderson, America's most famous blond bombshell, surfing and Slater rose to superstar status.

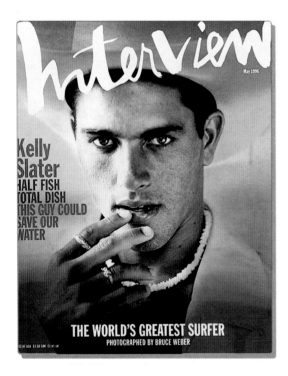

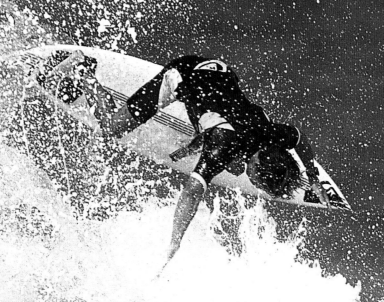

MUCH TO THE
DISAPPOINTMENT and
the shame of all the people
that had been supporting the
ASP, Kelly Slater being on
Baywatch, and subsequently
meeting and dating Pamela
Anderson, brought pro surf-
ing more into the limelight
than any contest at J-Bay or
perfect Teahupoo or Tavarua.

—Sam George, *Surfer* magazine

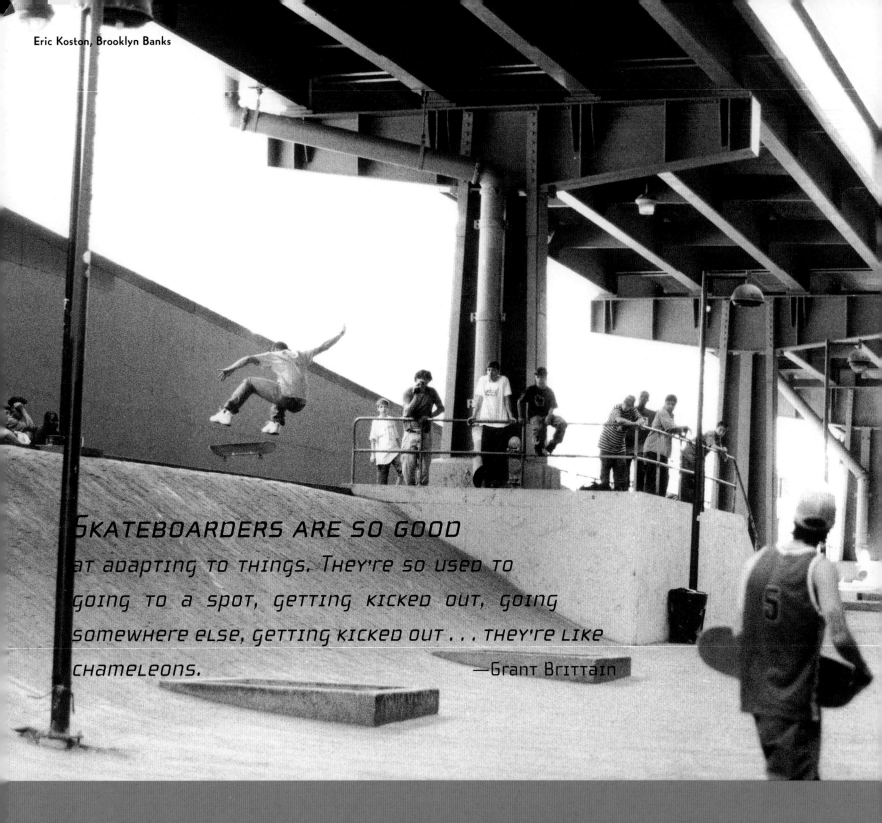

Eric Koston, Brooklyn Banks

SKATEBOARDERS ARE SO GOOD at adapting to things. They're so used to going to a spot, getting kicked out, going somewhere else, getting kicked out... they're like chameleons.
—Grant Brittain

SCENES

As street skating exploded throughout the country, so did skate scenes centered around specific venues, most famously Embarcadero. Located along the wharf of San Francisco Bay, EMB became a spawning ground for some of the best street skating of the time. Skaters from all over the country would gather in droves and push each other, lifting the bar higher and higher with every move. More scenes popped up, with Love Park in Philadelphia and the Brooklyn Banks in New York City as major venues. These were places where urban kids could skate, shoot the shit, and stretch the boundaries. But not without interruption. These were also places where skateboarding was not allowed and cops would sporadically show up and ruin the day.

Valdez, Alaska

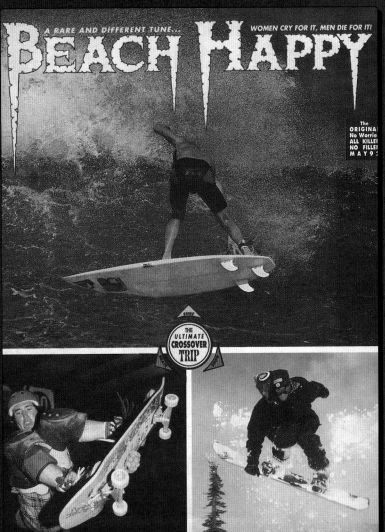

ALASKA

Nick Perada and Shawn Farmer ventured up to Alaska in the early nineties on the quest for insane terrain, which they found—bigtime. It was pow pow for miles, the kind of white dream that had filled snowboarding's collective unconsciousness since the beginning. Everything in Alaska was of a grander scale, and along with big mountains they found big men. Locals like Ritchie Fowler and Jay Liska had been shooting guns, fishing salmon, knocking back whiskey, and riding big boards up there for a long time, and when the new kids rolled into town they befriended them, showing them the ropes and turning them on to hot spots. Alaska was happening, and since then it's become a destination of choice, the place to go if your dreams, board, wallet, and balls are big enough.

THE BOARDRIDING CULTURE

It began with *Warp* magazine, an idea brewed up by the insightful folks responsible for *Transworld Skateboarding* and *Snowboarding*. *Warp* was the first ever surf/skate/snow glossy, and it helped kick the "boardriding culture" into motion, giving equal attention and relevance to all three sports. More surf/skate/snow mags and 'zines followed, along with competitions that pooled together surfers, skaters, and snowboarders participating in all three disciplines. It was the beginning of a renaissance period that encouraged crossing over. No longer was it enough to do just one boardsport—you had to do at least two and ideally all three.

The Flowering of Women

Women's surfing has had its moments of glory and its moments of being swept under the rug. Back a couple centuries you'd have actual queens riding waves with regal grace and royal poise. Australia's first surfer was a woman—fifteen-year-old Isabel Letham rode atop the shoulders of the Duke back in 1914. Throughout the sixties and seventies women's divisions were added into contests, and for a time the Women's International Surfing Association (WISA) was up and flourishing, running independent of the men's events. But through the eighties interest was minimal. The women's heats at pro events were treated like intermissions; crowds would virtually clear the beach then regroup later for the men's heats. But all this changed drastically when a teenage runaway named Lisa Andersen came on the scene in the early nineties. Lisa had a dream. And she had to head west to make it come true. She moved from Florida to California, climbed the amateur ranks, went pro, fought like a banshee, and won her first of four world titles in 1994, single-handedly raising the profile of women's surfing about twenty notches upward and giving it a facelift in the process. Andersen surfed like a guy. And to drive the point home even more, she wore shorts, not bikinis. The combination of her boundless talent, good looks, and cute surfing attire made her an instant icon. Women's surfing was suddenly huge.

The women's surf movement was basically invented by Roxy, which is sort of ironic in that they started out with the cult of celebrity and quickly shifted into marketing the lifestyle. You know, twenty-five almost thirty years of surfwear marketing was focused on endorsement-based marketing and suddenly Roxy broke that mold and created an image that inspired women to surf.

—Sam George, *Surfer* magazine

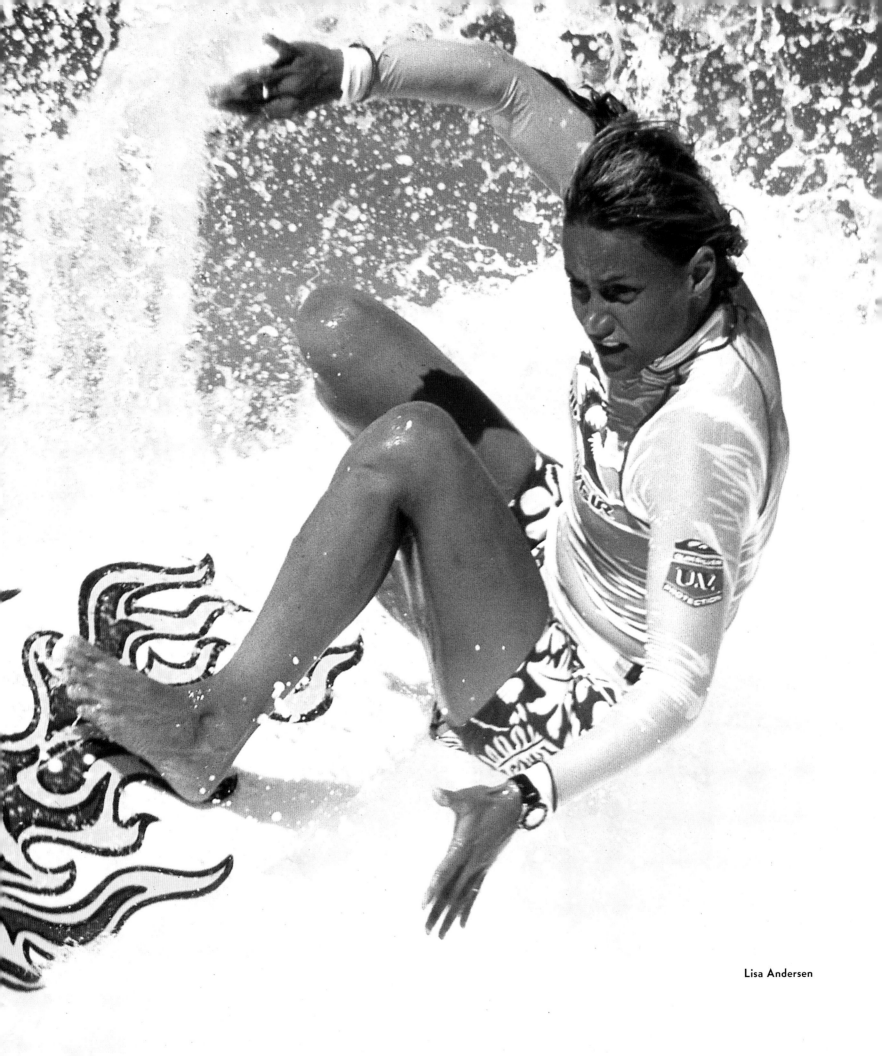

Lisa Andersen

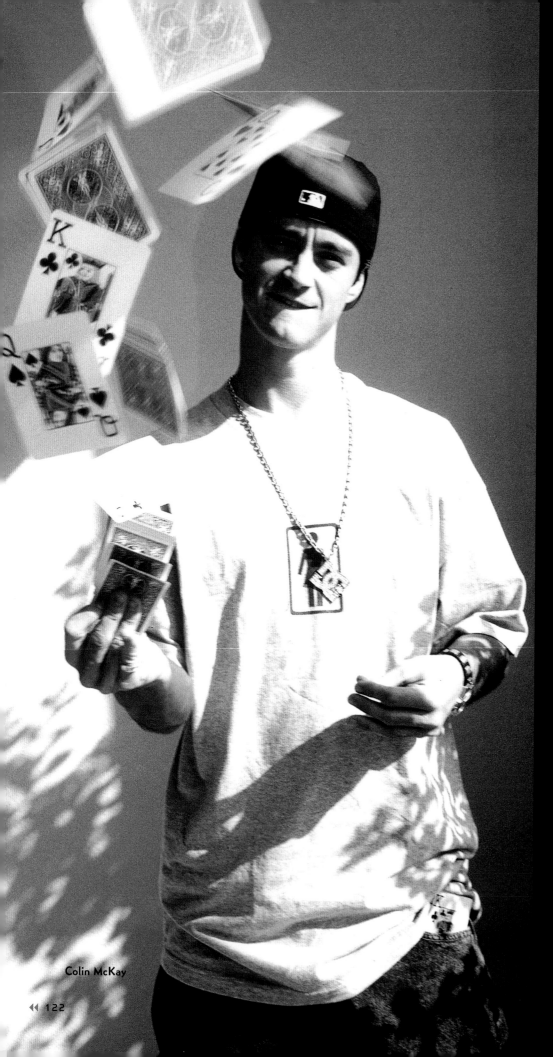

Colin McKay

BIG BROTHER AND BLUNT

Take the irreverence of *Thrasher* magazine, multiply it times ten, pepper in some inner-industry dispute, toss in the Bong Olympics, boost the "How to Build a Ramp" section into "How to Kill Yourself," drizzle on some pseudoporn, and you get the gist of *Big Brother*, undoubtedly the most scatological skate mag of all time. Started in 1992 by Steve Rocco, *BB* shook up the system and scared concerned parents in a big way. It was skateboarding in X-rated form. Dickhouse Publications started a snow mag as well. *Blunt* presented snowboarding as rough and raw as *BB* presented skateboarding. In 1997, the two titles were picked up by Larry Flint Publications, the folks who bring you *Hustler*, and sex and skateboarding and snowboarding all shared the same factory.

SKATE VID REVOLUTION

Skate videos circulated about the world and pro skaters busted their balls to put on the best show they possibly could. Plan B released *Questionable* and *Virtual Reality*, with guys like Colin McKay, Danny Way, Ryan Fabry, Sal Barbier, Matt Hensley, and Rick Howard rewriting the record books. Blind put out *Video Days*, with the Gonz going completely gonzo. Unlike surfing, where contest rankings play a big part in determining an athlete's worth, skateboarding became more and more about video parts. In fact, some pro skaters, Chad Muska being a classic example, don't even compete. But they show up in vids going ballistic and that's enough to keep the money rolling in.

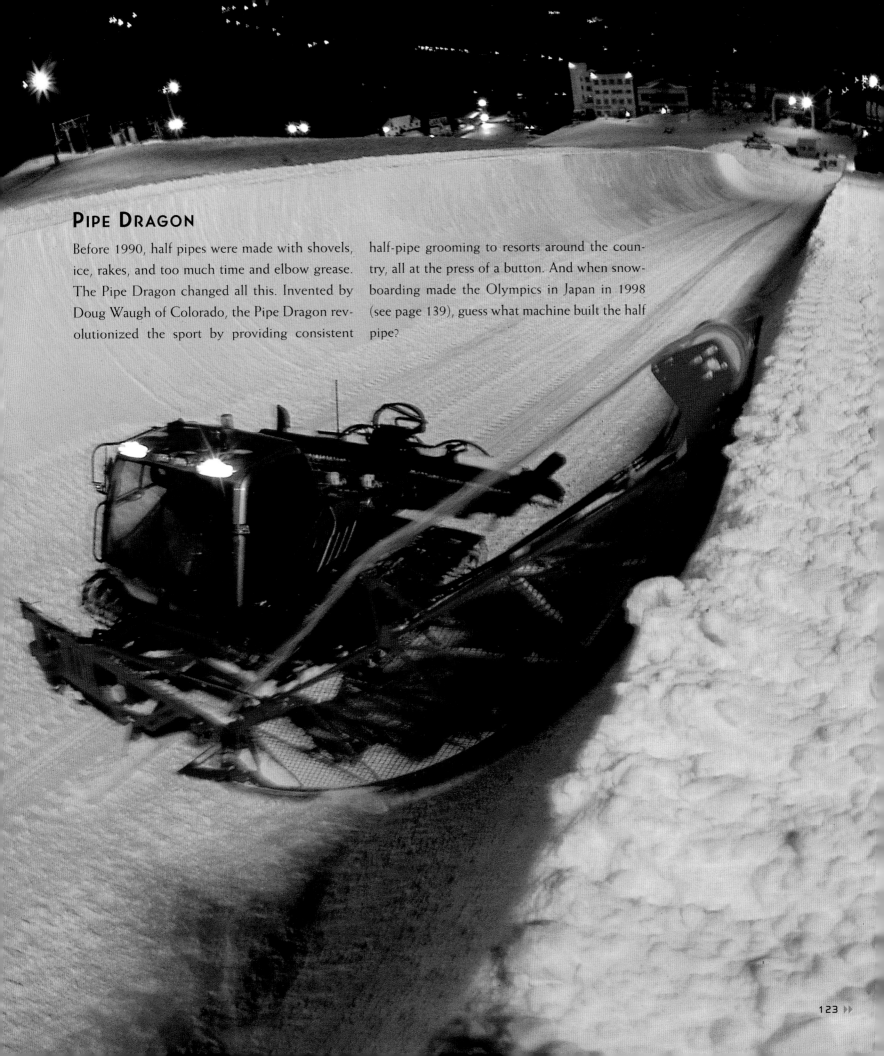

PIPE DRAGON

Before 1990, half pipes were made with shovels, ice, rakes, and too much time and elbow grease. The Pipe Dragon changed all this. Invented by Doug Waugh of Colorado, the Pipe Dragon revolutionized the sport by providing consistent half-pipe grooming to resorts around the country, all at the press of a button. And when snowboarding made the Olympics in Japan in 1998 (see page 139), guess what machine built the half pipe?

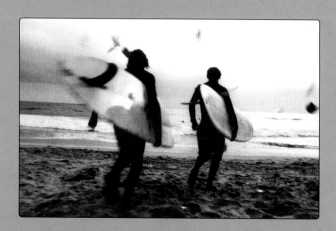

LONGBOARDING RESURFACES

Longboarding had a huge resurgence in the early nineties that still exists today. But it was about more than just riding longer boards, it was about surfing for fun. As much as the Slater generation pushed high performance wave-riding to new heights, the longboard movement resurrected the idea of surfing as sheer recreation. Surfing became a family affair, with moms and pops and grandparents and grandkids cluttering lineups from San Onofre to Santa Cruz.

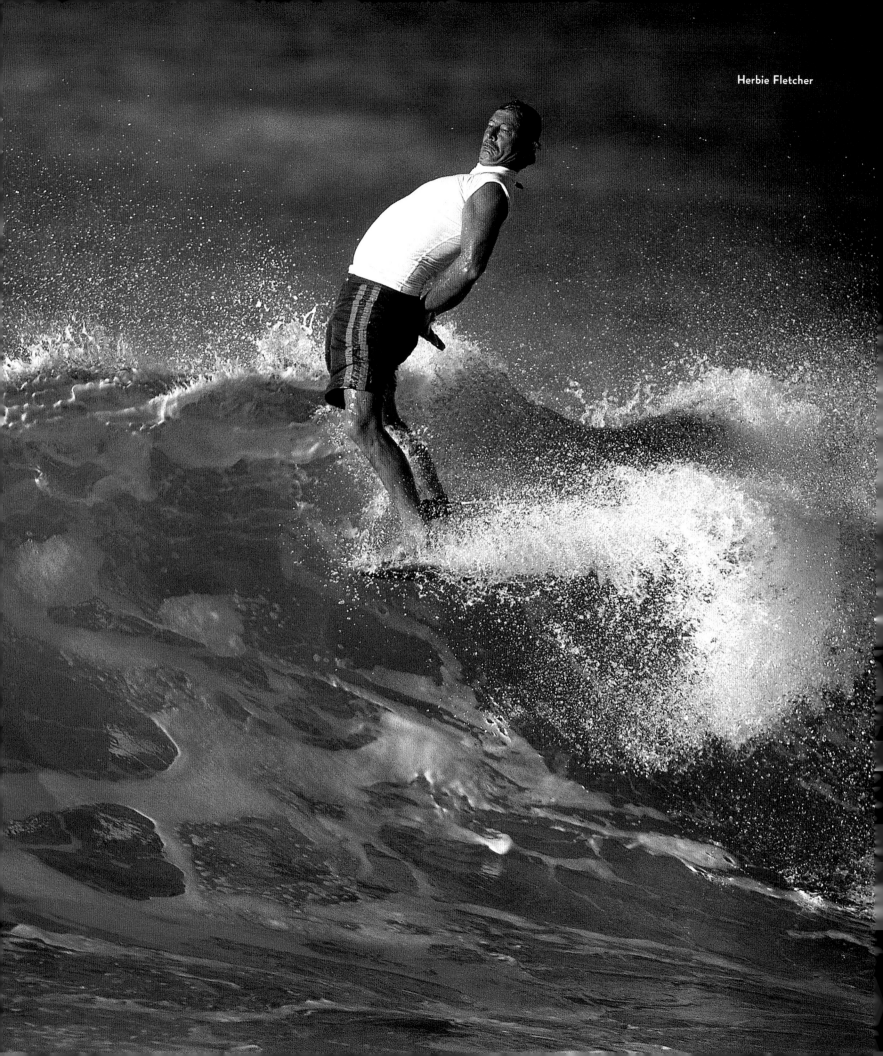

Herbie Fletcher

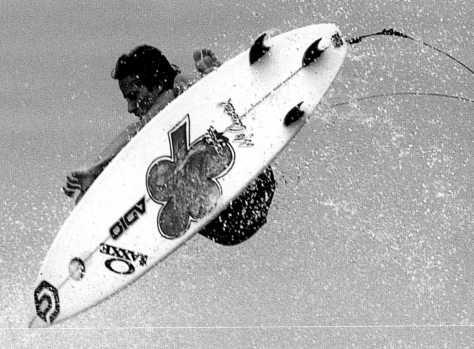

Tim Curran

NEW SCHOOL

Reverses arrived on the scene in the early nineties and ultimately drew a line in the sand—if you could do them you were new school; if you couldn't, you were yesterday's dropout. Reverses are hard, snappy off-the-tops into backyard slides where the nose spins around fluidly, making the entire motion a 540-degree turn. In other words, highly technical, entirely fresh, and very much skate inspired. Reverses showed up in the Taylor Steele vids (a series of flicks showing the hottest, latest, most futuristic surfing of the early nineties) with guys like Kelly Slater, Rob Machado, Ross Williams, Tim Curran, Shane Beschen, and Shane Dorian doing them effortlessly. They spun a new approach into motion that included air moves and all kinds of backward, slidy tech stuff that required light-footedness and quick weights and unweights. They also inspired a new direction in design—boards went into a thin and narrow phase where volume decreased considerably.

THE SCANNERS

Since snowboarding's inception, Europe has churned out red-hot rider after red-hot rider, but never in a more concentrated punch than when the Scanners arrived on the scene in the mid-nineties. With Terje Haakonsen at the helm, Scandinavian kids like Oskar Norberg, Sebu Kuhlberg, Aleksi Vanninen, Daniel Franck, and Ingemar Backman put the proverbial flame under the ass of American freestyle riding, in turn pushing performance levels to new and improved heights.

LIVE AND LET RIDE

Despite its undeniable legitimacy, there were still resorts in the mid-nineties that banned snowboarding, and *Transworld Snow* editor Eric Blehm was one of many who weren't particularly pleased with this. So he transformed himself into the Chameleon." Wielding a specially-built snowboard that could split vertically, Blehm would pose as a skier from the parking lot to the top of the mountain, but coming down the runs he was 100 percent snowboarder. His experiences were published in a series of articles. "The Chameleon proved what we already knew anyway," says Blehm, "that skiers and snowboarders *can* coexist in the same realm."

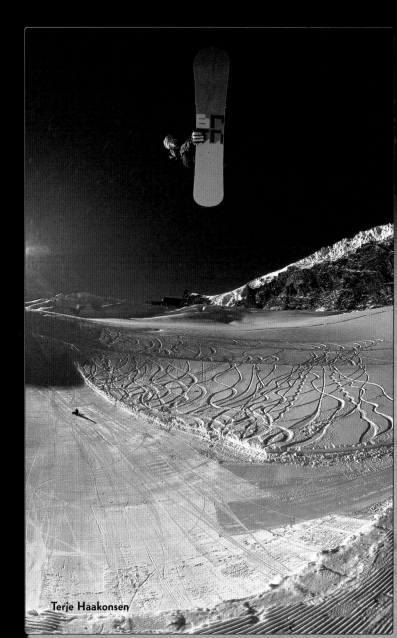

Terje Haakonsen

BOB BURNQUIST

Bob Burnquist showed up on the scene in the mid-nineties, prodigiously talented and hungry as hell. Hailing from São Paulo, Brazil, Burnquist's arrival was a wake-up call. He let America know that the entire world had indeed arrived; that the best skaters were not just coming from the States anymore, but from all around the globe. Burnquist won the Slam City Jam in 1995 with a flawless "switch" act. "Switch" means going opposite to your usual stance. In other words, if you're goofy foot, switch would mean riding regular foot, and vice versa. Burnquist was so ambidextrous you could hardly tell whether he was goofy or regular. His light-footed and balletic style was mind-boggling, and his impact on vert skating today is enormous.

BURNSIDE

Under a bridge in Portland, Oregon, Mark "Red" Scott and Mark "Monk" Hubbard took it upon themselves to build a skate park with their bare hands. Using leftover concrete from their construction jobs, they laid a few banks and waited for the authorities to come cracking down. But the city backed it (!), allowing them to create a skateboarding wonderland on public property. Burnside has brought on more work for Monk and Red (Lincoln City, Newberg, Orcas), and their parks have evolved into architectural marvels, looking more like concrete rollercoasters than what skate parks looked like in the late seventies.

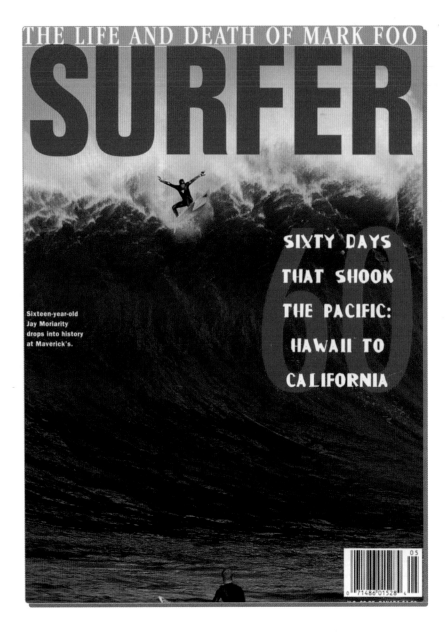

THE LIFE AND DEATH OF MARK FOO

SURFER

Sixteen-year-old Jay Moriarty drops into history at Maverick's.

SIXTY DAYS THAT SHOOK THE PACIFIC: HAWAII TO CALIFORNIA

MAVERICK'S

Once upon a time in the 1970s, during a massive, cold winter swell, a brave soul by the name of Jeff Clark looked out to sea and saw rideable waves where the rest of his surfing pals saw only fear. The spot's called Maverick's, and it's located in Pillar Point near San Francisco. The waves break about a quarter mile from shore—generally in the fifteen- to thirty-foot range. The water is icy, there are big rocks, and sharks are known to frequent the place.

So Clark paddles out by himself and proceeds to surf, proving to himself and only himself that Maverick's was one of the best big-wave spots on the planet. Clark continues to surf there, solo, for about fifteen years, until one day he gets lonely. In 1990, he drags a few Santa Cruz hellmen out there and the rest

is history. Maverick's quickly becomes a huge media spectacle. It was man vs. nature at its very finest. It was balls and blood and fear and potentially fatal. And predictably enough, it became home to the most famous wipeout of all time. Sixteen-year-old pizza delivery boy Jay Moriarty paddled into an offshore peak on December 19, 1994. The wave bounced. Actually, it kind of heaved. It was like a giant, oceanic sneeze. And as the momentum shot forward, so did Moriarty, arms spread, board blown back, a surfing Christ on a Pacific Ocean cross if there ever was one. The whole fiasco landed on the cover of *Surfer* magazine, and Moriarty became instantly famous. Somehow he emerged from it all unscathed, but tragically lost his life at sea in 2001 while free-diving in the Maldives.

Bob Burnquist

15

10

WHO ARE THEY

THESE MEN WHO RIDE BIG WAVES

A SPECIAL BREED, I SAY

WHO WAIT PATIENTLY FOR THAT DAY

SOME WAIT FOR YEARS

FOR THOSE SPECIAL TIMES

WHEN HUGE WAVES

BREAK ACROSS THE BAY

WHY WAIT SO LONG, SOME MAY SAY

THESE SURFERS ANSWER IN THIS WAY

LIFE IS LIVED, EVERY SINGLE DAY

WITH EACH NEW BEGINNING

A NEW STORM, A NEW SET OF WAVES

BEING PATIENT IS A PART OF OUR GAME

EACH BIG WAVE

A SPECIAL GIFT THEY SAY

A TIME WORTH WAITING

A BIG WAVE WHEN RIDDEN, NEVER FORGOTTEN

A LIFETIME MEMORY

WAVES IN ENDLESS MOTION

PLAYFUL

FORCEFUL

BEAUTIFUL

FORGIVING

ALWAYS SATISFYING

LIKE A WOMAN IN DISGUISE

—George Downing

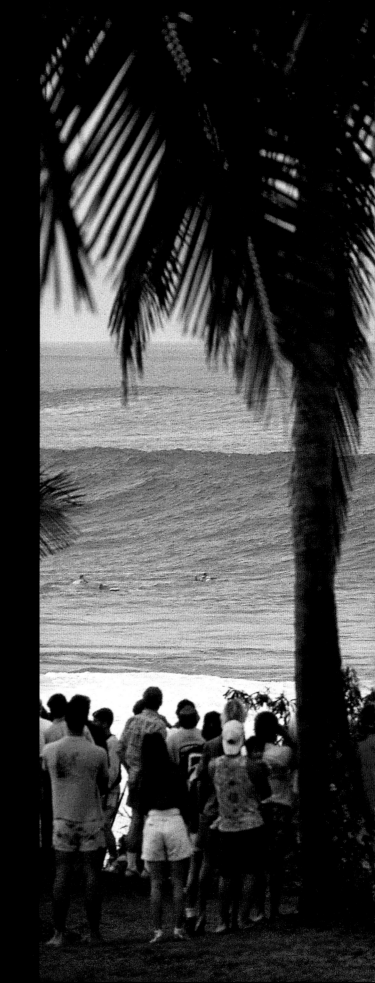

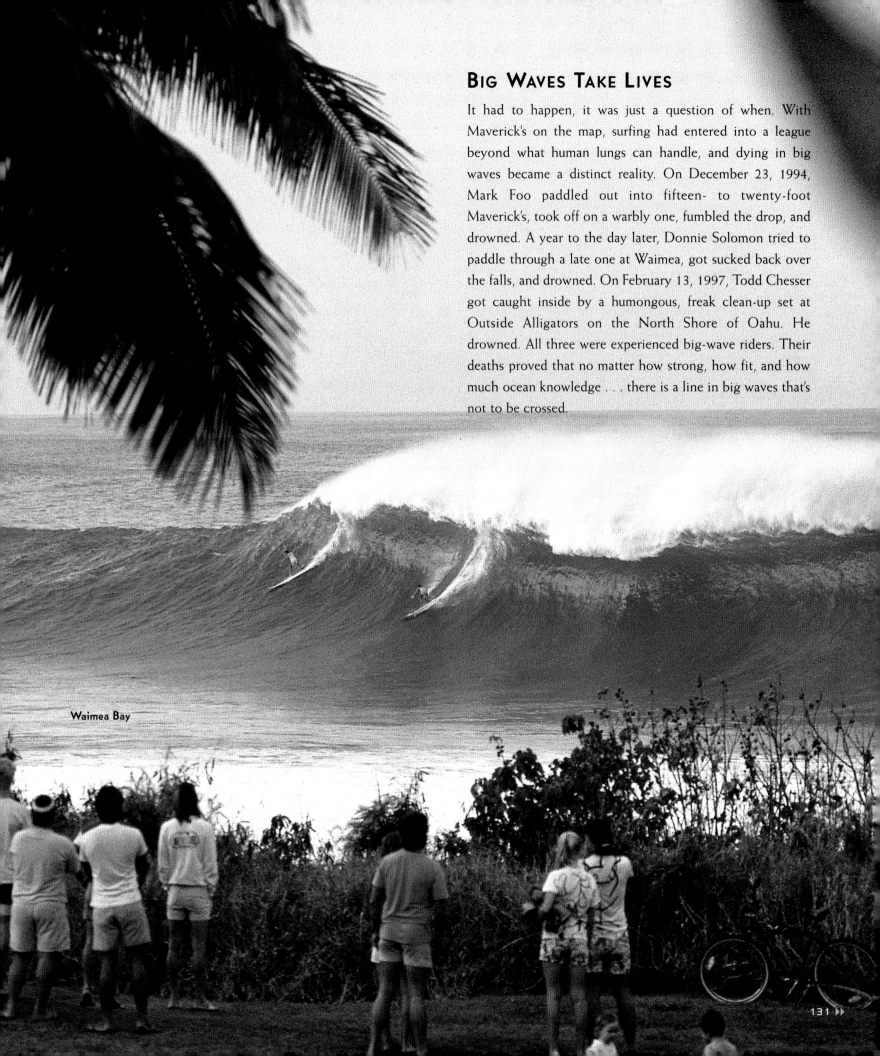

BIG WAVES TAKE LIVES

It had to happen, it was just a question of when. With Maverick's on the map, surfing had entered into a league beyond what human lungs can handle, and dying in big waves became a distinct reality. On December 23, 1994, Mark Foo paddled out into fifteen- to twenty-foot Maverick's, took off on a warbly one, fumbled the drop, and drowned. A year to the day later, Donnie Solomon tried to paddle through a late one at Waimea, got sucked back over the falls, and drowned. On February 13, 1997, Todd Chesser got caught inside by a humongous, freak clean-up set at Outside Alligators on the North Shore of Oahu. He drowned. All three were experienced big-wave riders. Their deaths proved that no matter how strong, how fit, and how much ocean knowledge . . . there is a line in big waves that's not to be crossed.

Waimea Bay

TERJE

Norwegian Terje Haakonsen arrived on the scene in the early nineties and has since impacted the sport like no one before him. To date, he's a five-time European champ, three-time U.S. Open champ, and three-time world champ. In 1995, he shifted his focus from contests to filming and a year later came out with *Subject: Haakonsen*, a video that's refined the term "goin' big."

Roundabout the same time he picked up a surfboard, paddled out, and immediately fell in love with the everchanging nature of waves. "Surfing has made me look at the terrain a little differently," he says. "The way I like doing power turns in the critical point in the mountains is similar to surfing. I think surfing has helped my snowboarding."

Brad Edwards

CARVING ON CONCRETE

Owing as much to surfing as it did skateboarding, a movement of longer boards emerged, harkening back to the old sidewalk surfing days. It was a far cry from street skating, in fact it was void of any technical moves. Long skateboarding was more slalom-based, more cruisy and old school. Companies like Gravity, Sector 9, and Carve brought these long decks into vogue with wide trucks and big-ass wheels. Surfers loved them and vert skaters boosted on them.

SKATE PARKS ARE NOT A CRIME

In the mid-nineties skate companies banded together and formed the International Association of Skateboard Companies (IASC), headed by Jim Fitzpatrick. Fitz lobbied the California legislature, spurring state senator Bill Morrow to pen a bill that made cities immune to skate park injury litigation. In other words, skate at your own risk. Thus, the park revolution was set into motion. Skate parks are popping up all over, many of which are funded by the city. Suggestion: Dance on down to city hall and tell them it's in their best interest to build a public skate park. . . . It's for the kids! But be warned, there are people who feel the public skate park deal is merely a ploy by the powers that be to perpetuate skateboarding's illegality. "If you've got a park down the road then why the hell you skating in the street?" said the angry cop with the bulging belly.

Whistler, BC

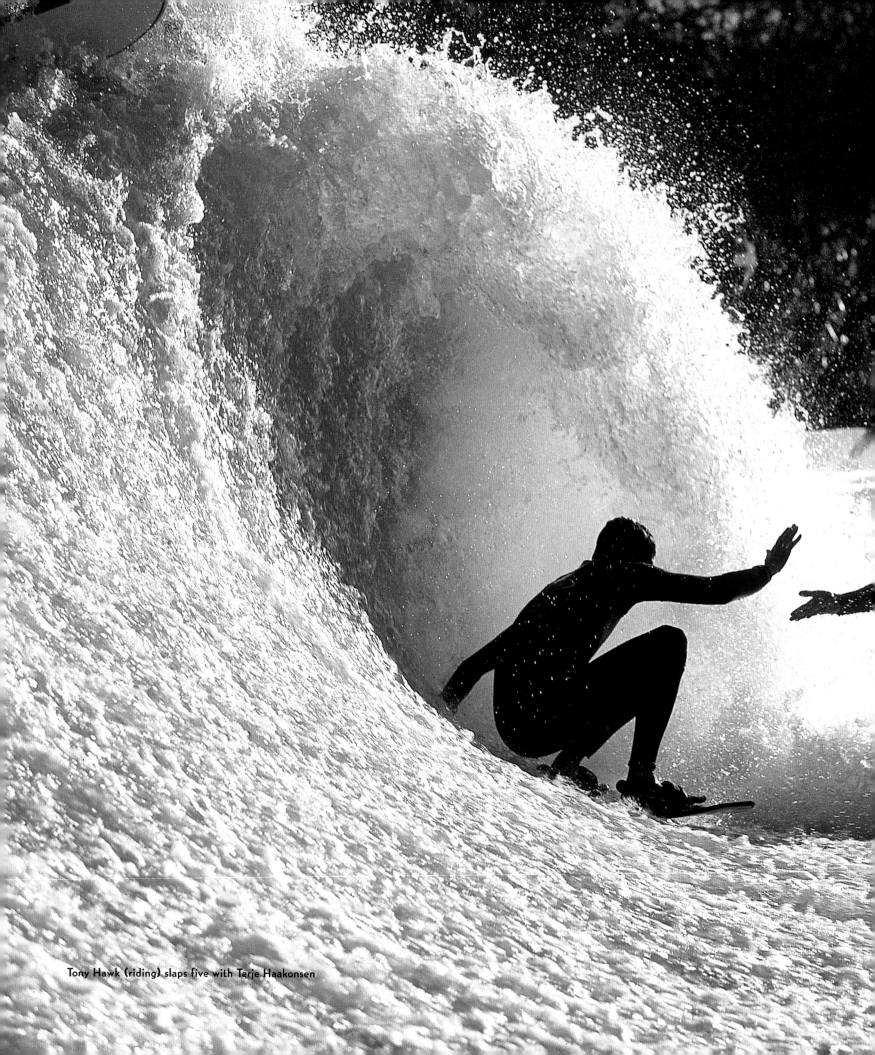

Tony Hawk (riding) slaps five with Terje Haakonsen

WHERE WIZARDRY HAPPENS

The Wave Loch/Flowrider is, in fact, exactly the opposite of a real wave. Real waves are natural and they move, but they cannot be moved. The Flowrider is man-made and stationary, but the whole package is portable. Invented by Tom Lochtefeld of San Diego, the Flowrider has traveled to Munich, Florence, Oslo, Dubai, Sydney, and San Antonio, sharing this odd strain of boardriding with the uninitiated. A typical demo goes like this: Christian Fletcher, Kelly Slater, Tony Hawk, Chris Miller, Terje Haakonsen, and Bill Bryant take turns trying hybrid surf/skate/snow moves while the rest analyze and take notes from the sidelines. In fact, Slater is rumored to have conceived of his Rodeo Clown move at the Flowrider, which he would later take to Pipeline (see page 140).

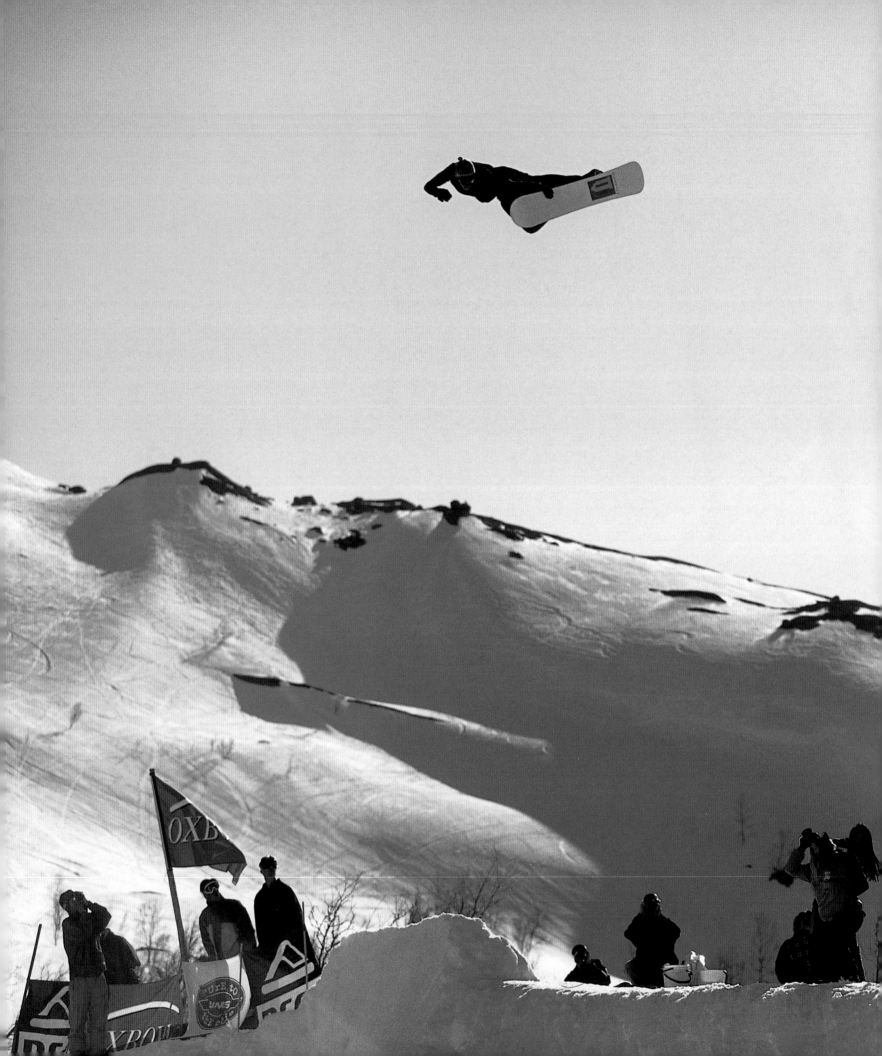

INGEMAR'S AIR AFFECTED a lot of people outside of snowboarding as well as in. I think it made skateboarders think a lot, it made Moto-X guys think a bunch. It was outside the box for snowboarding. And it legitimized it.

—Travis Parker

INGEMAR'S AIR

The scene: A quarter-pipe contest in the Norwegian backcountry, off in its own little autonomous universe. Riders charge down a chute, climb the wall, and boooost—eight, ten, twelve feet up into the air. The scenario: There are days in an athlete's life when the planets and stars and whatever they ate for breakfast that morning converge into a confidence that could move mountains. Ingemar Backman was having one of those days. His airs were flawless. Every run he was hitting higher and higher. The standard changed forever: Perched atop a higher cliff band in order to pick up more speed on the approach, Ingemar bombed the chute with all the intensity of a Formula One racecar driver. He climbed the wall, flew skyward, flew skyward, flew even more skyward, grabbed his heel edge in a perfect method, arced backside with more in common with the winged than the footed, and then fell for what seemed like a small eternity. He landed it and threw his hands in the air triumphantly. Ingemar's air was on the cover of at least four international snowboard magazines, and the bar on how high can we fly was raised to a new height.

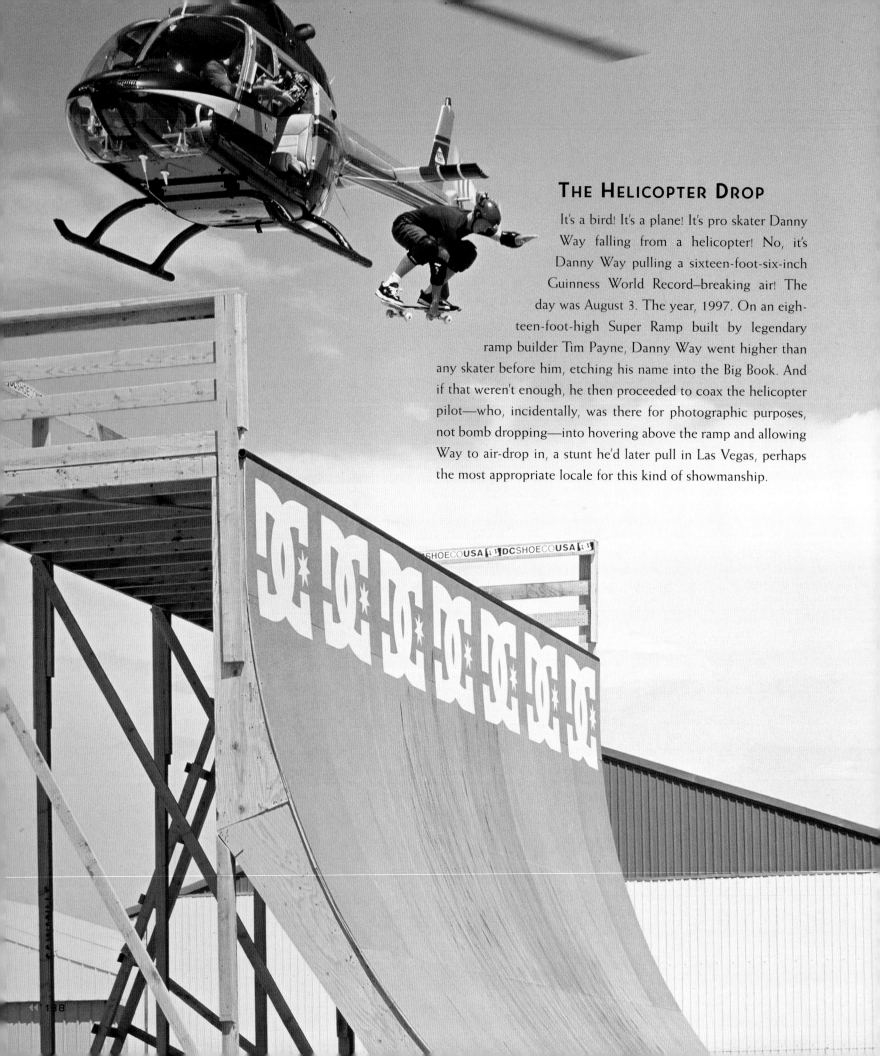

THE HELICOPTER DROP

It's a bird! It's a plane! It's pro skater Danny Way falling from a helicopter! No, it's Danny Way pulling a sixteen-foot-six-inch Guinness World Record–breaking air! The day was August 3. The year, 1997. On an eighteen-foot-high Super Ramp built by legendary ramp builder Tim Payne, Danny Way went higher than any skater before him, etching his name into the Big Book. And if that weren't enough, he then proceeded to coax the helicopter pilot—who, incidentally, was there for photographic purposes, not bomb dropping—into hovering above the ramp and allowing Way to air-drop in, a stunt he'd later pull in Las Vegas, perhaps the most appropriate locale for this kind of showmanship.

THE OLYMPICS

To some a triumph, to others a tragedy. Snowboarding made the 1998 Winter Olympics in Nagano, Japan—the only boardsport ever to make this leap. But to fit into the box that is organized sport of this magnitude, snowboarding had to abandon the ISF (International Snowboarding Federation—run by riders, for riders) and join forces with the FIS (Federation Internationale de Ski). It was ironic and compromising and rubbed a lot of riders the wrong way, but it didn't stop the majority of the invited competitors from participating. Canadian Ross Rebagliati won the first ever Olympic snowboarding gold medal. But then he tested positive for marijuana and had it revoked. Then they decided, based on the minute amount of marijuana found in his system, that it could have been simply second-hand smoke, which it purportedly was, and later gave the medal back to him.

G-LAND

Over the course of the first two decades of organized surf contests, pros would complain at length about event venues revolving more around easy access than quality waves. The sponsors of the contests, the ones putting up all the bucks, had a valid rebuttle: They needed these events to be seen by as many pairs of eyes as possible. In other words, they needed bang for their buck. The Information Age changed all this. Thanks to cable TV, video, and the Internet, sponsors now hold their events where the waves are best. The Quiksilver Grajagan Pro, held in 1995, was the first World Championship Tour (WCT) event to go for quality of surf at the expense of easy access. G-Land is located in an isolated corner of Java. There weren't a lot of spectators at the event, but there were a lot of cameras. And thanks to technology, people got to watch Kelly Slater win the thing in perfect surf. The event set a standard. Today, the world's best surfers have the luxury of competing in the world's best waves.

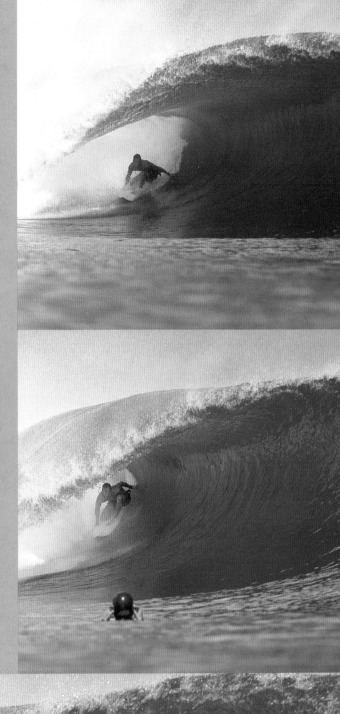

Kelly Slater, G-Land

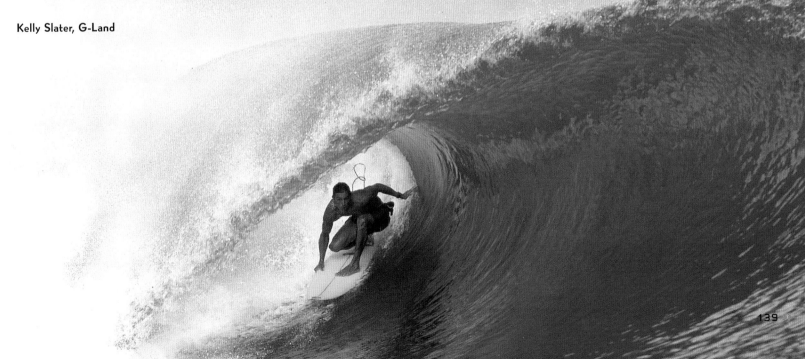

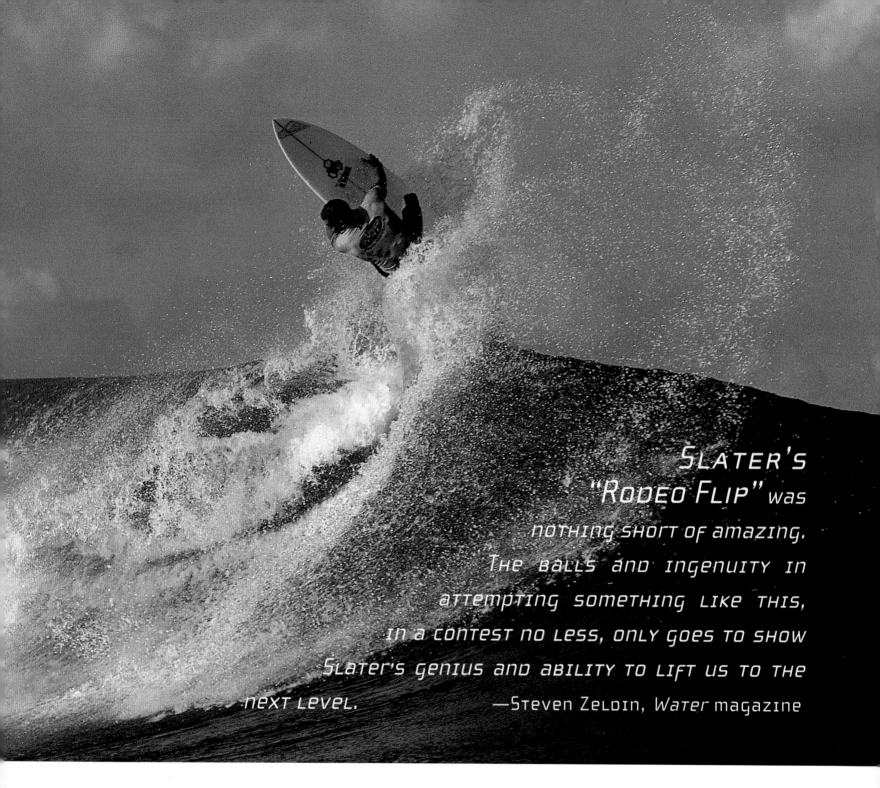

SLATER'S "RODEO FLIP" was nothing short of amazing. THE BALLS AND INGENUITY IN ATTEMPTING SOMETHING LIKE THIS, IN A CONTEST NO LESS, ONLY GOES TO SHOW SLATER'S GENIUS AND ABILITY TO LIFT US TO THE NEXT LEVEL. —STEVEN ZELDIN, *Water* magazine

RODEO FLIPOUT

It left people scratching their heads. The contest was the Pipeline Masters. The year, 1999. As expected, Kelly Slater was leading the heat. There was a massive crowd present. The combination of Slater and spectators spells "spectacular," and no one knows this better than Kelly. He took off on a medium-sized left. He got going really fast. He bottom-turned, burst out of the top, and threw this flipping, twisting 360 thing. It was beyond the average surfer's comprehension. They didn't even have a name for it yet. Later Kelly called it a "Rodeo Clown," but above all else, it was a glimpse into the future. On a half pipe, be it skateboard or snowboard, it would have been a lot more plausible, but on a wave, on a surfboard, it was mind-boggling.

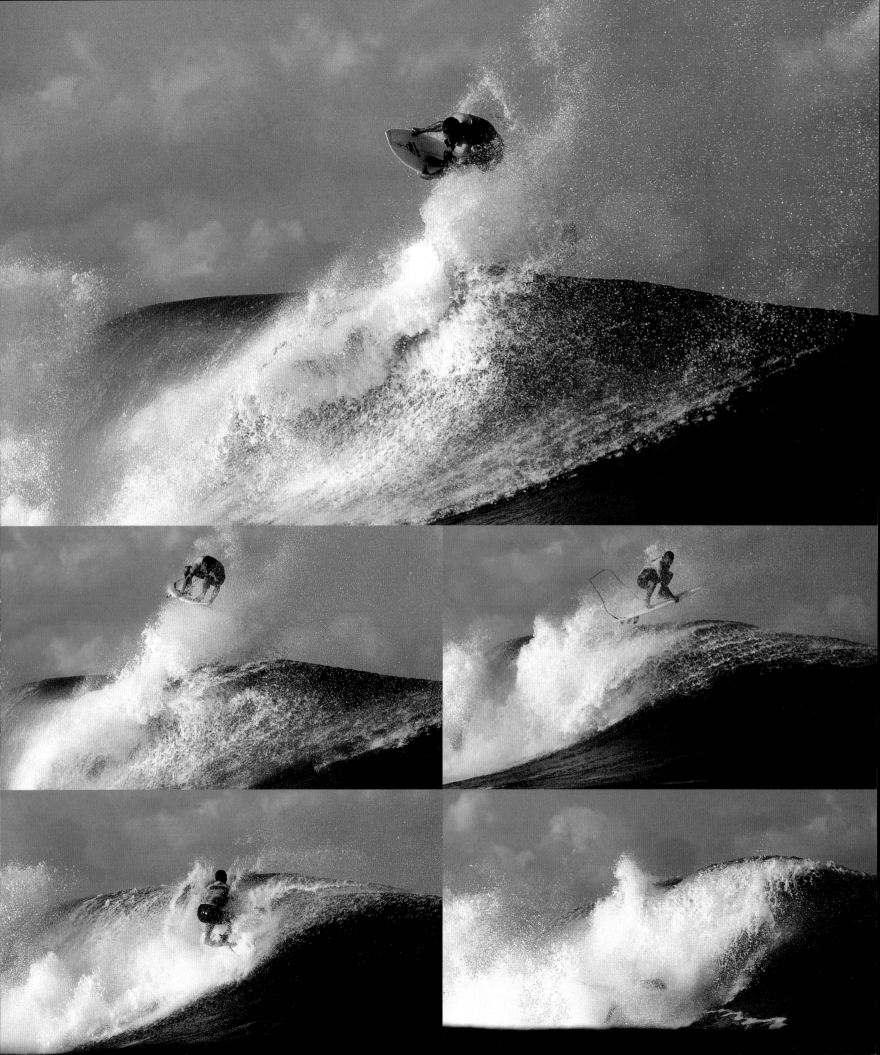

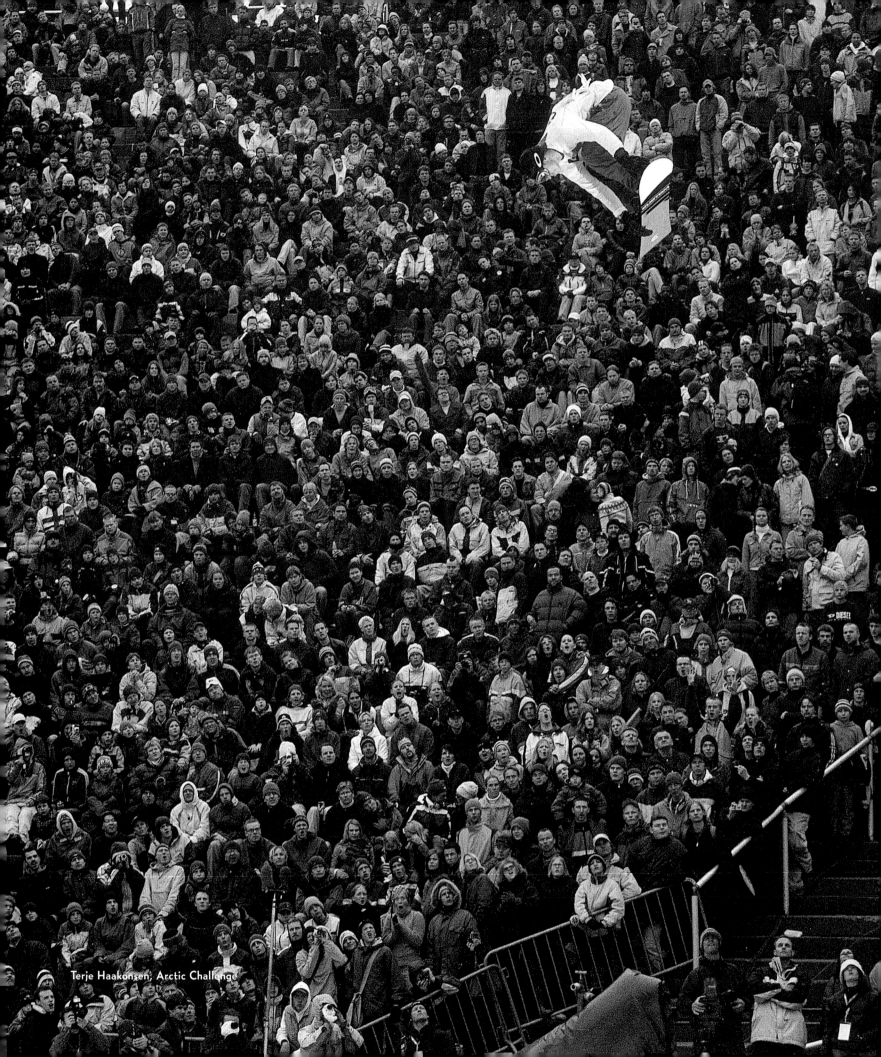

Terje Haakonsen, Arctic Challenge

TERJE'S SNOWBOARD CHALLENGE

Uninterested in the rules, regulations, and restraints the Olympic people put on snowboarding, Terje Haakonsen elected not to compete. Instead he started the Arctic Challenge, a snowboarder-run event that's all about experimenting, mixing it up, and moving the sport forward. Terje invites his version of the world's best to Lofoten, Norway. They democratically decide when and where to compete. Everyone generally has a great time and no one has to urinate into a cup.

TODD RICHARDS GOES BOTH WAYS

He was a skateboarder who discovered snowboarding as a way to maintain sanity during the frigid winter months in Paxton, Massachusetts. He got good. Real good. So good that within a few years he was traveling the world, a full-fledged pro winning money, signing autographs, and making history. In 1994 he won the U.S. Open in Vermont with back-to-back 720s, something that had never been done before. In 1998, he had the honor of competing in the Winter Olympics. And at the roots of his riding is skateboarding. Todd Richards's shift from one discipline to the other perfectly exemplifies just how overlapping the branches of boardriding really are.

PRO SURFER/SKATER/SNOWBOARDERS

John Cardiel won "Skateboarder of the Year" in *Thrasher* magazine's reader poll in 1993. A few years later he was a professional snowboarder. "When you do an air on a snowboard, you get a little more time to stretch things out," he says. "I like to bring that into skateboarding, just tweak a maneuver and hold it for days." Cardiel made a seamless jump from pro skater to pro snowboarder, and then brought elements of snowboarding back into his skateboarding. And he's not the only one. Skateboarder Danny Way snowboarded professionally for a time. And Christian Fletcher and his little brother Nathan are internationally known for lighting things up on surfboards, skateboards, and snowboards, and they get paid to do all three.

AIR SHOWS

Surfing was going airborne on an hourly basis and yet there were no contests there to honor airs and only airs. Enter the *Surfing* Magazine Air Show in 1996. Masterminded by aerialist Shawn "Barney" Barron and *Surfing* editor Skip Snead, the first air show happened at Steamer Lane in Santa Cruz, California, and quickly became a thing. Today, air shows are happening all around the world, serving as major catalysts for the progressive-experimental movement.

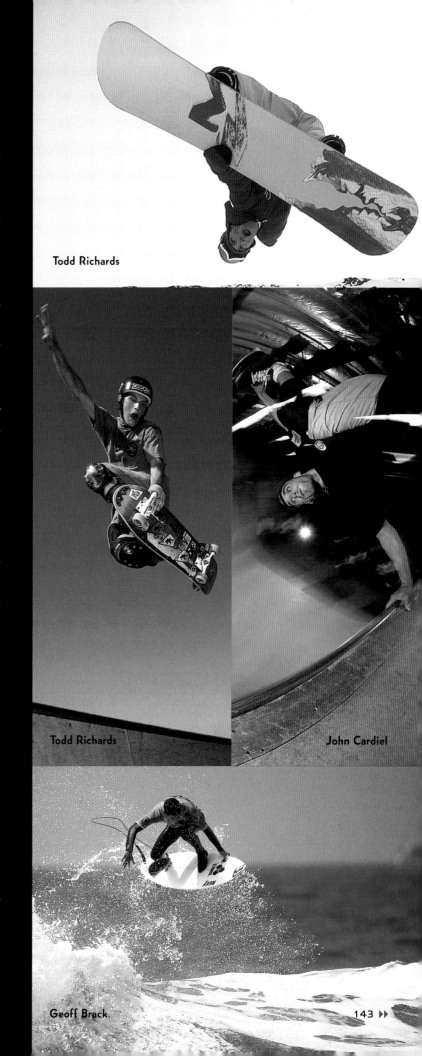

Todd Richards

Todd Richards

John Cardiel

Geoff Brack

TOW SURFING

It all started when longboard wizard/jet ski maestro Herbie Fletcher coaxed a trio of big wave–hungry pros out to Third Reef Pipeline and dragged them into a few twelve-footers. There'd always been a big hurdle in big-wave surfing, and that hurdle was getting over the ledge. No matter how good a paddler you are, the speed and force of a monstrous swell is hard to match, which in turn makes catching one like trying to jump a train that's moving at full speed. This problem was solved via personal watercraft. Herbie's forays with Tom Carroll, Gary Elkerton, and Martin Potter at Pipeline led to a huge movement on the North Shore. Tow surfing has completely revolutionized big-wave surfing and here's why: Before tow-ins, big waves had always meant big boards. Big boards paddle faster, so with a bigger board, you're able to get into the wave earlier, and hence, more likely to make the drop (to use the metaphor again—big boards are like getting a sprinting start to catch the moving train). But big boards are also stiff and difficult to control. Thanks to motorized assistance, the guys are getting into the wave plenty soon; in fact, the drop's not even an issue anymore. So the boards have gone a lot shorter. And shorter means more control, more maneuverability, more command of your weapon, and, consequently, more performance. Instead of the wave riding them, they're actually riding the wave—up and down and all over the face. Tow surfers wear straps—a lot like the bindings snowboarders wear. And while we're on the subject, tow surfing and big-mountain snowboarding have much in common. Surfers are holding their rails longer than ever imagined. The speed, technique, and mind-set are on a scale that's bigger than ever before imagined. "It's like Chinese architecture," as screenwriter Matt George said in the film *In God's Hands*. "Tow surfing is thinking on a much larger scale."

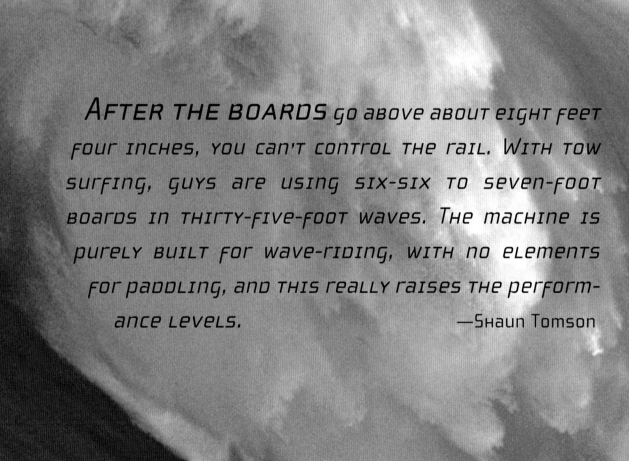

AFTER THE BOARDS go above about eight feet four inches, you can't control the rail. With tow surfing, guys are using six-six to seven-foot boards in thirty-five-foot waves. The machine is purely built for wave-riding, with no elements for paddling, and this really raises the performance levels.

—Shaun Tomson

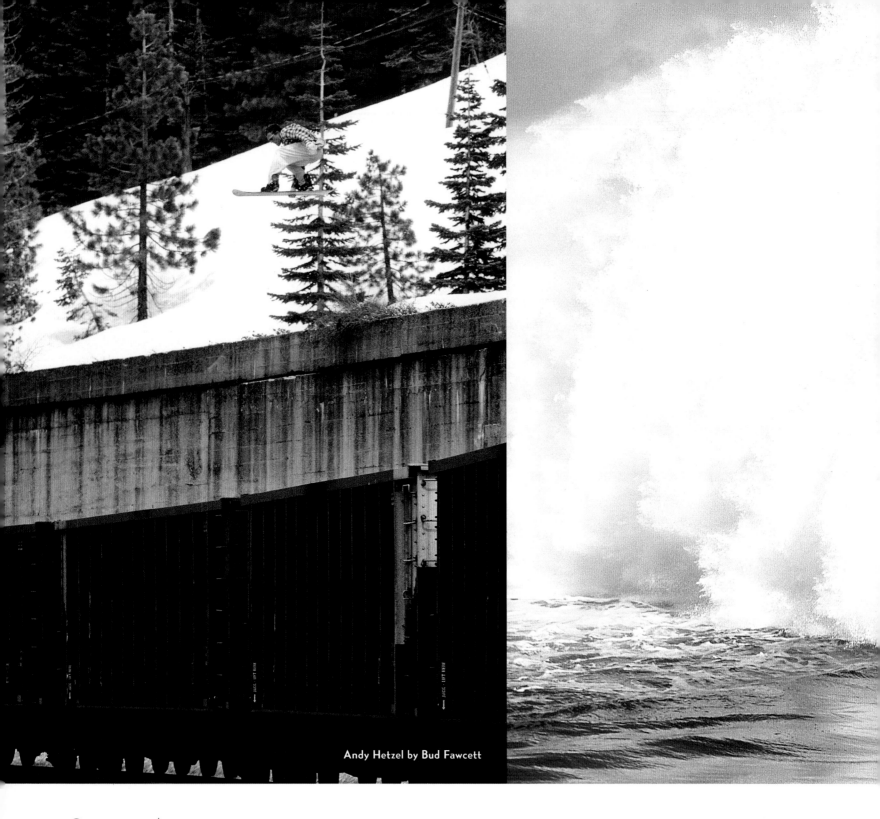

Andy Hetzel by Bud Fawcett

CRYSTAL AWARDS

Delivered to the world in 1999 by Dani Kiwi Meier, the Crystal Awards melded the best in snowboarding with the best in celluloid. Ten Top-10 snowboard photographers were teamed up with ten top riders. They were given a hundred rolls of film and a week to do the job. The categories were Air, Lifestyle, Landscape, Jibbing, Turn, B&W, Resort, and Sequence. Strongest photo wins. The Crystal Awards were an international success. They presented snowboarding as more than just a sport, they honored it as a culture—boiling with talent and bursting with creativity.

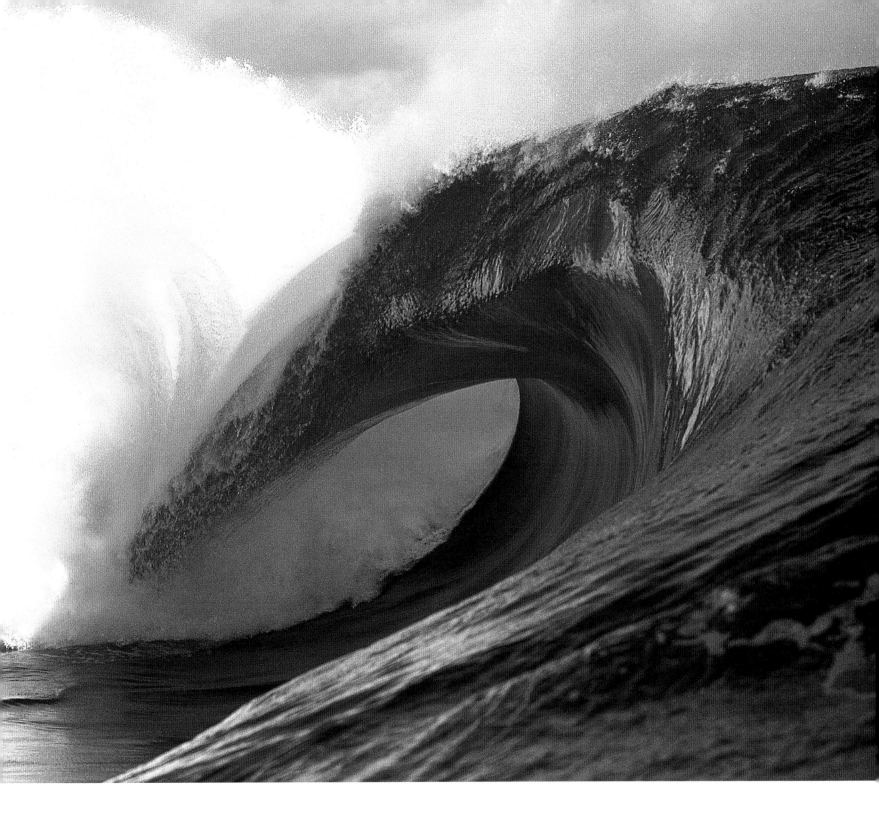

TEAHUPOO

From about the seventies onward, Tahiti had built up a reputation for crystal-clear barrels, but not sea monsters. Sea monsters were the things that popped up in nightmares. They were larger than life, mean and nasty, and wanted to eat you. In the latter half of the nineties, a Tahitian sea monster became a reality. Teahupoo is really a wave, but on the right swell at the right tide under the right light, it appears more as a monster. In 1999, the ASP held the first World Championship Tour (WCT) event there. Cory Lopez caught a beast. The following year Laird Hamilton did the same. Today they're riding sea monsters out there every time the swell comes up, and to lift the game even further, they're towing in, riding waves that ten years ago would have been written off as sheer suicide.

THE ADVENT OF THE BIG STUNT

Gravity games, extreme games, prime-time TV coverage, the whole more, more, more, big, big, big she-bang collectively conspired to fuel the need for the Big Stunt. Doing it out on the street or in someone's backyard wasn't good enough any-more. You had to do it on a grand scale. And you had to get it on film. As Grant Brittain recalls, "TV came in . . . and TV is God!"

Tony Hawk, Murietta

HAWK'S 900

If there's one move that highlights the 1990s "bigger is better" skate boom, it's undoubtedly Tony Hawk's 900 on June 27, 1999, during the Summer X-Games in San Francisco. The "9" had eluded Hawk for over ten years, and pulling it at the X-Games with a thousand cameras pointed in his direction (as opposed to doing it on a backyard ramp with just a few friends around) not only helped Hawk, but also the whole of skateboarding, in ways that only CEOs of major TV networks can fully fathom. The 900 is a horizontal midair twist of two and a half revolutions. It's somewhere between Olympic level gymnastics and Olympic level diving, adding in a skateboard, of course. In a sport that has no finish lines, no hoops to put the ball through, no walls to hit a home run over, only a lot of subjective, highly technical, extremely style-based intangibility, the 900 was something the non-skating public could fully grasp. And when Hawk tucked, grabbed, spun, and skated back down the ramp in triumph, not only did he throw his arms up in the air and let his emotions fly, but so did a good chunk of the TV-watching American public. It was skateboarding's version of a grand slam, and its effects still resonate today.

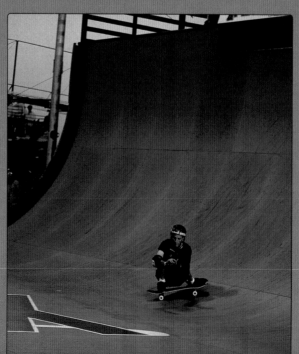
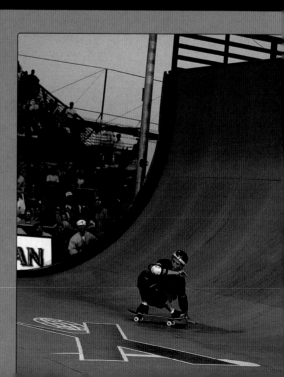

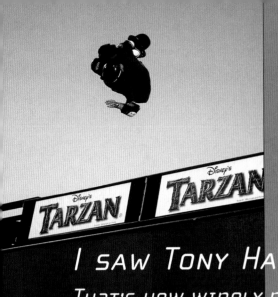
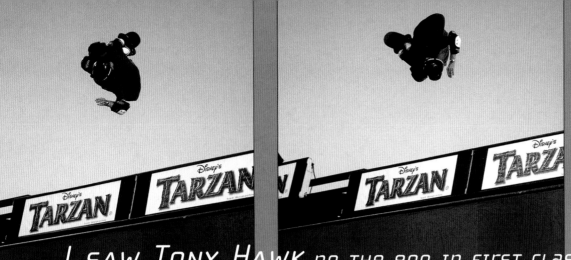
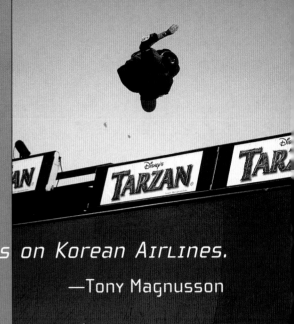

I saw Tony Hawk do the 900 in first class on Korean Airlines. That's how widely publicized that was.
—Tony Magnusson

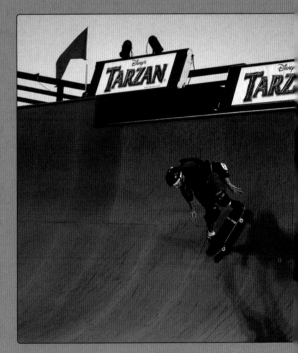
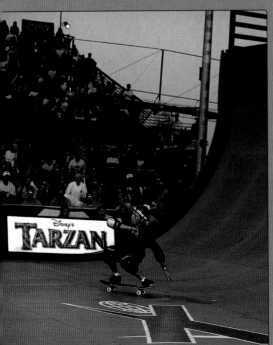

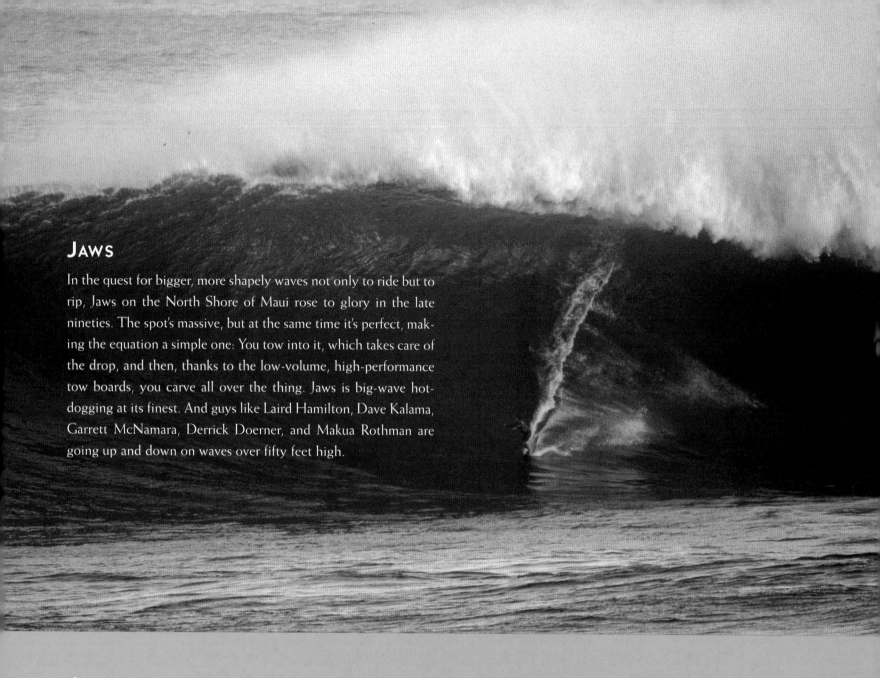

JAWS

In the quest for bigger, more shapely waves not only to ride but to rip, Jaws on the North Shore of Maui rose to glory in the late nineties. The spot's massive, but at the same time it's perfect, making the equation a simple one: You tow into it, which takes care of the drop, and then, thanks to the low-volume, high-performance tow boards, you carve all over the thing. Jaws is big-wave hotdogging at its finest. And guys like Laird Hamilton, Dave Kalama, Garrett McNamara, Derrick Doerner, and Makua Rothman are going up and down on waves over fifty feet high.

I APPLAUD TODAY'S BIG-WAVE BOUNTY HUNTERS FOR TAKING THE BIGGEST QUANTUM LEAP OUR SPORT HAS EVER SEEN IN A TEN-YEAR PERIOD. THE UPSIDE OF TOW-IN SURFING HAS BEEN A PLEASURE TO WATCH, AND WE'RE LUCKY TO HAVE IT HAPPEN IN OUR LIFETIME. I JUST HOPE THE ELITE CREW IS STILL HAVING FUN, BECAUSE THAT SHOULD ALWAYS BE THE UNDERLYING REASON WHY YOU GO SURFING. AS FOR THE DOWNSIDE OF POWER SURFING, I DON'T THINK WE'VE SEEN HOW BAD IT CAN REALLY GET. AND I'M AFRAID IT'S ONLY GOING TO GET WORSE. A LOT WORSE.

—Evan Slater

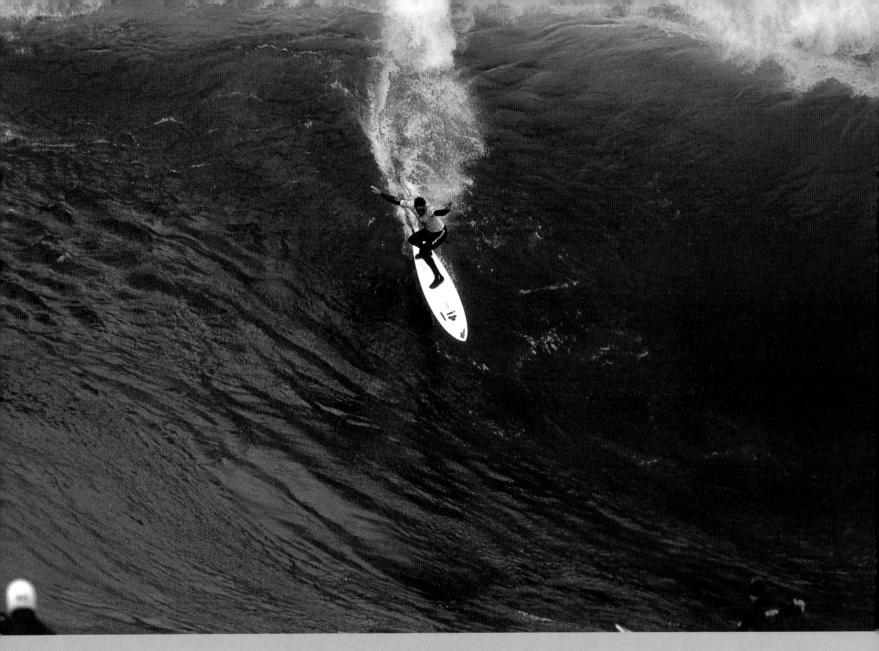

The $50,000 Wave

It was more a bounty hunt than a surf contest. During the El Niño winter of 1997/1998, the K2 company offered up $50K for whoever rode the biggest wave of the season. The rules were simple: The wave had to be paddled into—no Jet Skis, and the wave had to be photographed—the proof is in the celluloid. So surfers went hunting—at Jaws, at Waimea Bay, at Outer Reef Log Cabins, and at Maverick's. But the big moment happened at Todos Santos in northern Baja, during a contest no less. Taylor Knox caught a beast, skittered to the bottom, the cameras clicked, and a month or so later, after much debate and a big education in which angle makes the wave appear largest, Taylor and his fifty-two-foot mega-wave took the $50K, setting off a trend in big-wave bounty hunting that continues to this day.

2000s
AND BEYOND . . .

According to a survey conducted in 2001, there's an estimated 2,420,000 surfers, 10,331,000 skateboarders, and 7,960,000 snowboarders riding wild in the United States alone, making the total number of boardriders 20,711,000. Over half of them are between the ages of twelve and nineteen and over half of those twelve- to nineteen-year-olds are active in all three board sports. Surf/skate/snow is a $10 billion industry and only getting bigger.

GLIDING FORWARD

Since the dawn of the new millennium, surf, skate, and snow have moved forward at typical breakneck pace. There have been countless incidents and advancements that will undoubtedly affect the future. Trouble is, when something's superfresh it's often hard to gauge its impact on the future. Here are a few recent happenings that should stand the test of time:

In the summer of 2003, surfing was added into the X-Games, introducing a new "teams" format and broadcasting the sport out to a bigger, more diverse audience than ever before. In terms of air tricks, surfing has become more and more skate-influenced. In fact, it wasn't until only recently that surfers began to use the term "trick." Before Kelly Slater's 1999 Rodeo Clown there were variations on power moves involving slides and twists and spins, but it was considered bad form to call them "tricks." Today surfers are doing skate-influenced flip tricks on surfboards. They're also toying with hand rails. You're probably thinking there are no hand rails in the ocean. And you're right. What surfers do is attach portable hand rails to floating devices, have a friend swim them out to the surf break, and voilà, they're board-sliding the way skateboarders do. . . . Another major breakthrough in the last three years has been Cortes Bank, a reef located one hundred miles off the coast of California. Discovered from an airplane by *Surfing* magazine photo editor Larry "Flame" Moore, Cortes Bank is the crème de la crème of tow surfing, a truly extreme spot that's believed to hold the biggest waves on the continental United States. Mike Parsons, Brad Gerlach, Peter Mel, Kenny "Skindog" Collins, and Evan Slater all made history when they pioneered it in January 2001. And we're happy to report that there were no drownings, no shark attacks, and no killer whale sightings—just five guys riding waves that looked more like mountains, which segues us perfectly into snowboarding . . .

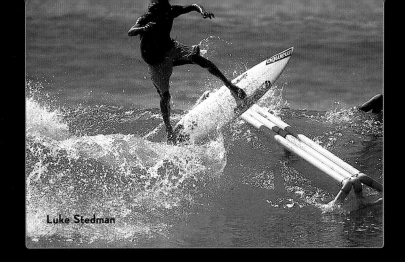
Luke Stedman

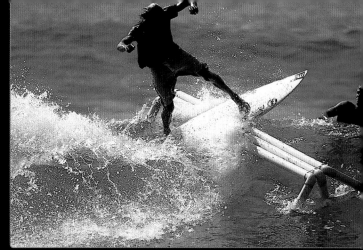

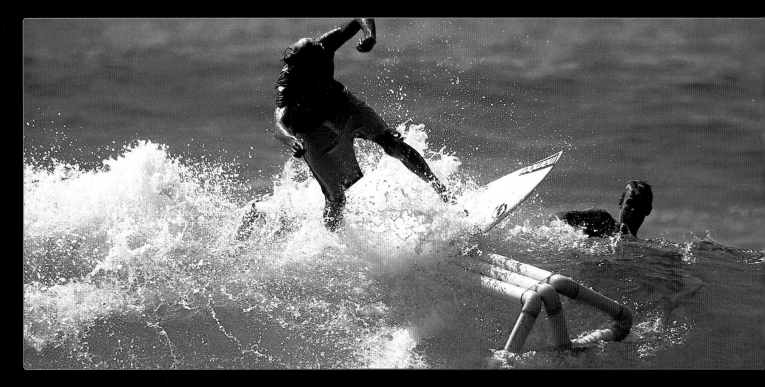

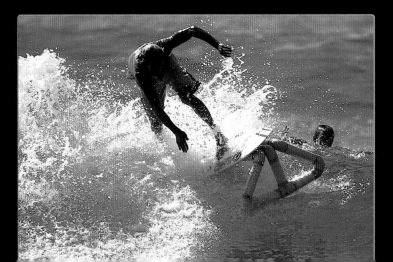

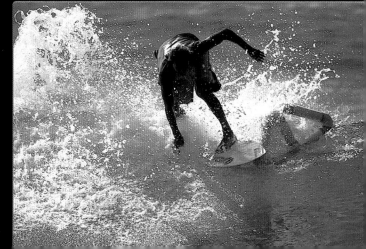

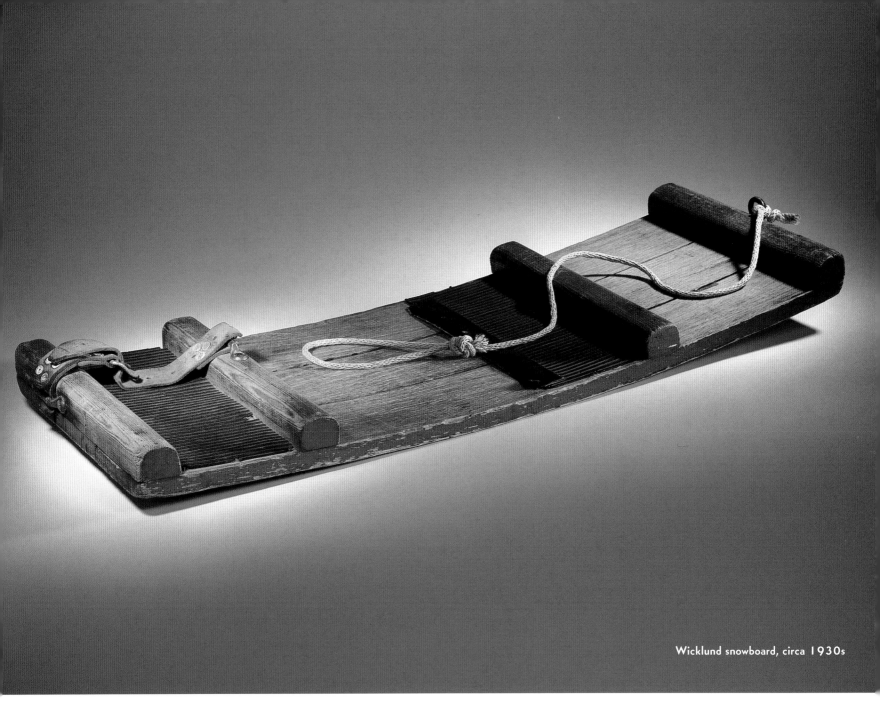

Snowboarding suffered a huge loss on January 20, 2003, when Craig Kelly was killed in an avalanche while training to become the first snowboarder to be fully certified as a Canadian mountain guide. Since the mid-eighties, Kelly has been hailed as the most complete rider of all time. He'd explored every facet of the sport—from competition to design to mountaineering to inner searchings that helped show the snowboarding populace what the whole game is all about. The other thing to happen in 2003 was the discovery that we've been wrong all along about the seedlings of snowboarding. It didn't start with Sherman Poppen and the Snurfer in the mid-

sixties. Snowboarding dates back to at least 1939. The story goes like this: A Burton representative is onboard a flight when he gets to talking with the woman seated next to him. She asks what he does for a living. He tells her he works for a snowboard company. She says, "Oh, my grandfather started that sport in the late thirties." He tells her that's impossible, it didn't start until the sixties. She insists it started in the thirties and says she's got the super 8 film footage to prove it. Well, indeed the film surfaces. It's purchased by Jake Burton and is unquestionably the real deal—no smoke, no mirrors. So it's all true, snowboarding started in the thirties.

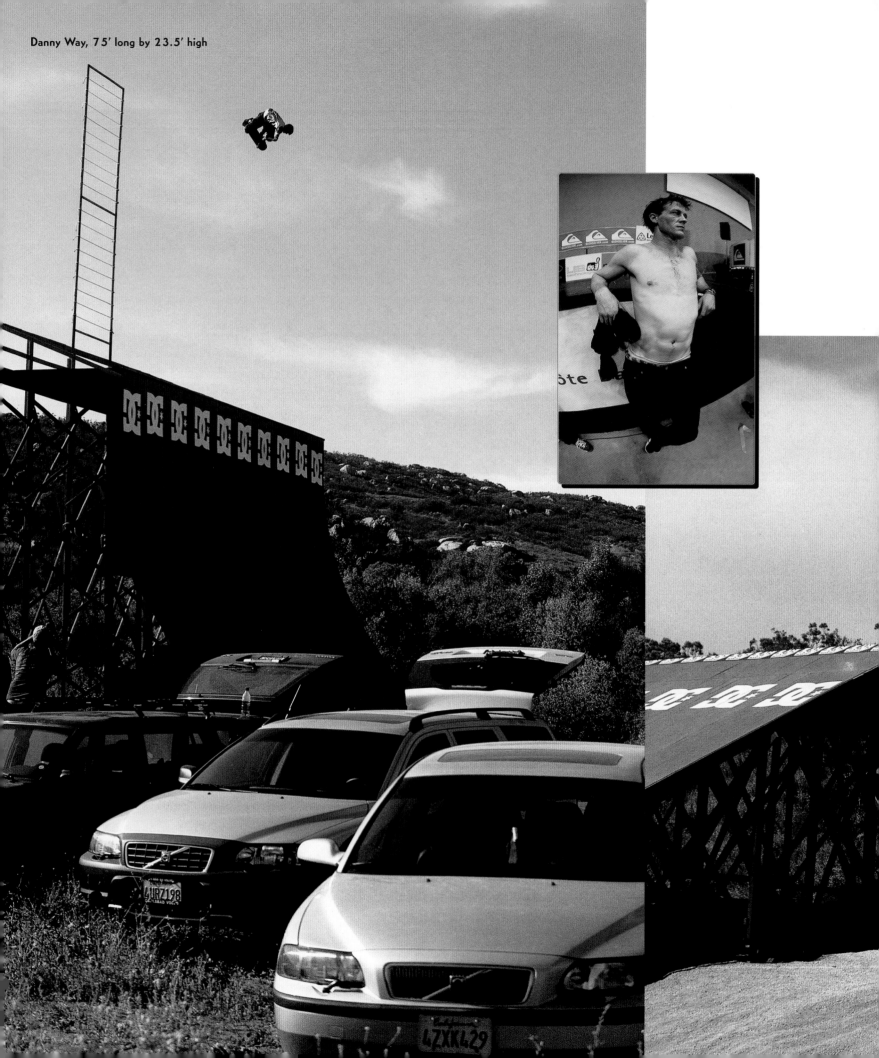

Danny Way, 75' long by 23.5' high

After a couple decades of borrowing maneuver after maneuver from skateboarding, snowboarding has finally given back. On June 12, 2003, Danny Way broke two world records with the highest air (23.5 feet) and the longest distance jump (75 feet) together in the same run. The combo was pure snowboarding—a backside 360 on the long jump and a simple backside air on the vert. In fact, the only thing that separated this marvelous stunt from snowboarding was the fact that it happened on a skateboard on wood rather than snowboard on snow. The scale of it was exactly the same, and the historical significance is monumental. The other thing that's surfaced in the last couple years is "Already Been Dones." ABDs go like this: Kids who skate love to watch skate videos, which in turn creates a huge market for the vids. The vids are pumped out on a monthly basis, showcasing the hottest skating at popular places throughout the country. Let's say a kid skates regularly at Love Park in Philadelphia. He watches the DC vid, sees the crazy things skate legend Stevie Williams did on a particular ledge or rail, then goes there himself and tries to one-up Williams. Kids today are acutely aware that the title is there for the taking. It's a Rocky Balboa story, and anyone can play the starring role.

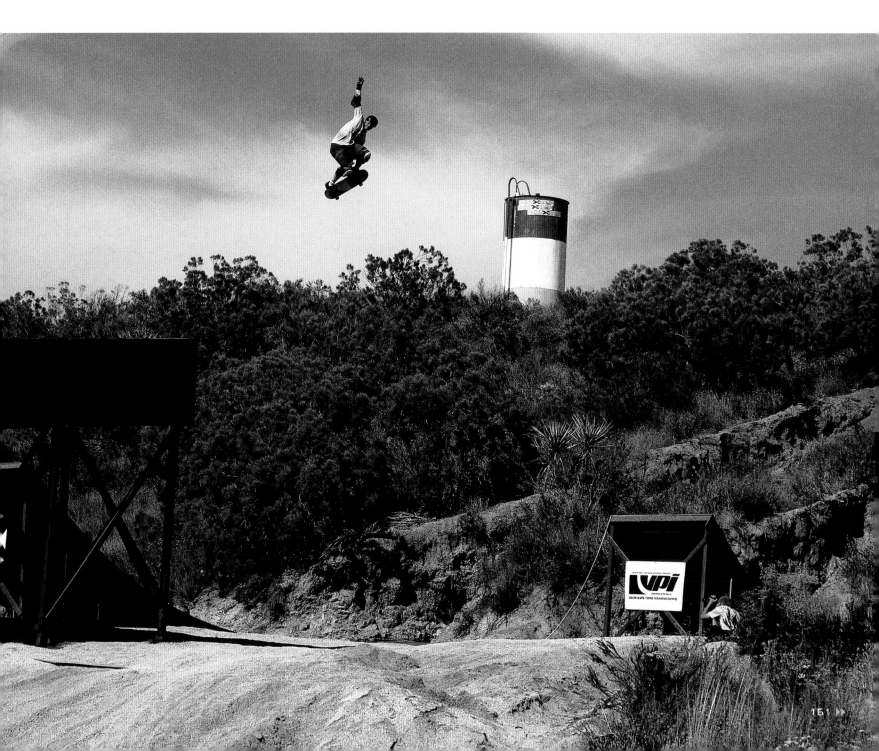

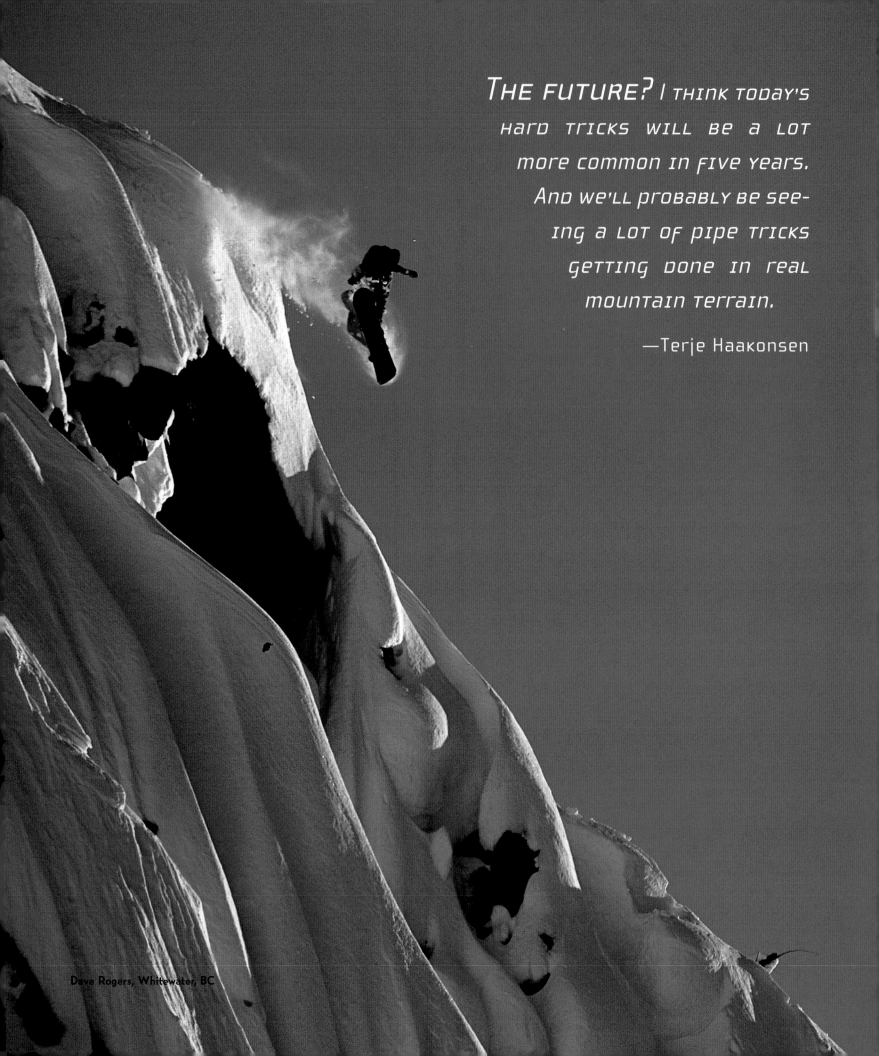

THE FUTURE? I think today's hard tricks will be a lot more common in five years. And we'll probably be seeing a lot of pipe tricks getting done in real mountain terrain.

—Terje Haakonsen

Dave Rogers, Whitewater, BC

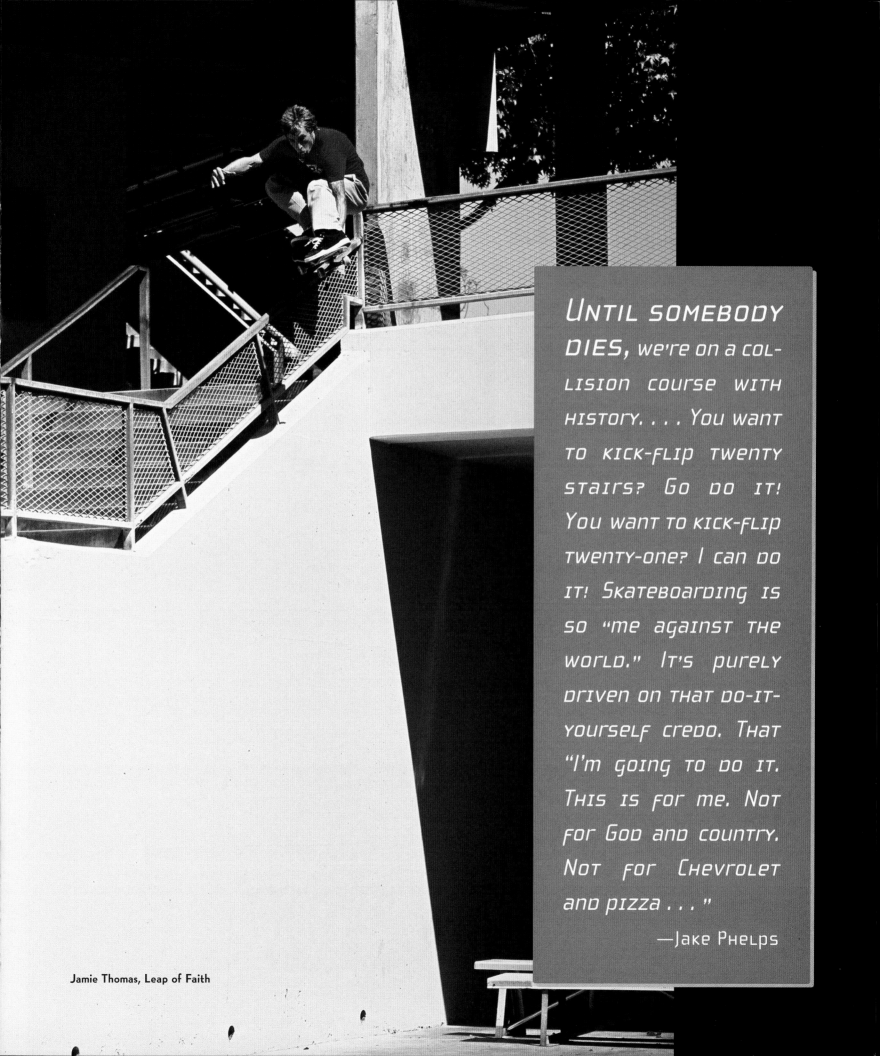

Jamie Thomas, Leap of Faith

UNTIL SOMEBODY DIES, we're on a collision course with history. . . . You want to kick-flip twenty stairs? Go do it! You want to kick-flip twenty-one? I can do it! Skateboarding is so "me against the world." It's purely driven on that do-it-yourself credo. That "I'm going to do it. This is for me. Not for God and country. Not for Chevrolet and pizza . . ."

—Jake Phelps

THE SIDE-STANCE

Sometime in the late nineties outside forces came up with the term "Extreme Sports" and classified surfing, skateboarding, and snowboarding as such. But really they missed the point. Surfing one-foot waves is not exactly extreme, nor is grinding a curb or soul-carving a kiddie slope. What links the three together much more than the "extreme" factor is the stance. Surfers, skateboarders, and snowboarders ride side-stance. One foot forward, the other foot back. They lead with the shoulder, same way a boxer does. And there's something that comes from this, something more mental than physical that rounds up the three and puts them in the same stable. They're also individual sports, which breeds a strong sense of individuality in the participants, which in turn breeds a rich and diverse culture. Surfers, skateboarders, and snowboarders have a unique take on the world. Things are not so much black or white but rather "rideable" or "unrideable."

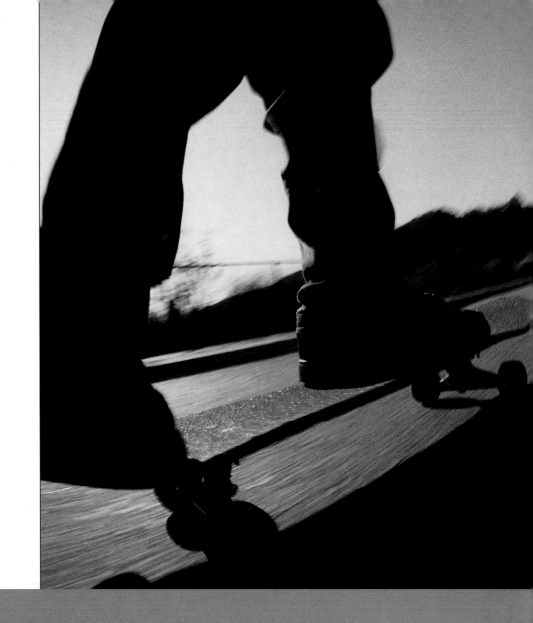

IT'S REALLY SUBTLE, but when you're standing and you turn your head to look over your shoulder as opposed to standing straight and looking straight ahead, it's only a 90-degree difference, but its 180 degrees in terms of your psychology. And it's interesting, I think, when you look around at the X-Games, the skaters aren't really identifying with the inline skaters and they're not identifying with the BMXers, who both have that forward stance. I think the side-stance is the strongest link between skating, surfing, and snowboarding.

—MIKI VUCKOVICH

LINES

Lines mean different things to different people. To an architect, a line is something you draw on a piece of paper that eventually leads to some sort of building. To an actor, a line is something that's said in a play or film, hopefully on cue. To surfers, skateboarders, and snowboarders, lines are something you see in your head then translate to terrain. Skaters and snowboarders have it different in that their terrain is static. They can look down a mountain or a half pipe or a schoolyard and imagine where they want to go. Surfers, on the other hand, have to improvise—waves are in motion and no two are exactly the same. But as far as the boardriding culture is concerned, a line is ultimately a signature, a mind-set, a way of expressing how you see the world.

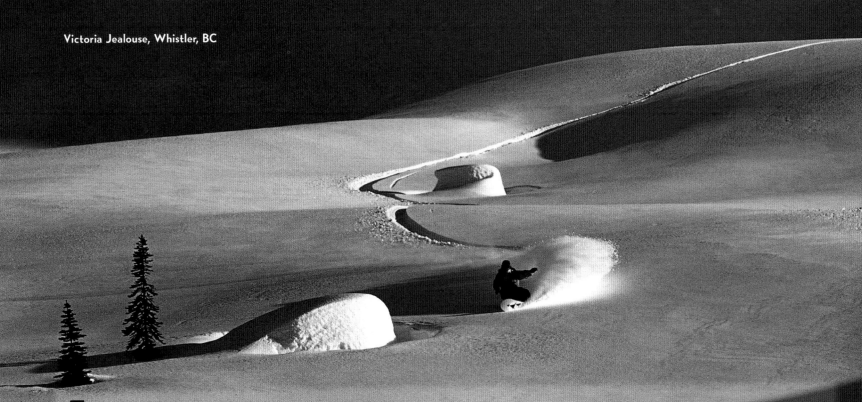

Victoria Jealouse, Whistler, BC

THE ESSENCE OF POOLS is like finding your line—there's the stairs, the death box. It's a line. And that's how skaters look at life—my line is like I'm going to go to the bank and then I'm going to go get pizza and then I'm going to go drop this off at my house and then I'm going to go to my weed dealer and then I'm going to come back. This is your line . . . a constellation as it were. And that's why once you're a skater you're always a skater.

—Jake Phelps

Into the Great Unknown

Surfing has hundreds of years of history, skateboarding half a century, and snowboarding thirty or so years. Relatively speaking, these sports are still young and still defining themselves, and based on their interconnectedness, they'll continue to cross-pollinate. What happens in one discipline will inadvertently affect the others, which is why these sports progress so quickly. And the walls that once separated and sub-separated them are crumbling. Before the 1990s, surfers who thrived in big waves were rarely any good in the small stuff, and vice versa. Here in the 2000s, the same guy who tows into thirty-five-foot Cortes Bank one day is just as likely to be popping airs in the shorebreak the next. Same thing in skateboarding. The line between "vert" and "street" has never been more blurred, and the top guys are able to do both. And then in snowboarding we've got big-mountain free-riding as the popular forum. But what we're seeing now is not the conservative lines that would have been the norm a decade back. These guys are bringing freestyle spontaneity to the backcountry. What previously would have demanded familiarity—hitting the same terrain again and again and again, a half pipe, for instance—we're now seeing done on the first run.

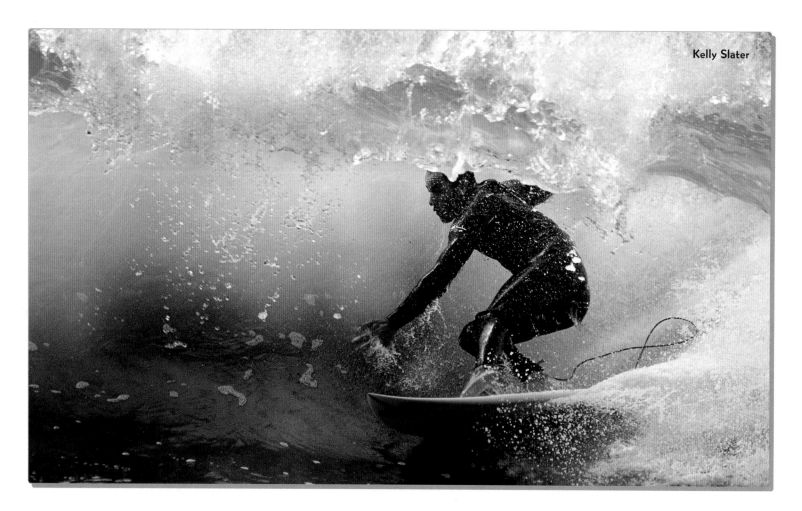

Kelly Slater

Slater and Hawk

They've been called the Michael Jordans of surfing and skateboarding, but the question begs: Has Michael Jordan ever been called the Kelly Slater or Tony Hawk of basketball? Kelly Slater is a six-time world champ and Tony Hawk has won more than twice as many pro contests than any other skater in history. In two words, both are freakishly talented. There's a natural dance to the way they ride their boards that puts them on par with your Baryshnikovs, Beethovens, and Beatles. Once upon a time, Kelly was a grom with a dream. Today, he defies the laws of hydrodynamics. Once upon a time, Tony Hawk struggled with frontside airs. Today, he does 900s and loop-de-loops like mini racecars do on Hot Wheels tracks.

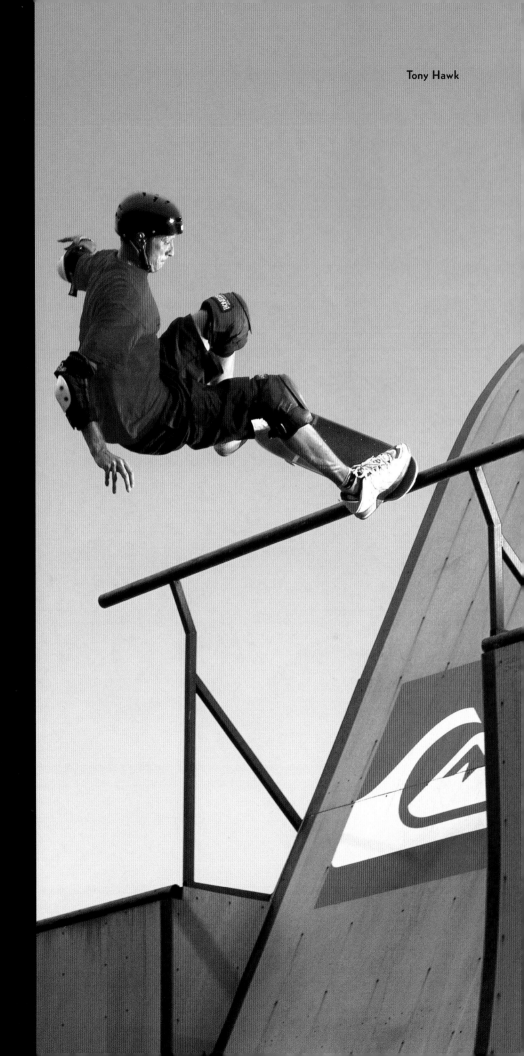

Tony Hawk

TONY IS PROBABLY the most willful skateboarder there has ever been. He's by far the greatest skateboard champion there has ever been. By far. Easily. There is just no comparison. And he's the only skateboarder in the world that has given skateboarding a face internationally. And he's the only skateboarder in the world that has gone beyond skateboarding to literally become an athletic icon. Up there with Tiger and Shaquille and Michael, he literally surpassed skateboarding.

—Stacy Peralta

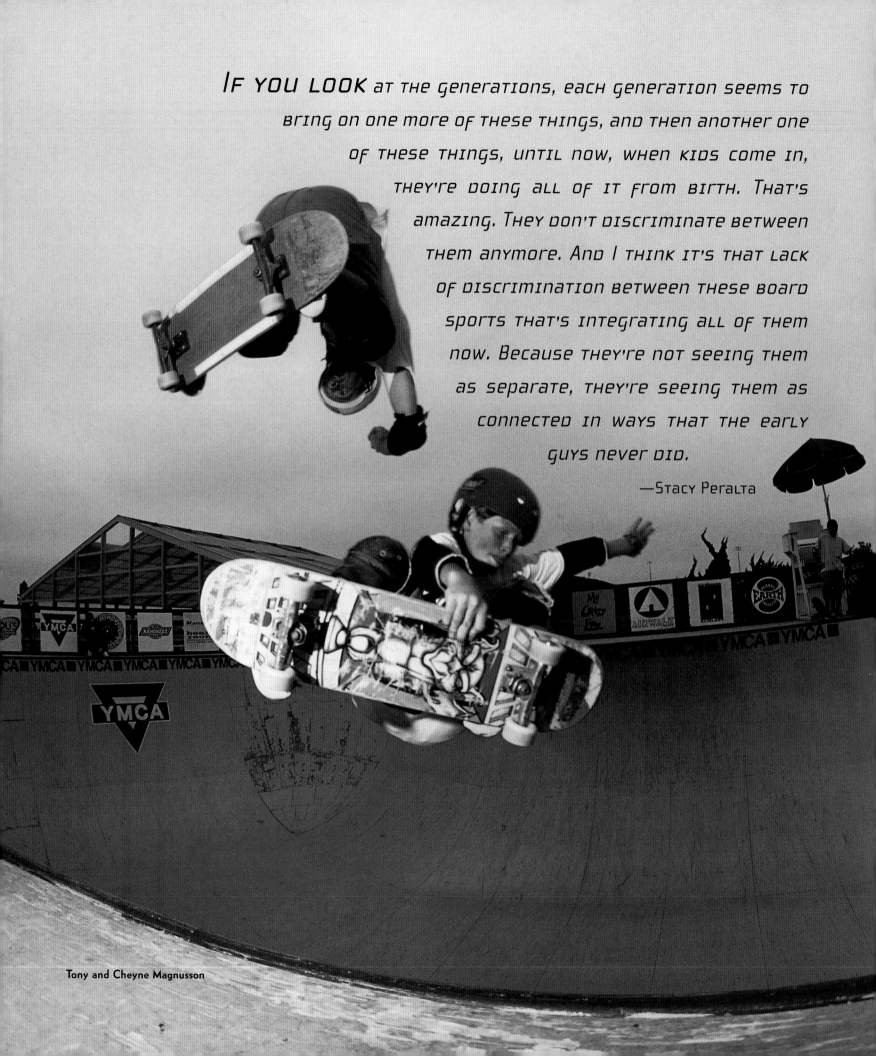

IF YOU LOOK at the generations, each generation seems to bring on one more of these things, and then another one of these things, until now, when kids come in, they're doing all of it from birth. That's amazing. They don't discriminate between them anymore. And I think it's that lack of discrimination between these board sports that's integrating all of them now. Because they're not seeing them as separate, they're seeing them as connected in ways that the early guys never did.

—Stacy Peralta

Tony and Cheyne Magnusson

IT'S A FAMILY AFFAIR

Former skate pro Tony Magnusson is the only forty-year-old in the world today who can do a McTwist (540). Magnusson rode the first wave of vertical skating in the first half of the eighties, had a kid called Cheyne (named after pro surfer Cheyne Horan), started his own company, and continues to skate hard. Cheyne began skating at an early age, which later segued him into surfing, which he now does at a professional level. And the list goes on and on. World surfing champ (1966) Nat Young's son Beau won a world title in 2000. World *Surfing* Champ (1976) Peter Townend's kid Tosh is one of the hottest skaters in the world today. Legendary longboard surfer Herbie Fletcher's sister-in-law was a world champ and father-in-law was a big-wave charger. His two sons have achieved legendary status in the crossover department. They surf, skate, and snowboard at extremely high levels, cross-pollinating the three sports and coming up with new strains of maneuvers in the process. Then there's the husband/wife teams. Top pro snowboarder Dave Downing is married to top pro snowboarder Shannon Dunn. Top pro skateboarder Bob Burnquist shares a bed with top pro skateboarder Jen O'Brien. And they have a baby who's already riding half pipes.

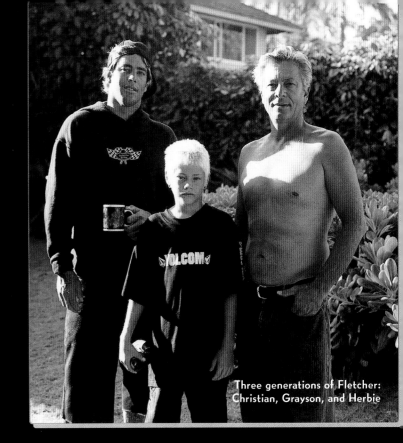

Three generations of Fletcher: Christian, Grayson, and Herbie

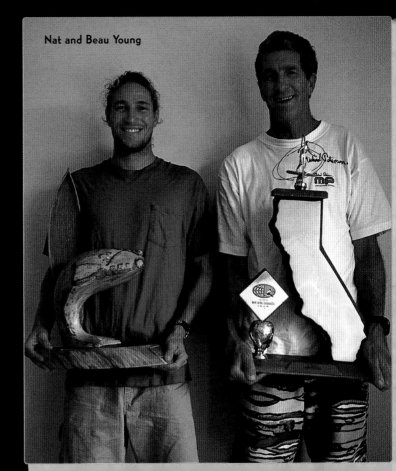

Nat and Beau Young

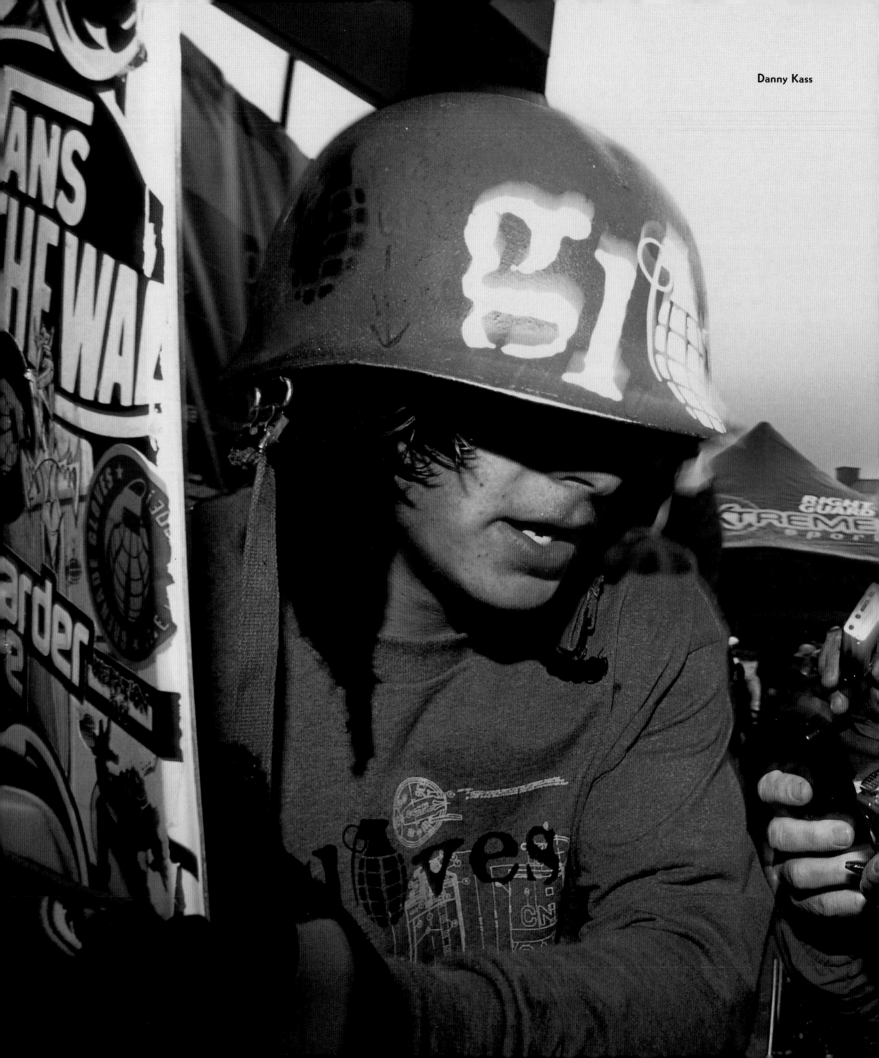

Danny Kass

Truth Lies on the Stranger Side of Fiction

It's 8:30 P.M. on a Wednesday night. Former world surfing champion Sunny Garcia just got in a bar brawl on WB's *Boarding House,* while over on Fox, Bart Simpson's Ollie-ing higher than in previous episodes. Click to the Movie Channel, and it's James Bond snowboarding across a lake in *A View to a Kill.* Three hours back, 54321 was showing highlights of Kelly Slater winning "The Eddie," and if that weren't enough, at the time of this writing, a billboard off the side of the heavily trafficked 405 freeway through the heart of SoCal shows screen starlet Cameron Diaz about three times the size of life, standing tall in a right-hand barrel. Board sports have never been bigger. And to insure their staying power, just check out how many six-year-olds are entering into the board-sporting culture via PlayStation and Rocket Power. But this is only the media version. At the core level, the three surf/skate/snow trees are spilling seeds everywhere, with hybrid roots destined to grow new tricks, new terrain, new perceptions, and new ideas. Design will continue to evolve, which will, in turn, raise performance levels, which will, in turn, make surf/skate/snow an even more captivating sport/lifestyle both to participate in or simply to watch. Whether or not they'll reach the scale of football/baseball/basketball is yet to be seen, but one thing's for sure—as the world's population grows, so does the need to declare our own individuality. Surf/skate/snow are extremely appealing in this regard because they are pure self-expression and purely individualistic. There are no real rights or wrongs, just so long as you do it from the heart—a great metaphor for life if there ever was one. The future is upon us. The question is: Where are you?

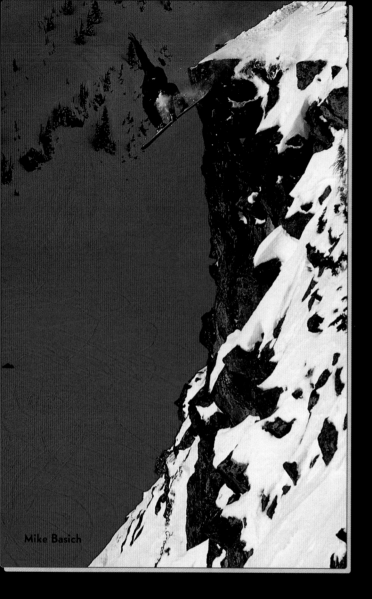

Mike Basich

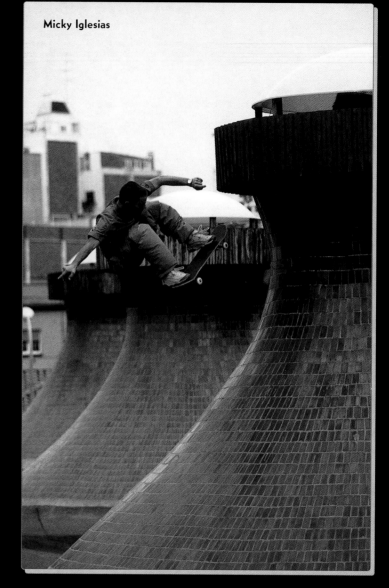

Micky Iglesias

THE FOUNDATION OF ALL these sports, especially when you get into more technical stuff up in the air, is how good is the transition? Whether it's in a half pipe or, in the case of surfing, that transition is so different every single time, and the waves different, and it's moving, so you've got to flow with the transition, 'cause you always want to land on a good tranny. And that's the whole thing if you're in the air snowboarding, whether it's a sixty-foot jump or an eighty-foot jump or a super pipe, you're only as good as how you're dealing with your transition. —Richard Woolcott

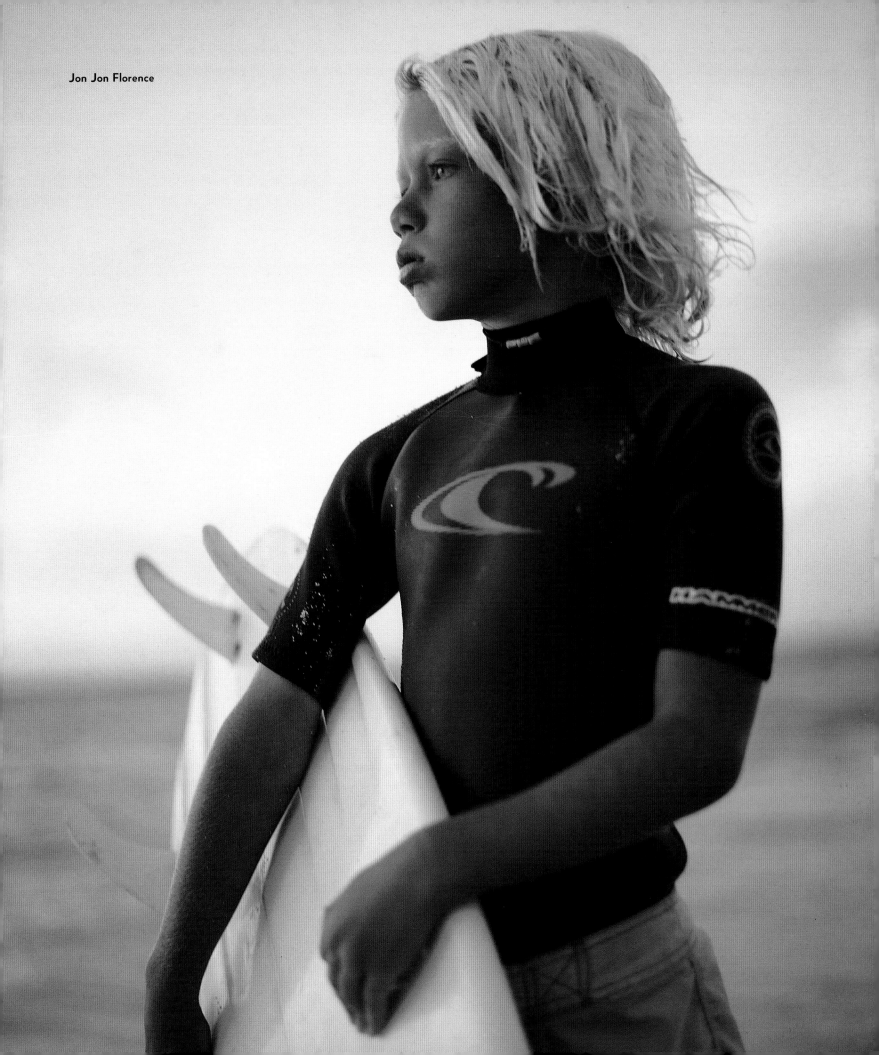

Jon Jon Florence

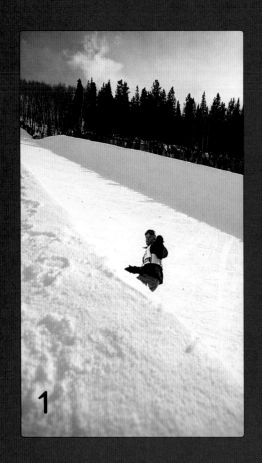

1

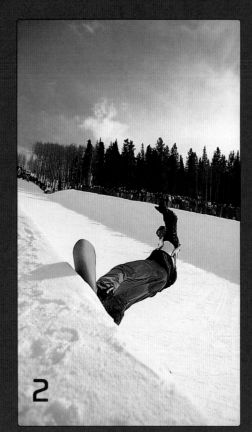

2

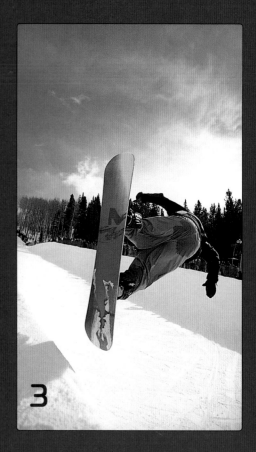

3

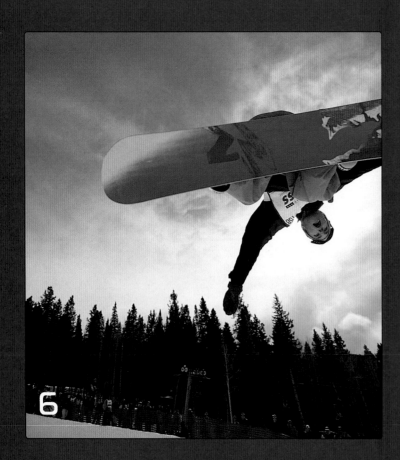

6

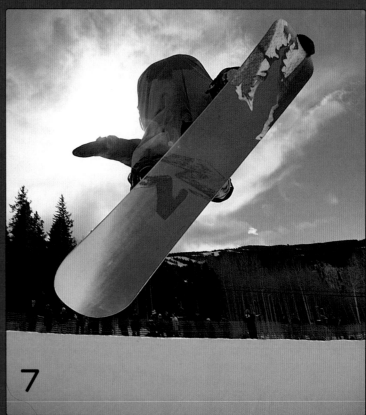

7

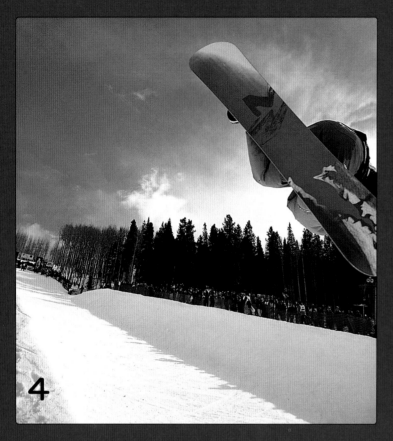

4

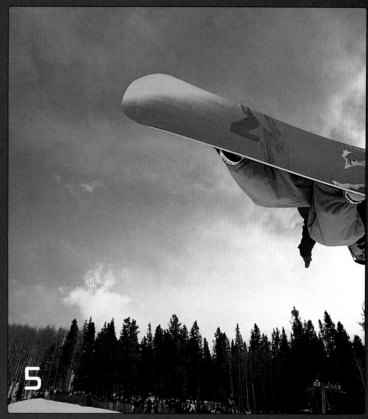

5

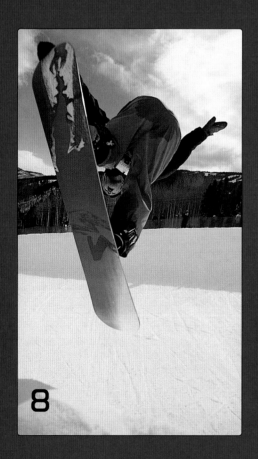

8

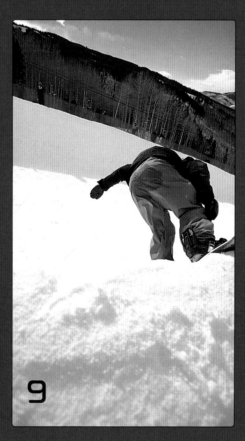

9

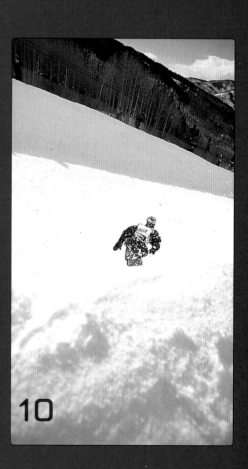

10

Todd Richards

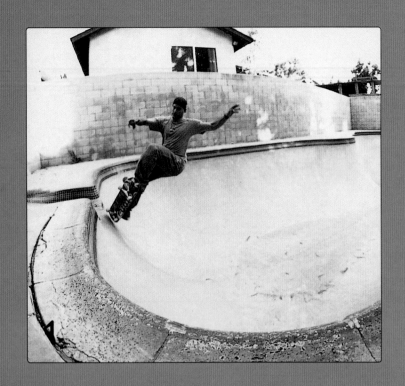

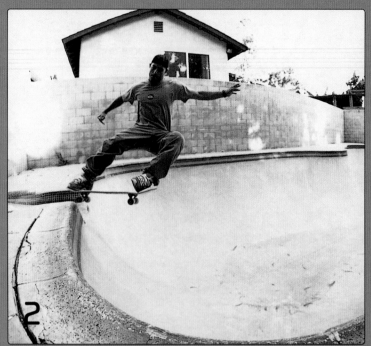

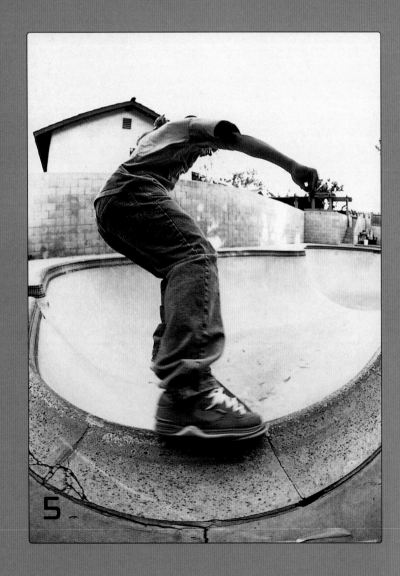

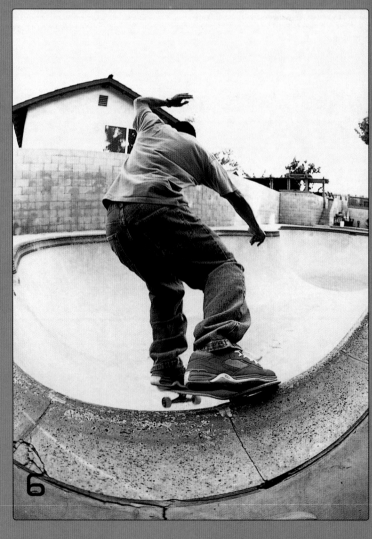

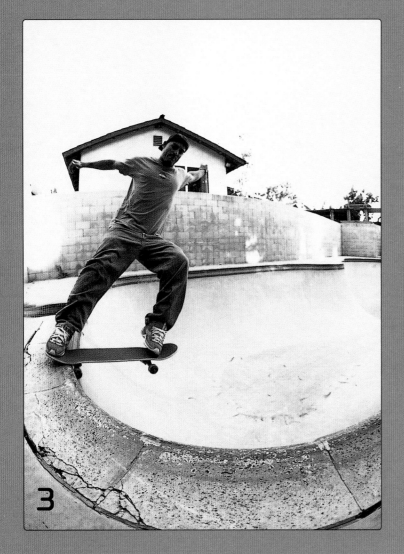

3

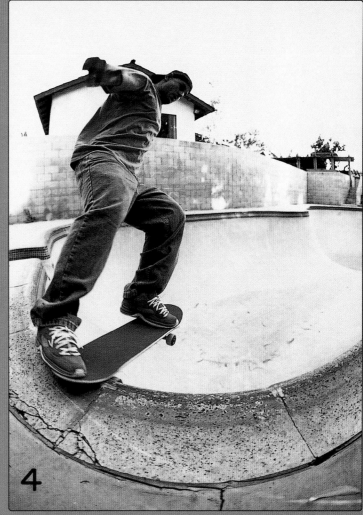

4

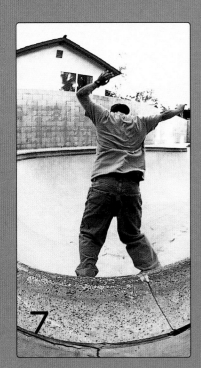

7

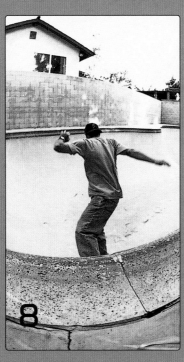

8

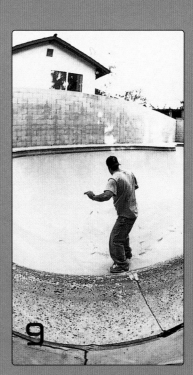

9

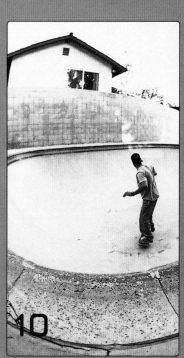

10

Omar Hassan

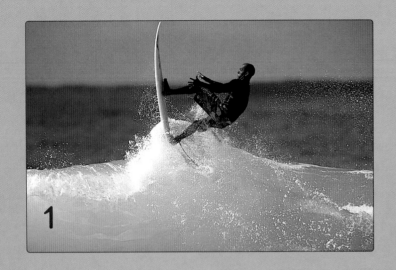

1

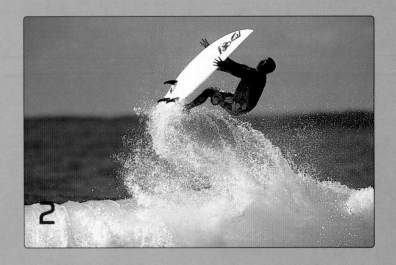

2

WHEN I WAS A KID I had this idea that every wave could be ridden perfectly for what the wave is, so I've always tried to ride a wave for what it provides. Maybe it can be ridden a few different ways, but basically there is a flow line to the wave, where if you start to ride on that line, you dissect the wave and all your maneuvers will flow together. But there's more: Your body positioning has to be right, you need the right equipment, and you have to approach it with the right speed. There is a perfect line for every wave out there, it's all about trying to tap into that.

—Kelly Slater, *Water* magazine

5

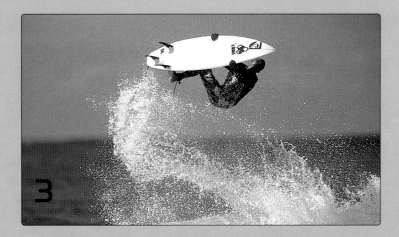

3

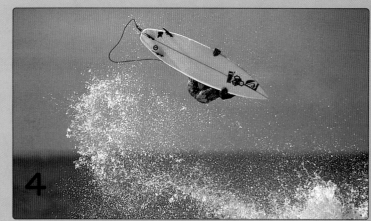

4

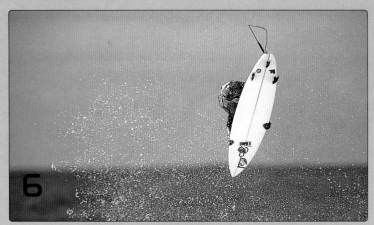

6

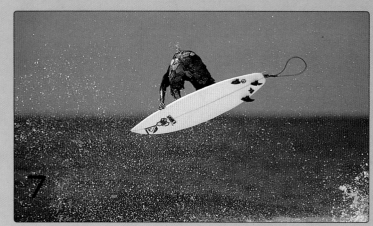

7

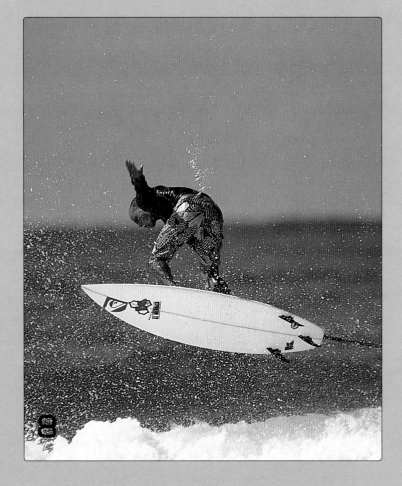

8

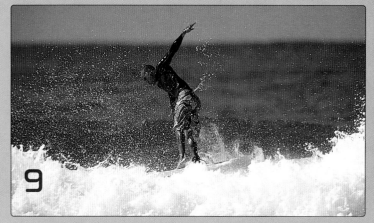

9

10

Kelly Slater

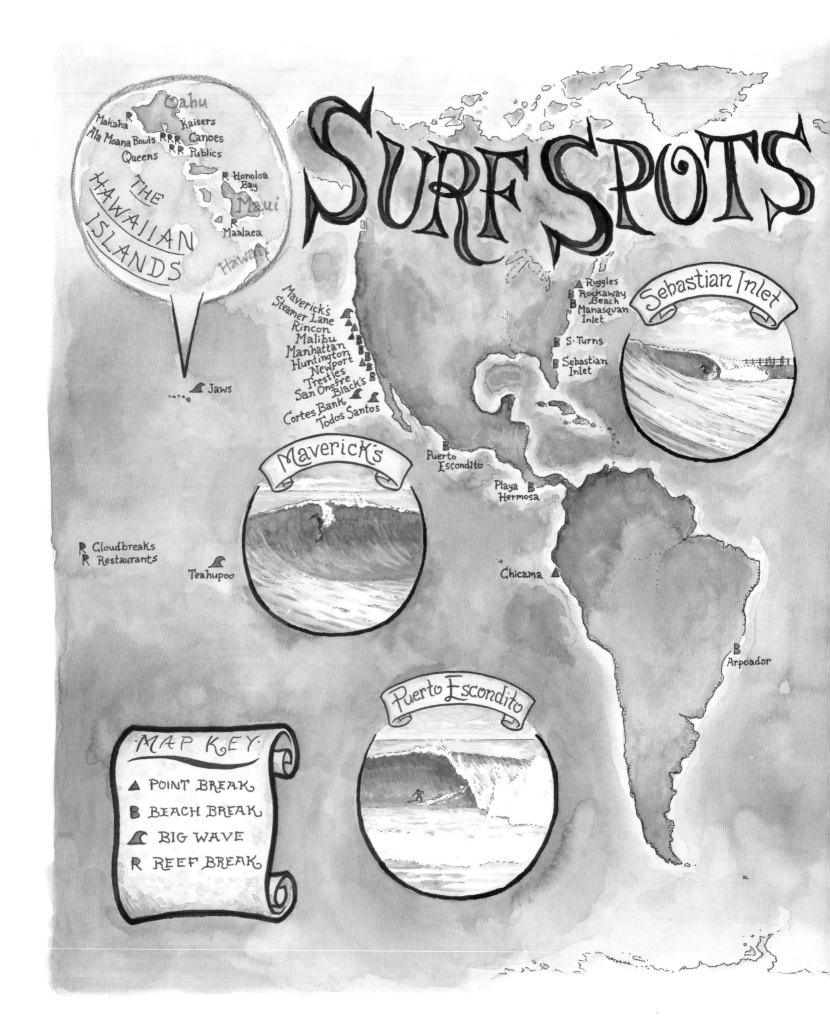

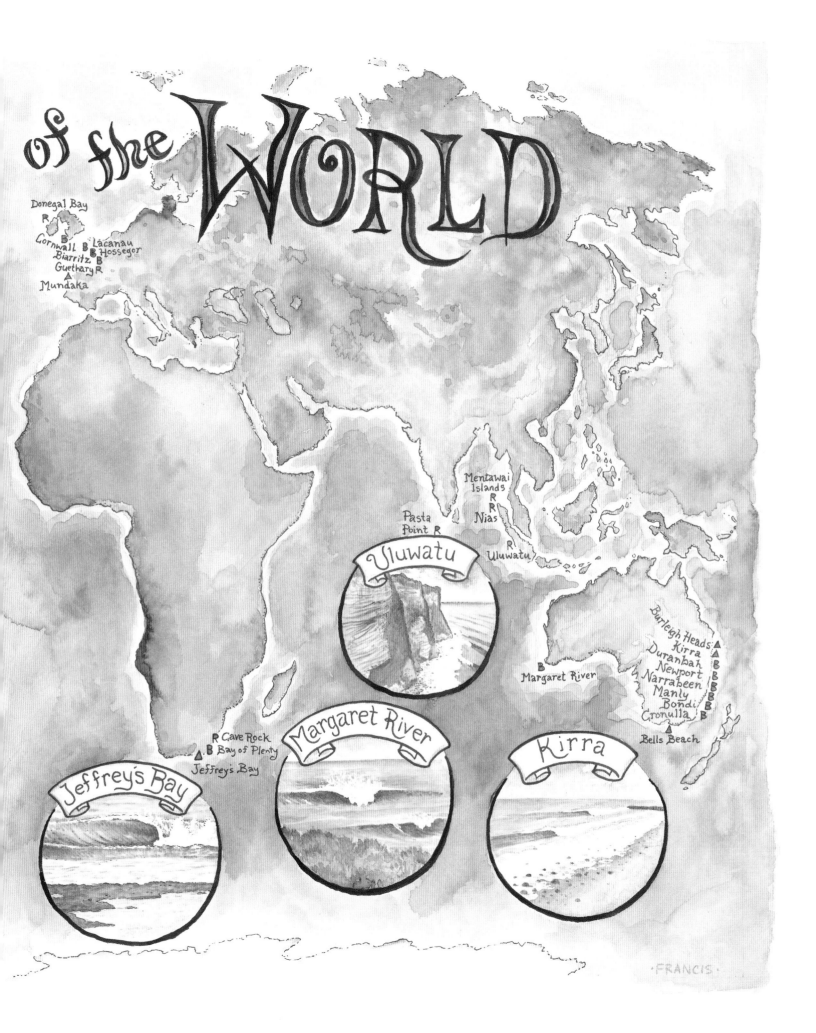

of the WORLD

Donegal Bay
R
Cornwall B Lacanau
Biarritz B Hossegor
Guethary R
Mundaka

Mentawai
Islands
R
Nias
R

Pasta
Point R

Uluwatu
R
Uluwatu

Uluwatu

Burleigh Heads
Kirra
Duranbah
Newport
Narrabeen
Manly
Bondi
Cronulla

Margaret River
B

Bells Beach

R Cave Rock
B Bay of Plenty
Jeffrey's Bay

Margaret River

Kirra

Jeffrey's Bay

FRANCIS

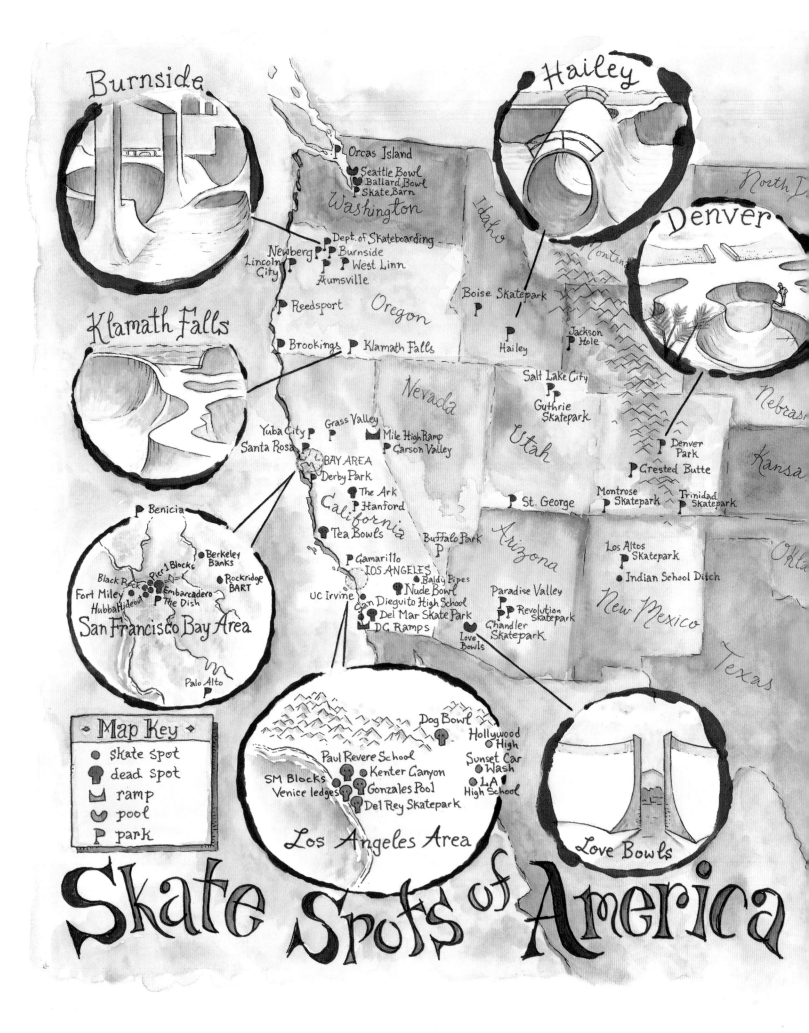

Burnside

Hailey

Denver

Klamath Falls

Orcas Island
Seattle Bowl
Ballard Bowl
Skate Barn
Washington

Idaho

North D.

Montana

Dept. of Skateboarding
Newberg Burnside
Lincoln West Linn
City
Aumsville
Oregon

Boise Skatepark

Reedsport

Hailey

Jackson
Hole

Brookings Klamath Falls

Nevada

Salt Lake City

Guthrie
Skatepark

Utah

Nebrask

Yuba City Grass Valley
Santa Rosa

Mile High Ramp
Carson Valley

Denver
Park

BAY AREA

Derby Park

The Ark

Crested Butte

Benicia

Hanford
California

Montrose Trinidad
Skatepark Skatepark

St. George

Kansa

Tea Bowls

Buffalo Park

Arizona

Los Altos
Skatepark

Berkeley
Banks

Pier 1 Blocks
Black Rock Rockridge
Fort Miley Embarcadero BART
Hubba Hideout The Dish

San Francisco Bay Area

Camarillo
LOS ANGELES

UC Irvine

Baldy Pipes
Nude Bowl

San Dieguito High School
Del Mar Skate Park
DG Ramps

Paradise Valley

Revolution
Skatepark

Chandler
Skatepark

Indian School Ditch

New Mexico

Palo Alto

Love
Bowls

Texas

Dog Bowl

Hollywood
High

Map Key

• skate spot
♟ dead spot
⌴ ramp
♡ pool
⚑ park

Paul Revere School

SM Blocks
Venice ledges

Kenter Canyon

Gonzales Pool

Del Rey Skatepark

Sunset Car
Wash
LA
High School

Love Bowls

Los Angeles Area

Skate Spots of America

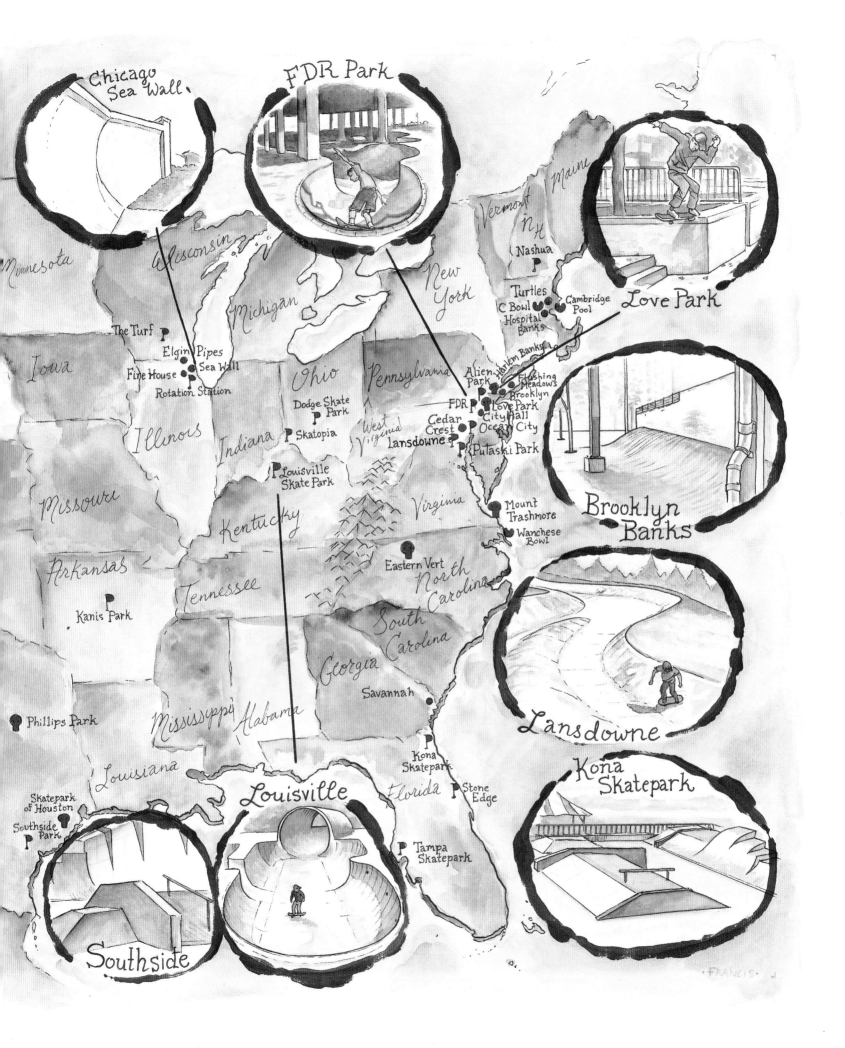

Chicago Sea Wall

FDR Park

Love Park

Brooklyn Banks

Lansdowne

Kona Skatepark

Louisville

Southside

Minnesota

Wisconsin

Michigan

New York

Vermont

Maine

N.H.

Nashua

Turtles

C Bowl

Hospital Banks

Cambridge Pool

Iowa

The Turf

Elgin Pipes

Fire House

Sea Wall

Rotation Station

Ohio

Pennsylvania

Harlem Banks

Alien Park

Flushing Meadows

Brooklyn

FDR

Love Park

City Hall

Ocean City

Illinois

Indiana

Dodge Skate Park

Skatopia

West Virginia

Cedar Crest

Lansdowne

Putaski Park

Missouri

Louisville Skate Park

Kentucky

Virginia

Mount Trashmore

Wanchese Bowl

Arkansas

Eastern Vert

North Carolina

Kanis Park

Tennessee

South Carolina

Georgia

Savannah

Mississippi

Alabama

Phillips Park

Louisiana

Kona Skatepark

Florida

Stone Edge

Skatepark of Houston

Southside Park

Tampa Skatepark

FRANCIS

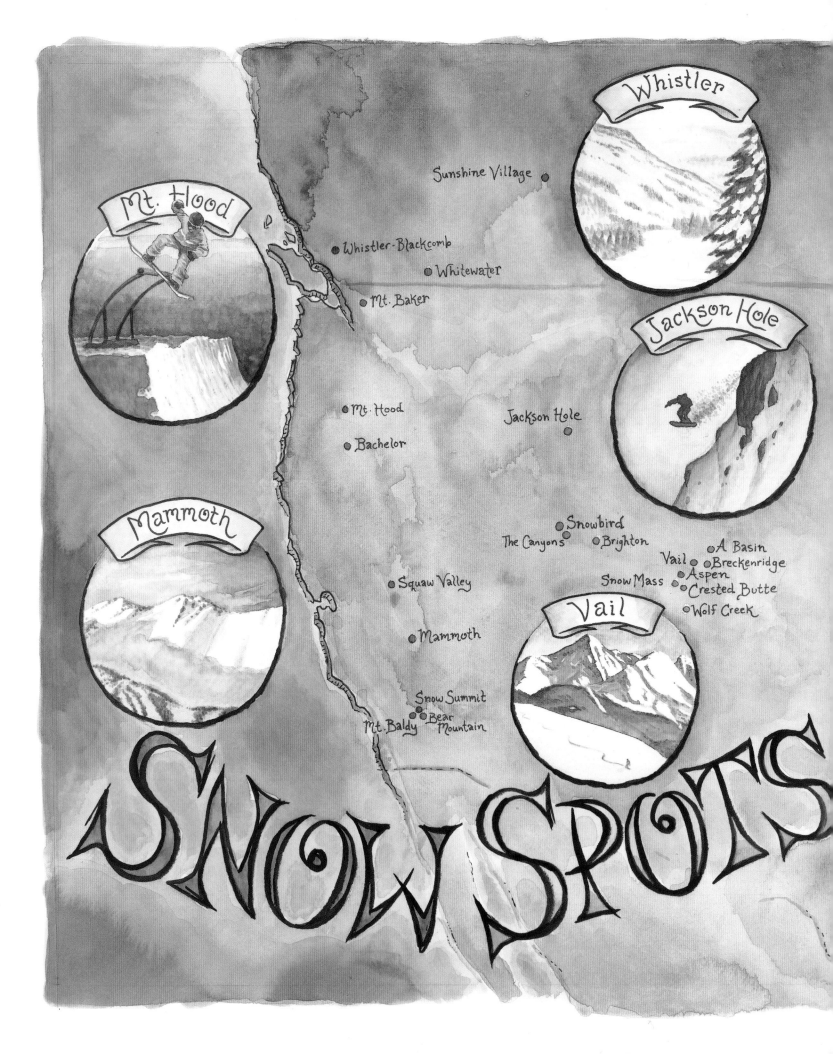

Whistler

Mt. Hood

Jackson Hole

Mammoth

Vail

Sunshine Village

Whistler-Blackcomb

Whitewater

Mt. Baker

Mt. Hood

Bachelor

Jackson Hole

Snowbird

The Canyons

Brighton

A Basin

Vail

Breckenridge

Snow Mass

Aspen

Crested Butte

Wolf Creek

Squaw Valley

Mammoth

Snow Summit

Mt. Baldy

Bear Mountain

SNOW SPOTS

Sugarloaf

Sugarloaf

Stowe

Sugarbush

Killington
Stratton

Tuckerman's
Ravine

Stratton

Breckenridge

of America

FRANCIS.

Dedicated to those who have glided, slided, and rolled into the next eternity. May your barrels be endless, powder be bottomless, and vertical be ceilingless: Donnie Soloman, Todd Chesser, Mark Foo, Mark Sainsbury, Jay Moriarty, Phil Shao, Jeff Phillips, Keenan Milton, Tristan Picot, Neil Edgeworth, Jeff Anderson, Craig Kelly, Vince Jorgenson, Jamil Kahn—RIP.

ACKNOWLEDGMENTS

Thanks: Mom, Dad, Steven, Gant, Jennifer, Gage, Sabena, Gisela, Danny Kwock, Matt Jacobson, Josh Behar, Bob McKnight, Rob Colby, Matt Warshaw, Ira Opper, Miki Vuckovich, Joel and Matt Patterson, Steve Zeldin, Drew Kampion, Nick and Tom Carroll, Leonard Leuras, Garth Murphy and Euva Anderson, Nat Young, Scott Hulet, Nathan Myers, Marcus Sanders, Grant Brittain, Jeff Divine, Steve Pezman, Terje Haakonsen, Mike Hatchett, Richard Woolcott, Troy Eckert, Jack McCoy, Derek Hynd, Andrew Kidman, Scooter Leonard, Susanna Howe, Stacy Peralta, Strider Wasilewski, Kevin Kinnear, Vava Ribeiro, Scott Sullivan, Jim O'Mahoney, Craig Stecyk, Kelly Slater, Randy Hild, David Kennedy, Pat Bridges, Jeff Baker, John Cardiel, Jake Phelps, Jeff Curtes, Thomas Campbell, Bud Fawcett, Sammy Willis, The Fletcher Family, Sam and Matt George, Jocko Weyland, Mike Doyle, Board-Trac Inc., Eric Blehm, Robert Earl, Diana Krupa, Tim Lelvis, Willy Morris, Tim Richardson, Tony Alva, Tony Hawk, Steve Siegrist, Natas Kaupas, Mark Richards and Val Surf, Mikke Pierson, Todd Roberts and ZJ Boarding House, Corb Donahue, John Millei, Benjamin Weissman, Jay Harrison, Sandow Birk, Mike Chipko, Christian Troy, Richard Brown, Family Auger, Stephen Alesch, Robin Standefer, Monster Children, Roman Barrett, Jon Foster, Atticus Gannaway, Mike Doyle, Janel Anello, Michael Marckx, Jeff Novak, Kirk Gee, Craig Marshall, Quiksilver, and to all the photographers who contributed their wonderful work.

CREDITS

Clockwise from top left where applicable. Page ii: Jason Reposar; iii: Grant Brittain, Scott Sullivan; vi: Andrew Kidman; viii: Grant Brittain; x: Scott Sullivan; 2–3: Jason Reposar; 4–9: Randy Hild Collection; 10: Doc Ball, Doc Ball, Doc Ball, Bob Johnson, Doc Ball, Leroy Grannis; 12: Doc Ball; 13: Leroy Grannis; 14: Bruce Brown Films; 16–17: Leroy Grannis; 18: Grant Brittain; 20: Leroy Grannis; 21–22: Grant Brittain; 24: Randy Hild Collection; 26: Leroy Grannis; 29: Herbie Fletcher Collection; 30–32: Leroy Grannis; 34: Ron Stoner; 36–39: Jim O'Mahoney; 40–41: Ron Stoner; 42: Jeff Divine; 43: Jim O'Mahoney; 44: Jim O'Mahoney, Jeff Divine; 45: Jim O'Mahoney; 46: Wynn Miller; 48–49: Jeff Divine; 50–51: Jim O'Mahoney; 52–54: Jeff Divine; 55: Jeff Divine, Jamie Brisick, Jeff Divine; 56: PT Collection; 57: Jim O'Mahoney; 58: James Cassimus; 61: Quiksilver Collection; 62–63: Quiksilver Collection; 64: Grant Brittain; 66–67: James Cassimus; 68: Bud Fawcett; 70–71: James Cassimus; 72–73: Jeff Divine; 74: Bud Fawcett, Grant Brittain; 75: Jeff Divine, Flame; 76–78: Bud Fawcett; 79: Jeff Divine, Mike Moir; 80–81: Jeff Divine; 82–83: Bud Fawcett, Grant Brittain, Bud Fawcett; 84: Bud Fawcett, Jeff Divine, Bud Fawcett; 85: Grant Brittain; 86: Jeff Divine; 88: Grant Brittain; 89: Grant Brittain, Bud Fawcett; 90: Bud Fawcett; 91–93: Grant Brittain; 94: Bud Fawcett; 95: Bud Fawcett, Quiksilver Collection; 96: Grant Brittain; 98: Brian Bielmann; 99: Brian Bielmann, Quiksilver Collection; 100: Bud Fawcett; 101: Grant Brittain; 102: Scott Sullivan; 104–105: Jeff Divine; 106–107: Jeff Curtes, Bud Fawcett; 108: Dan Merkel, Grant Brittain; 109: Mark Gallup; 110: Bud Fawcett; 111–113: Grant Brittain; 114: Bud Fawcett; 115: Bud Fawcett, Jeff Divine; 116–117: Brian Bielmann; 118: Grant Brittain; 119: Jeff Curtes; 120: Jeff Divine; 122: Jamie Brisick; 123: Jeff Curtes; 124: Jamie Brisick; 125–126: Jeff Divine; 127: Jamie Brisick, Jeff Curtes; 129: Grant Brittain; 130: Brian Bielmann; 132: Jeff Curtes; 133–135: Grant Brittain; 136: Jeff Curtes; 138: Grant Brittain; 139: Jeff Divine; 140–141: Aaron Chang; 142: Jeff Curtes; 143: Jeff Curtes, Grant Brittain, Pete Taras, Grant Brittain; 144: Hank; 146–147: Bud Fawcett, Jason Reposar; 148: Grant Brittain; 150–151: Rob "Whitey" McConnaughy; 152: Brian Bielmann; 153: Jeff Divine; 154: Grant Brittain; 156: Flame; 157: Andrew Christie; 158: Jeff Curtes; 159: Geoffrey Fosbrook; 160–161: Grant Brittain, Affif, Grant Brittain; 162: Scott Sullivan; 163–164: Grant Brittain; 165: Scott Sullivan; 166: Jason Reposar; 167: Chris Ortiz; 168: Tony Magnusson Collection; 169: Jamie Brisick, Andrew Kidman; 170: Jeff Curtes; 172: Scott Sullivan, Affif; 173: Jamie Brisick; 174–175: Jeff Curtes; 176–177: Affif; 178–179: Andrew Shield.

Illustrations and maps by Todd Francis.

INDEX